CLOSE-UP & MACRO

A PHOTOGRAPHER'S GUIDE

FRONT COVER: ORANGE-TIP *ANTHOCHARIS CARDAMINES* (MALE) SPINE: MADAGASCAN COMET MOTH *ARGEMA MITTREI*
BACK COVER (MAIN IMAGE): BURNT ORCHID *ORCHIS USTULATA* BACK COVER (SMALL INSET PHOTOS – TOP): MADAGASCAN COMET MOTH *ARGEMA MITTREI* EYESPOT
(MIDDLE): COMMON FROG *RANA TEMPORARIA* (BOTTOM): LARCH BOLETES *SUILLUS GREVILLEI* THIS PAGE: SPOTTED TOUGHSHANK *COLLYBIA MACULATA*
TITLE PAGE: SIX-SPOT BURNETS *ZYGANEA FILIPENDULAE*

A DAVID & CHARLES BOOK
David & Charles is a subsidiary of F+W (UK) Ltd.,
an F+W Publications Inc. company

First published in the UK in 2005
Paperback edition published in North America in 2005

Distributed in North America
by F+W Publications, Inc.
4700 East Galbraith Road
Cincinnati, OH 45236
1-800-289-0963

A catalogue record for this book is available
from the British Library.

ISBN 0 7153 1903 5 hardback
ISBN 0 7153 1905 1 paperback (USA only)

Printed in China by SNP Leefung
for David & Charles
Brunel House Newton Abbot Devon

Commissioning Editor Neil Baber
Senior Editor Freya Dangerfield
Desk Editor Ame Verso
Project Editor Nicola Hodgson
Executive Art Editor Ali Myer
Art Editor Lisa Wyman
Production Controller Kelly Smith

Visit our website at www.davidandcharles.co.uk

David & Charles books are available from all good bookshops; alternatively you can contact our Orderline
on (0)1626 334555 or write to us at FREEPOST EX2 110, David & Charles Direct,
Newton Abbot, TQ12 4ZZ (no stamp required UK mainland).

CLOSE-UP & MACRO
A PHOTOGRAPHER'S GUIDE

Robert Thompson

D&C

David and Charles

For Jonathan and Ethan
May you always appreciate the beauty and fragility of the
natural world in all its diversity.

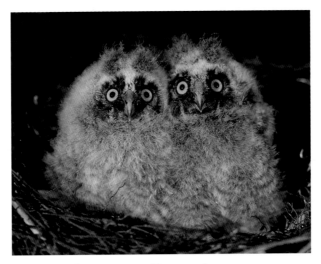

LONG-EARED OWLETS *ASIO OTUS*

Acknowledgments

My thanks to all the people who have helped and provided me with information for this publication, especially my good friends Mike Parsons and John Spencer, with whom I have shared many enjoyable orchid trips throughout Europe.

To Paul Roper at Mamiya UK and JP Distribution, my sincere thanks and gratitude for all your help and continued support regarding this project, and thanks also to Keith Sanderson for providing help and information on equipment.

I owe a special thanks to my commissioning editor, Neil Baber. In addition to his help and guidance, he cheerfully endured my numerous lengthy conversations with remarkable resilience. Thanks also to Freya Dangerfield, Alison Myer and Lisa Wyman at David & Charles for their valuable contribution to the project; and to Kerry White, Paul Jolly, Phil Turner and Ed Hayes at Colorworld for all of their help and support throughout the year.

I would also like to thank the following individuals for their help and assistance with equipment and additional information: Fabio Prada of Manfrotto, Italy; Derek Gatland of Hasselblad UK; Leo Cunningham of Queens University, Belfast; Howard Fox of the Botanic Gardens, Dublin; Michael Edwards of Fixation; Jim Williams and Bill Oberman of SmartDisk UK and America; and Martin Wood and David Kitchin of Kodak UK.

Finally, my heartfelt thanks to my wife Catherine for all her help with the manuscript and her continued support and understanding during my long and frequent absences from home.

CONTENTS

Introduction

This book is about the natural world in close-up – a hidden world beyond the familiar; a micro-cosmos of astonishing beauty and diversity, which for the most part goes unnoticed. Nature in all its diversity has the capability to intrigue and enthral us. Few people could fail to be captivated by its beauty. The subject material is infinite; the creative potential is limited only by your imagination and ability. Most of the images contained in this book are of subjects commonly encountered or easily found. I have generally avoided illustrating material that is beyond the reach of the average photographer.

Exploring the beauty and complexity of the natural world has long been a fascination of mine. My interest in natural history stems back to my childhood, when I spent the summer months exploring the grounds of the large estate where I grew up. No manner of insect or creature escaped my notice. I have since been fortunate enough throughout my career to have travelled to many locations in search of new and interesting subjects to photograph.

For me, photography is a means of recording my engagement with the natural world, and a way of sharing my experience with others through the subjects I photograph. It will be apparent to many that most of the photographs in this book were taken on medium-format film. I am not advocating that medium format is the only way to achieve the end result. I have used it for most of my career and am very happy with the quality and the results that it can deliver. While I still use film for the majority of my work, I also use digital capture where possible. Digital capture has had a profound effect on the photographic world over the last few years, and it is now a serious alternative to film in the 35mm format. My photographic sales still favour film, although my digital sales are increasing at a steady pace. The imminent introduction of Mamiya's ZD digital camera and back will bring high-end digital capture within the remit of most professionals. It will threaten what are perhaps the last bastions of film: landscape and medium-format photographers.

However, this book is not about formats, nor about the relative merits of different camera brands. It is about fieldcraft, methodology, and the photographic techniques that I use and have found successful. If you want to explore the technical aspects in greater detail, there are many books available that specialize in discussing equipment hardware. These days, photographic books and magazines seem to place greater emphasis on equipment and less on methodology and application; consequently, photographers seem more than ever hung up on specifications rather than photography itself. Reading most photographic magazines bears testament to this. The standard of photographic equipment today is so good that high-quality close-ups can be taken with most modern photographic systems.

As photographers, we strive to create images that have pictorial appeal and impact. However, we should also be mindful of the subject's welfare and preservation at all times – something that seems to have been less of an issue in recent years. The most accomplished nature photographers are also good field researchers. Understanding the behaviour and ecology of your subjects and how best to portray them is the difficult and challenging part of nature photography. There are no secrets or infallible techniques, except persistence and a discerning eye for detail and artistic form. All too often, I see images reproduced in books, photographic magazines and other publications that appear technically good. However, the photographer's lack of knowledge of the subject's behaviour or habitat preferences is clearly evident in their contrived depictions.

In this book, I have tried to show you what is possible in the world of close-up and macro photography. I have described the tools and methods needed to create great close-ups, whether you are a 35mm, medium-format or digital user. Part One deals with photographic hardware and the specialized equipment that is needed to achieve good results. Part Two discusses the methods and the application of the equipment and techniques for photographing and finding popular subjects in the wild. Part Three is a gallery of photographs that typically reflect each season, giving the reader some ideas of the sorts of subjects that can be looked for and photographed at the appropriate time of year.

I have not given any exposure information for the photographs, as I don't normally keep a record of it – after all, each situation is unique and cannot be repeated. I must also point out that no digital manipulation of the photographs has been done apart from removing the odd scratch or mark.

Finally, I hope that this book encourages you to explore the beauty and complexity of our hidden world and develop a greater understanding and appreciation of its fragility and the subjects whose fate ultimately rests in our hands.

Robert Thompson

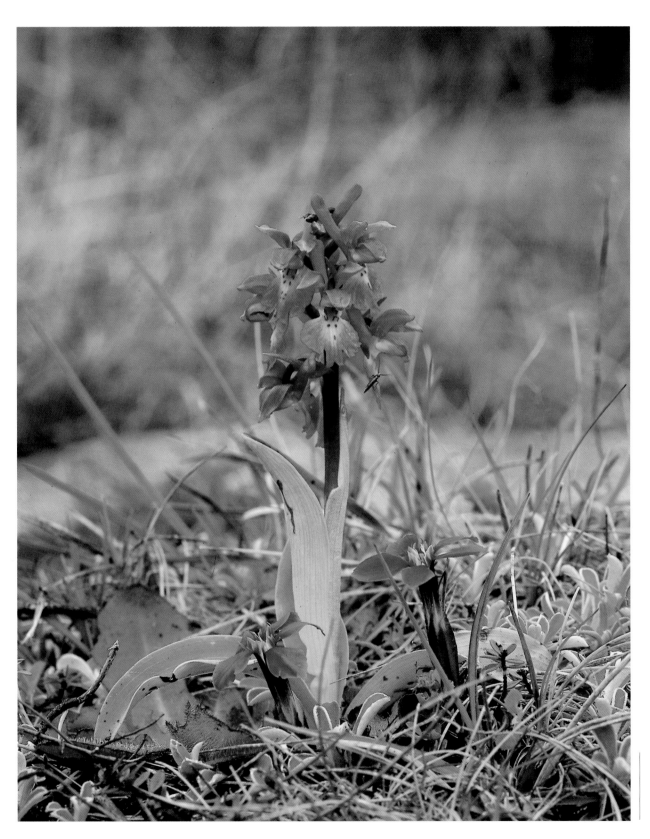

EARLY PURPLE ORCHID
ORCHIS MASCULA
Kodak DCS Pro 14/nx, Nikon
200mm macro lens, ISO 160,
Raw format converted to Tiff

PART ONE

Photographic hardware

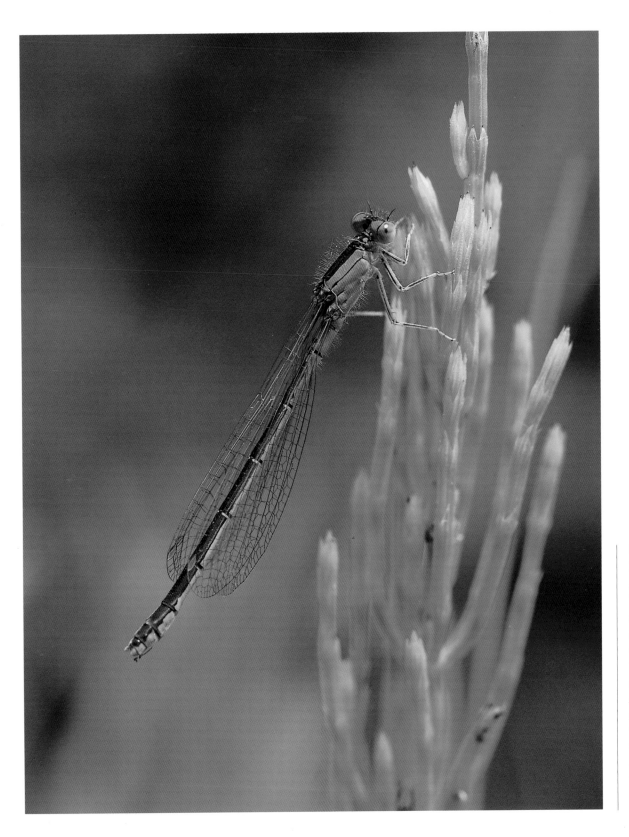

**SCARCE-BLUE-TAILED
DAMSELFLY *ISCHNURA
PUMILIO***
*Whichever format you choose,
the single lens reflex (SLR)
camera is the ideal choice for
capturing nature in close-up.
The viewfinder allows you to see
the subject as it will appear on
film. This immature female was
perched low down among the
vegetation. I used a monopod for
extra stability, as the nature of
the terrain made it difficult to
work off a tripod.*
Mamiya 645, 120mm macro lens,
fill-flash, Fuji Velvia

Choosing a camera system

The wide range of cameras and lenses available today makes choosing a camera system a daunting task for anyone wishing to take up nature and close-up photography. Advances in design and in electronics have taken modern cameras to unprecedented levels of sophistication. The last few years have also seen profound changes in the photographic industry, especially in terms of digital capture.

Factors that affect your decision

There are many issues to consider before you decide which camera system to buy. One of these, of course, is how much money you have to spend. Then, perhaps the most important issue is whether you want to use digital capture or to stick with film. You also have to decide on whether you want to use 35mm or medium format. A visit to a reputable camera shop with a wide range of equipment in stock is a good starting point in making your decision, as you can handle and compare different formats and brands. The important thing is to make sure that the camera feels comfortable in your hand and that the main function buttons are easily accessible.

Bear in mind that a camera that suits one person may not be right for another. Research your system thoroughly and contact other photographers who are using the camera that you are interested in – they will be able to tell you the pros and cons first-hand. Investing in a camera system is, for most people, a long-term commitment – think carefully about where your main photographic interests lie, and make sure there are sufficient lenses and accessories available should you decide to branch out into photographing other natural history subjects.

Well-known 35mm camera manufacturers such as Nikon and Canon have some of the most comprehensive ranges of close-up and macro accessories available. They tend to be more expensive than other 35mm brands, but you pay for robustness and reliability. In medium format, Mamiya and Hasselblad have a comprehensive range of lenses and equipment suitable for close-up and macro. Their equipment is more expensive when compared to other brands. However, they have an excellent reputation for quality and reliability

– an important factor to consider if you are planning to operate at a professional level.

Detailed information on cameras, including specifications and instruction booklets, are usually available on manufacturers' websites. There are also many useful websites that carry out in-depth reviews on cameras and other photographic equipment. Their findings are generally useful and may influence your decision. Before you purchase any system, you should first of all define your field of interest. This is important, since it will largely dictate what your equipment needs will be.

Digital or film?

The most difficult question facing photographers at the moment is whether they should invest in digital or stay with film. The last few years have seen digital technology advance in leaps and bounds, gathering momentum and converts along the way. Digital has revolutionized some aspects of photography, particularly photojournalism, which is ideally suited to digital capture. When it comes to other photographic disciplines, however, such as nature and landscape, many photographers have been cautious about making the change.

Whether you choose the digital or film path, the single lens reflex (SLR) camera is still the ideal choice for capturing images of nature in close-up. The viewing system allows you to see your subject as it will appear on film. For years, the 35mm format, with its renowned versatility and wide selection of lenses and accessories, has been the obvious choice for professionals and amateurs engaged in nature photography. However, trends change and more professionals have seen the advantage of using medium format for many aspects of their work that don't require speed and ultra-fast lenses. Mamiya's 645 AFD and the Hasselblad H1 are designed both for film and digital capture – a distinct advantage, as it avoids carrying two systems into the field.

**NIKON
F100 SLR CAMERA**
Modelled on the F5, the F100 is suitable for professionals and serious amateurs who want the functionality of a top professional camera but don't need all of the features.

MAMIYA 645 CLOSE-UP ACCESSORIES
These are some of the lenses and accessories that are currently available for the Mamiya 645 system. Mamiya also manufactures fully automated bellows and extension tubes in different sizes. These can be used in combination with a macro or with other short telephoto lenses.

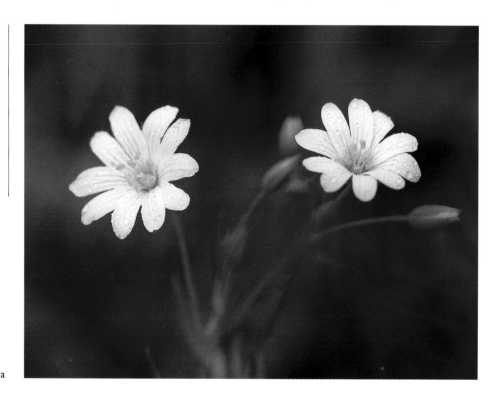

The 645 format is perhaps the most popular and widely used for general nature and macro photography. It offers a film area that is 2.7 times larger than the 35mm format. The Mamiya 645 AFD and Hasselblad H1 are perhaps the most widely used models – their streamlined appearance and slick design are a major improvement over the older, bulkier versions. These cameras have many of the characteristics that are familiar to 35mm users, with the added advantage of a greater film area, offering increased resolution and saturation.

Contax and Pentax also manufacture cameras in this format which are not as widely used as the more popular brands. However the latter does not have interchangeable backs which can be a disadvantage.

Most of the leading medium-format manufacturers have a reasonable variety of close-up accessories and usually at least one macro lens, in addition to various extension tubes and bellows. Whatever system or format you choose, there is little difference between individual cameras in terms of image quality and reliability. The photographic market is a highly competitive industry, and manufacturers are very aware of the need to maintain high standards of quality and reliability.

MAMIYA 645 AFD WITH 120MM MACRO LENS

Mamiya has a reputation for quality and versatility when it comes to medium-format cameras. The 645 format is highly versatile and shares many of the features common to the 35mm format. It is an excellent choice for close-up and general nature photography.

GREATER STITCHWORT *STELLARIA HOLOSTEA*

The larger format is ideally suited for many aspects of nature photography that don't require fast telephoto lenses.
Mamiya 645, 120mm macro lens, Fuji Velvia

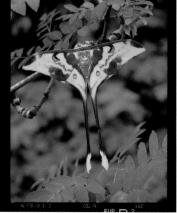

Image left Mamiya 645, 120mm macro lens, Fuji Velvia

Image below Pentax LX, 100mm macro lens, Fuji Provia F

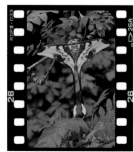

MADAGASCAN MOON MOTH *ACTIAS MAENAS*

These photographs depict the actual size of the 645 and 35mm formats. The greater film area of the larger format allows subjects to be photographed at higher magnifications while still being able to include the same amount of the surrounding habitat. This can be an advantage when you want to illustrate the subject in the context of its environment. The larger format is also much easier to crop than the smaller format.

Digital capture

When Kodak introduced the first commercially built digital SLR (D-SLR), the DCS 100, in 1991, with a staggering price tag of £15,000 ($25,000) and a mere 1.3-megapixel sensor, few people then believed that digital would ever be a serious contender against film. Now, digital appears to threaten its very existence.

The last few years have seen a dramatic change in the cost and quality of D-SLRs, especially in the amateur sector. The cost of many 35mm D-SLRs was, until recently, largely prohibitive for most photographers. However, the latest generation of high-tech cameras are generally more affordable.

When digital first began to take off, many people viewed it with apprehension, particularly the purists and the amateur sector. Digital was considered to be the enemy that threatened to make film redundant and destroy the craft of photography as we knew it. In fact, digital has helped to revitalize conventional photography and breathed fresh air into an art that had been static and lacking direction.

Digital capture is a relatively new technology that is constantly undergoing developmental change. It requires a much greater input at all stages from photographers than conventional film cameras did in the past. If you are not computer-literate, it demands a steep learning curve, but there is much enjoyment and satisfaction to be gained from this new technology.

The pros and cons of both systems

Although this is essentially a technical book that focuses on the methods of photographing nature in close-up, it is worth pointing out some of the pros and cons of both technologies. If you are contemplating the route of digital capture, you should first familiarize yourself with a number of important issues. The rate of technological change in the digital world means that many cameras and associated products have a relatively short life span. By the time you read this book, some of the equipment and information may well have been superseded. However, most of the advice given will be applicable even if the technology has moved on.

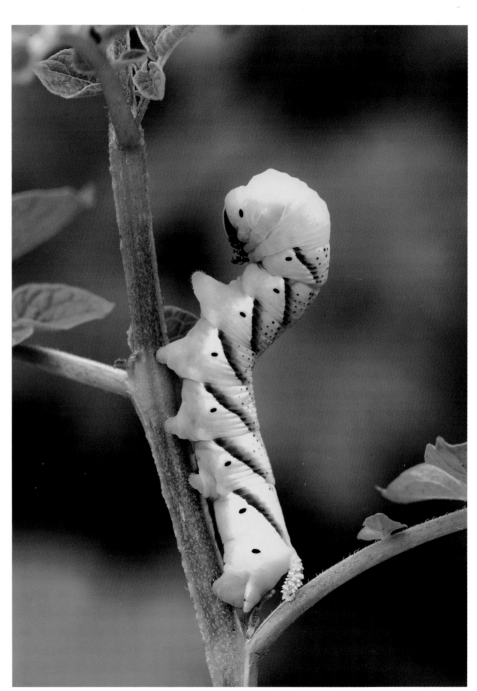

DEATH'S HEAD HAWK-MOTH LARVA *ACHERONTIA ATROPOS*
The Kodak is currently the highest-resolution D-SLR, producing finished Tiff files in the region of 40MB. I shoot in Raw format and convert to Tiff. I find the colour accuracy and results from this camera excellent. As with all cameras, you need to perform some tests and familiarize yourself thoroughly with the workings of the camera in order to get the best from it.
Kodak DCS Pro 14/nx, Nikon 200mm macro lens, ISO 160, Raw format converted to Tiff

Going digital: the issue of quality

The question uppermost in many photographers' minds is whether digital capture is as good as film. This has been a source of debate for some time. The results in the past have been conflicting and, in many cases, inconclusive. It is extremely difficult to compare two different imaging systems methodically and fairly. As a dedicated medium-format photographer for the last 15 years, I am used to seeing and working with transparencies that are considerably larger than 35mm. For me, the quality question is difficult to answer. There is a general consensus now that the current high-end range of 35mm D-SLRs will produce images that are better than film at the equivalent ISO value in this format. The issue is more controversial with medium format, since it depends on a number of other factors.

The type of photography you do will also have a direct bearing on what system is best suited to your needs. From a personal perspective, I find that shooting Fuji Velvia film on medium format produces images that are superior in every respect to my Kodak DCS Pro 14/nx digital camera. However, if you make the comparison against a larger sensor currently being used in some of the latest medium-format digital backs, the differences are less apparent.

KODAK DCS PRO 14N/X

This camera was originally a Pro 14/n but I had the sensor upgraded. This is the highest full-frame-resolution D-SLR available at the time of writing. It is primarily designed for professionals, although its high cost puts it well beyond the reach of many photographers. It delivers 14 megapixels with a resolution of 4536x3024, and finished Tiff files of about 40MB. It can be used quite successfully in nature photography with the added advantage of the large digital files, which suit professionals selling their work through agencies.
The autofocus is not as responsive or as fast as the high-end Nikon or Canon models. Kodak manufactures the camera in both a Nikon and a Canon mount.

SCARLET ELF CUP SARCOSCYPHA AUSTRIACA

Some manufacturers claim their current high end D-SLRs can deliver medium-format quality. In this example I used a Kodak Dcs Pro 14/N (before sensor upgrade) below left and a Mamiya 645 below right. The central portion of both images is shown at 400 per cent with no sharpening applied. The settings were as follows: aperture f/16 in both shots, ISO 80 (lowest ISO setting) on the Kodak, ISO 50 on the Mamiya. The long exposure mode was used on the Kodak. Both images were taken on a tripod and with a cable release. The mirror was raised prior to exposure. While I accept that all parameters are not exactly equal I still think 120 roll film has the edge.
Image below left Kodak DCS Pro14/n, 105mm Micro Nikkor lens, Raw format converted to Tiff
Image below right Mamiya 645, 120mm macro lens, Fuji Velvia

Sensor size

The majority of current D-SLRs use CCD (Charge-Coupled Device) or CMOS (Complementary Metal Oxide Semiconductor) sensors, which are smaller in size than a film-based 35mm camera. Consequently, the capture area is noticeably less when compared to a full 35mm frame. At the time of writing, only two professional D-SLRs with full-frame 35mm sensors are available: the Canon EOS 1Ds and the Kodak DCS Pro SLR/n. This means that there is no increase in the focal length of each lens and the angles of view are the same as for film-based cameras.

Focal length

The smaller sensor offers certain advantages, but it also has some disadvantages. It increases the focal length of a lens by a factor ranging from 1.4x to 1.6x, depending on sensor size. For example, a 100mm macro lens fitted on a D-SLR multiplied by a factor of 1.5 produces an increase in focal length to 150mm and a magnification of 1:5 times life-size. Similarly, a 300mm telephoto lens will become a 450mm.

Depth of field

You might say that this is an advantage for wildlife and macro photographers. However, there are other issues to consider. For example, depth of field is not the same as it would be using a lens of this focal length on a film-based 35mm camera. In fact, depth of field is greater with any lens on all small-sensor D-SLRs. This is because depth of field is related to magnification, or the size of the image compared to the true size of the original subject at a given distance. Put simply, a smaller image means greater depth of field. In the world of macro, some would say this is a good thing. However, if you want to control background focus and produce poster-like images, this can be difficult to achieve with a small-sensor D-SLR.

Wide-angle lenses

Wide-angle lenses also suffer an increase in focal length. For example, a 24mm lens multiplied by a factor of 1.5 would now have the coverage of a 36mm lens. Manufacturers are addressing the problem and producing digital wide-angle equivalents that produce the same field of view that you would see if using a 35mm film-based camera.

Going digital: financial issues

Digital capture offers a number of advantages over conventional film-based cameras. The greatest advantage is that of lower routine running costs. In addition to cost and processing, film requires good-quality mounts, storage sleeves, labels and filing cabinets, not to mention the large amount of time needed to complete the routine tasks of storing and filing. Digital capture eliminates these necessities.

However, it can sometimes be easy to become caught up in the hype surrounding digital and lose sight of some of its disadvantages.

While digital running costs may be lower, the cameras themselves are much more expensive, especially at the higher end of the D-SLR market. If you use large amounts of film, the initial cost incurred can be offset over a period of time. A typical D-SLR camera of around 6 or 8 megapixels generally costs twice as much as an equivalent film-based unit, while full-frame professional cameras in the range of 14 to 16 megapixels cost considerably more. Since digital capture is still

very much a developing technology, the depreciation costs of a D-SLR are extremely high when compared to film-based cameras, and your equipment will therefore need replacing every few years if you want to keep up with the latest developments.

The transition from a film system

If you already own a film system with several lenses, you may want to keep to the same manufacturer if possible. Initially, there is a higher overall outlay in converting to digital. However, bear in mind that designing digital cameras around the 35mm format may only be a short-term solution offered by camera manufacturers to ease the transition and the financial burden for photographers converting from film to digital. Being able to use your existing lenses with some digital cameras is a great advantage; it means less initial outlay and eliminates the duplication of lenses between camera systems.

The hidden costs with digital

There are certain hidden costs associated with digital. These include the need for storage or media cards – most digital camera bodies are sold without these. Storage cards come in an assortment of sizes; the most popular is 1 gigabyte (GB), but you can also buy 2- and 4GB cards. You need a minimum of two in the event of damage or if you don't have the means to download images in the field.

Additional equipment for digital

If you plan to go digital, you will need a high-spec computer, especially if you are working with large digital files from the higher-spec cameras, which can generate files between 40 and 50 megabytes (MB) per image. Processor speed and Random Access Memory (RAM) are important. The higher, the better; 512MB of RAM is an absolute minimum, and 1GB is preferable. A hard drive of around 80MB is only a starting point.

Without a disciplined approach to editing your images, you will quickly consume all of your hard-drive space. Backing up your images is an essential part of digital management; if you ignore it, disaster looms. If you are a professional earning a living from your work, this does not take into consideration the extra hours spent at a computer screen – something you don't have to do with film. My computer has a raid system that has three hard drives and automatically backs up my digital

files to the two other drives. One drive is removable, which means I can lock it away in a safe place in case of hard drive failure, fire or theft.

No matter how careful you are, backing up is still not as safe as storing film in cabinets or drawers. Remember also that storage media have changed dramatically from the days of floppy disks. We have witnessed CDs, zip drives, DVDs, and now external hard drive storage, all within the last ten years. The next ten years will bring more changes, which means that the long-term storage of electronic images will pose a lot more headaches than the storage of film.

You will also need a high-quality monitor, preferably a Trinitron unit, for image-editing and processing. I use a 19-inch Mitsubishi Diamond Pro. These devices are capable of producing a high-quality image on screen. TFT screens, despite coming down in price, are not quite as good or adaptable when it comes to using different screen resolutions. A CRT monitor is still a good option for working with photographic images; many of the high-spec units are reasonably priced now.

Other pros and cons

There are various pros and cons associated with digital. One of the great bonuses is that you can view your images immediately and make corrections and re-shoot if necessary. Being able to preview your work is a valuable aid in the field. However, on the down side, the LCD preview screen is quite small. It should be used only as a visual check for composition and not as a means to gauge exposure, as many inexperienced photographers do. Analysing the histogram of each image is vital, as this contains the information relevant to exposure. This is unlike film, where you have to finish the roll and wait on laboratory processing.

Digital images can be on screen and printed out in minutes. They can be edited in image-editing programs to correct faults or introduce special effects. This can involve a large amount of time spent at the computer. Film has to be scanned first, which involves additional time and hassle. On the plus side, film offers some advantages over digital, including its longevity and the fact that you have no additional work to perform.

The two systems demand a different approach to your work. When it comes to film, many photographers lack a proper structured filing system and tend to keep their slides loose in boxes and cabinets. Digital, however,

NIKON D70 DIGITAL SLR
The Nikon D70 is a typical middle-of-the-road D-SLR, with 6.1 million pixels, delivering an image size of 3008x2000 pixels and a minimum ISO of 200. This camera is more than adequate in terms of quality and performance for photographers who don't require large-size prints or need to publish their work through an agency.

requires you to take a far more structured and organized approach if you are going to keep your work under control. It is also easy to delete your valued photos.

Digital file formats

Most D-SLRs give you a choice of three file formats: Raw, Tiff and Jpeg. To get the best from your camera, it is a good idea to shoot in Raw format. This option has the greatest flexibility since you are dealing with the pure data processed from your D-SLR without anything else applied, such as sharpening and colour correction. The disadvantage with this format is that it can only be viewed and altered in the camera's own browser software, although Photoshop and a few other programs support some of the main camera manufacturers' Raw file formats.

Once you are happy with the image, you can convert it to the Tiff or the Jpeg format. These are both universally recognized formats. A Tiff file is quite large and uncompressed. It can be altered and resized as often as you like. A Jpeg, on the other hand, is compressed. This means that every time you open the file to make alterations, you lose information unless you save a copy to disk. A typical 6-megapixel camera produces a Tiff file of around 17.4MB, while a 14-megapixel camera produces a file size in the region of 40MB.

Working in the field

Working with the Kodak DCS Pro14/nx, I can shoot approximately 60 images in Raw format on a 1GB card. This is hardly enough for a single day's shoot in the field. You have a choice to make here: carry additional cards, which can work out quite expensive; or buy a laptop or a portable storage device. A laptop gives you freedom and portability and can be used to download images in the field, although it can be a bit of a nuisance to carry around. However, at the end of a session you have the option of transferring your images to a laptop for previewing and editing in situ.

A more practical solution for the field is a portable storage device, which is light and fits neatly inside your photographic bag. You can download the images from your card in the field quickly and then transfer them to your home or laptop computer at the end of each session. These devices are not cheap, but they are extremely useful and capable of holding large amounts of information. I find such devices indispensable when

I am on location or when I don't have access to my computer for long periods of time.

Staying with film systems

Many nature photographers, both amateur and professional, have invested considerable sums of money into building up a comprehensive film-based system. Some, naturally, are reluctant to convert entirely to digital, especially when the technology is still in a transitional phase and only marginally better than 35mm film. Staying with film does not prevent anyone from entering into the realm of digital photography, however. Images taken on film can be scanned to any file size and from that point onwards can be treated in the same way as digitally captured images.

This method is perhaps the best introduction for photographers who are coming fresh to digital technology, as it offers the benefits of both film and digital. Scanners are extremely popular among 35mm film users and are the easiest way to obtain digital copies of your images. The quality of scanners varies tremendously among brands, as do the price and the results. If you don't demand the ultimate in quality, many of the low-end scanners will probably meet your needs perfectly well. However, Nikon and Minolta produce high-quality 35mm film scanners that are capable of delivering reasonable results.

For medium-format users, the choice of scanners is much more limited. Both Minolta and Nikon make film scanners that cover medium format, but they cost considerably more than their 35mm counterparts. If you are operating professionally, getting a laboratory to scan your images for you is, in my opinion, probably

FLASHTRAX PORTABLE STORAGE DEVICE
When on location, I prefer not to carry a portable laptop into the field. Like many nature photographers, I'm already burdened with a heavy backpack. I have found this unit to be truly excellent; I can insert another card into my camera and continue working while the unit is downloading the files. The unit comes in three different sizes: 20, 40 and 80GB; I use the 40GB model. At the end of each day, I normally transfer the results to my laptop for editing when I am back at the hotel or base.

ROBIN MOTH
HYALOPHORA CECROPIA
*This is a high-resolution
scan from a 645
transparency produced by
Colorworld on a Kodak
Photo scanner. The quality
and colour balance are
excellent. I much prefer
this approach to spending
valuable time sitting at the
computer scanning my own
transparencies on a unit
that costs much less than
this professional model.*

the best approach; it also saves you valuable time. The results are generally far superior in terms of colour balance and image quality, since laboratory scanners cost considerably more than the best home-based units on the market. I routinely send my medium-format slides to my local laboratory for scanning and have always been extremely happy with the results. The images are scanned by one of the high-end Kodak scanners and returned on Kodak professional-quality disks. These are of archival quality, meaning that your images will be stored on the disks for the length of their lives – around 50–100 years, providing you store them in the appropriate conditions. The images can be scanned by a reputable laboratory to whatever file size you specify. Scans in the region of 60–70MB are more than adequate for use in the the vast majority of publications. These will also be more than adequate for producing prints at home on an inkjet printer, up to A3 size (11½ x 16½in).

The professional aspect

From a professional point of view, converting to digital capture can mean huge savings on film and processing costs. It also eliminates the need for creating duplicate slides of precious originals, and endless hours of mounting and cataloguing that never-ending backlog of processed films. You can email a client low-resolution previews, or upload your images to a website with a link to view within minutes from any part of the world.

Digital capture also opens up many new avenues for showing and marketing your work. One point to bear in mind if you're a professional, selling your work commercially or through an agency, is that the lower-end digital cameras of around six megapixels cannot produce large enough files sizes to cover a full A4 (8¼ x 11½in) spread. The Canon EOS 1Ds and the Kodak Pro SLR/n are, at the time of writing, the only high-end professional cameras that are capable of producing file sizes adequate to meet the needs of the publishing

industry, although the introduction of the Mamiya ZD, the D2X from Nikon, and the EOS 1Ds Mark II from Canon will expand the choice. The hefty cost of these cameras puts them well beyond the reach of the vast majority of photographers.

Most of the larger agencies ideally want file sizes of between 40 and 50MB, which will adequately cover an A3 (11½ x 16½in) spread. However, if you simply want to obtain good high-resolution images for personal use, then a 6- or 8-megapixel D-SLR is more than adequate for your needs. If you spend a lot of time lecturing and running workshops then you will also need to invest in a laptop and digital projector, which will significantly increase your overall outlay. Even the best digital projectors do not compare in quality to a good professional 35mm projector.

Canon and Nikon have been major players in digital technology, but other reputable companies, including Olympus, Sigma and Fuji, are worth considering if you are coming fresh to digital photography and are working to a restricted budget.

At present I own two digital camera bodies: the Nikon D100, which is 6.1 megapixels, and the Kodak Pro SLR/nx, which is 14 megapixels. The Kodak Pro SLR is the highest-resolution digital 35mm SLR at the time of writing, although Nikon has just announced the long-awaited replacement for the D1X. The new D2X has a 12-megapixel sensor. Canon offers the new 1Ds Mark II, which comes in at 16 megapixels. Both cameras will be available in the near future.

A personal view

My personal preference at the moment is still for medium format; its larger film area allows for greater magnifications and enlargements with superior results if used correctly. Running both systems seems to be the preferred approach for many photographers, myself included. It allows you to gradually ease your way into learning to work with digital technology.

Many of the medium-format manufacturers are aware that digital technology has caused their sales to decline, and they are keenly aware that they need to respond to this threat if they are to survive in this competitive marketplace. Mamiya, for example, has a good reputation for high-quality innovative technology. This company has produced the first medium-format D-SLR, with an impressive 22-megapixel sensor. All of the existing lenses and accessories from the Mamiya 645 AFD are compatible, which is a great advantage for photographers who are already using this system. There is also a 22-megapixel digital back available that integrates with the AFD, giving the photographer a choice between film and digital capture. No doubt this will greatly interest landscape photographers who want to shoot both.

Many independent companies, such as Leaf and Phase One, manufacture high-quality digital backs that integrate with the most popular 645 formats, like the Mamiya 645 AFD and Hasselblad H1. The image quality

MAMIYA ZD DIGITAL CAMERA
The large 22-megapixel sensor makes this camera an excellent choice for professionals and serious amateurs who need big enlargements of their images, or who are engaged in agency work.

MAMIYA 645 AFD WITH ZD DIGITAL BACK
High-end digital capture has been the norm in the professional sector for quite some time now, although the price is far beyond the reach of most professional photographers. The Mamiya digital back is designed for the AFD and offers high-quality untethered (that is, wire-free) digital capture at a competitive price. This camera therefore offers the best of both worlds.

OLYMPUS DIGITAL E-1 SYSTEM
The E-1 is based on the Four Thirds system and is the first professional camera designed purely for digital capture. It overcomes many of the problems associated with small sensors utilizing conventional film lenses. Its lightness and ease of use have made it a popular choice in both the professional and amateur sectors.

BEAUTIFUL UTETHESIA
UTETHESIA BELLA
*The small, attractive footman
moth is found throughout
North America. The 200mm
lens macro produced a soft,
diffused background, making
the moth more clearly defined.*

Kodak DCS Pro 14/nx, Nikon
200mm macro lens, ISO 160,
Raw format converted to Tiff

produced from any of the latest digital medium-format camera backs is still better than any of the current high-resolution 35mm D-SLRs from Kodak or Canon. Kodak claim their DCS Pro SLR/n is close to medium-format quality, but that cannot be strictly true, since the film area of the 645 format is 2.7 times larger than 35mm. In general, although the price of some well-known digital backs has come down, many models are still well beyond the reach of the vast majority of professional photographers.

Despite having taken digital on board, I do worry about the future of electronic image storage and the compatibility of this with older technology. I'm not afraid of change – in fact I welcome it – but I find it difficult to accept less in terms of the quality that I know I can achieve with film on medium format at the moment. That day may well change in the not-too-distant future. Until then, however, I will continue to use both technologies.

I can see the time approaching, perhaps faster than I would like, when my digital images will take preference over my film sales. There are so many advantages for clients engaged in the publishing business to use digital files; they can be emailed directly within minutes at the appropriate resolution for printing. It also saves on scanning costs and having the responsibility of looking after someone's valuable transparencies. However, I still like the feeling of holding a transparency in my hand and viewing it on a lightbox, rather than entrusting all of my prize images to an amalgamation of pixels stored on an electronic device, over which I ultimately have little control.

CALIGULA JAPONICA
The quality and resolution that can be produced from a medium-format digital back is amazing and still well above the best digital 35mm cameras.
Mamiya 645 AFD with back, 120mm macro lens

Useful features

The following items are important features to look for in a camera system before you commit to buying it. I am referring here to an SLR camera, since this, in my opinion, is the only camera that is suitable for serious nature photography. All of the suggestions apply equally to digital and film capture. I believe that many of these features are essential if you want to take high-quality close-ups.

Shutter speeds

Most modern cameras have shutter speeds well in excess of 1/1000 sec; these speeds are of no real advantage in close-up photography. However, many of the latest cameras are capable of shutter speeds as low as 30 seconds or more. These speeds are very useful, especially when you are photographing static subjects such as fungi or lichens, which often grow in shady areas in woodland.

Metering modes

Most modern cameras offer a choice of different metering modes: centre-weighted, spot, and matrix. These modes all have their uses. I use spot metering in difficult lighting conditions when I can take a reading of a small part of the overall scene. I use matrix metering for the rest of the time. With experience, you will be able to recognize difficult lighting conditions and select accordingly.

Program modes

Many of today's modern cameras are a combination of flashing LEDs and multiple program modes. Most of these functions serve no useful purpose in close-up photography. I use automatic aperture priority and manual. In automatic, you pre-set the aperture and the camera selects the appropriate shutter speed, while in manual you have ultimate control over both the shutter speed and the aperture.

Depth of field preview

Make sure the camera has a depth of field preview; this is an essential item and very important in close-up photography. It lets you view the image at the actual taking aperture, which allows you to check the zone of sharpness of the subject. It also lets you see any distracting highlights that may be present in the background. Remember when you look through the viewfinder that you are previewing the subject with the diaphragm in the lens set to its widest aperture. This is quite different to the image that will finally appear on film. Many camera manufacturers have removed this feature from their lower-priced models, but I personally would be very reluctant to buy a camera without a depth of field preview.

EMPEROR MOTH
SATURNIA PAVONIA
Depth of field preview is an essential feature if you want to control background focus. In this photo I selected an aperture that allowed me enough sharpness to keep the insect in focus.
Mamiya 645, 150mm lens plus extension tubes, Fuji Velvia

Through-the-lens (TTL) flash

Almost all cameras now have through-the-lens (TTL) or DTTL (digital TTL) flash capability. This is an extremely useful aid in the field. It will arrest movement in your subject and provide additional light through fill-in when conditions are less than perfect. It also eliminates the hassle of working out manual flash exposures, which many people found off-putting in the past. I wouldn't recommend buying a camera that did not have this facility. You should purchase your camera's own dedicated unit, as it will have total integration with your camera's exposure system. Make sure the flash unit can be operated off-camera by means of a dedicated flash cable. Be mindful that TTL flash is not foolproof and requires the same consideration regarding exposure of subjects that are not mid-toned.

Cable/electronic release socket

Many modern 35mm cameras no longer have a cable-release socket; some have provision for an electronic release. These do the same job but tend to be quite expensive and are easily lost. When working from a tripod at slower speeds, it is important to use one to minimize vibration, which can make your images appear soft. Most medium-format cameras still have provision for one or both.

Mirror lock-up

When working in close-up at slow speeds prior to exposure, the mirror flips up out of the way to allow light to pass through to expose the film. The speed at which the mirror hits the pentaprism can set up a vibration that then produces an unsharp image. Many modern cameras have improved damping, which has to some degree reduced the problem of mirror bounce. As a result, many manufacturers no longer incorporate this facility into their lower-end cameras. However, mirror lock-up is still a useful feature, especially when you are working at higher magnifications, since the slightest camera movement can affect the overall sharpness of the final image.

The shutter speeds that are most susceptible to vibration seem to be in the range from 1/15 sec through to 1/2 sec. Medium-format cameras are more prone to vibration, especially cameras with focal plane shutters. It's a good idea to get into the habit of locking up the mirror if you have this feature, especially when you are photographing static subjects. I tend to do this automatically, especially when I am shooting in natural light. You can only use mirror lock-up when working off a tripod. If your camera doesn't have the mirror lock-up facility, don't worry, but exercise due care when working at slow shutter speeds.

LARGE TORTOISESHELL
NYMPHALIS POLYCHLOROS
Flash is an essential part of the macro photographer's kit. The image right shows a loss of detail in the underside of the wings of this butterfly. In the image far right, the application of fill-flash adds additional light to the shadow areas, highlighting the texture and detail more clearly.
Mamiya 645, 120mm macro lens, natural light, fill-flash, Fuji Velvia

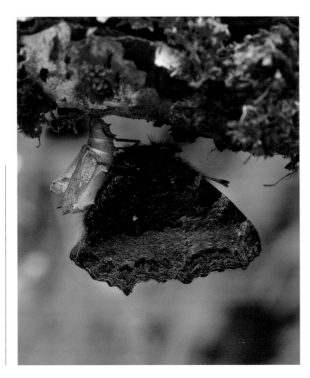
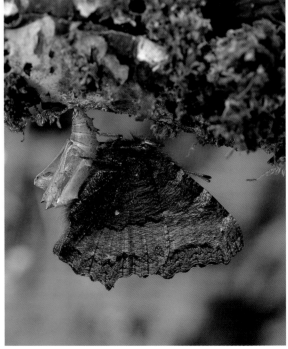

Motor drives

Virtually all modern cameras have some sort of integral motor drive fitted as standard. These units are more than adequate for all aspects of close-up and macro photography. There is no real advantage in having high-speed motor drives capable of delivering several frames per second. Where motor drives are particularly useful is when photographing active subjects such as insects and other small mobile creatures. You can take several images in sequence without have to trip the shutter each time in between shots. Having to advance the shutter manually is more of an inconvenience especially when you are working at higher magnifications, since it invariably means having to make slight adjustments to the focus after each shot.

Interchangeable focusing screens

The standard focusing screen in most cameras now is designed for general photography. Some of the older cameras have a split image surrounded with a microprism collar that appears black when focused in close-up. This makes it quite difficult to focus precisely on the subject. Many upmarket cameras have interchangeable screens that are designed for different types of photography. A clear matt screen with a central circle is ideal for photographing close-ups. It is also a good general-purpose screen for many other photographic applications.

Autofocus

Autofocus is standard issue on nearly every modern SLR. It has transformed some aspects of photography, especially action photography and photojournalism. In close-up and macro, it is more of an irritation, however, as the lens continually moves back and forth in response to subject or camera movement. Many of the leading camera manufacturers have additional focus points off-centre. However, chopping and changing between these can be fiddly and difficult with active subjects. I much prefer to switch it off and revert to manual focus, where you have the freedom to select the point of focus in the frame. If your subject is off-centre, the chances are that the autofocus will focus past the subject and onto the background.

XANTHORIA CALCICOLA
Many earlier cameras were prone to vibration at slower shutter speeds. By locking up the mirror prior to exposure, this could be virtually eliminated. This was especially relevant to medium-format cameras with focal plane shutters. If your camera has this feature (irrespective of your format size), I would recommend you to use it whenever possible. Finely structured subjects such as lichens will show any inaccuracies in focusing and vibration at slow speeds.
Mamiya 645, 120mm macro lens, Fuji Velvia

Tripods

Mention the word 'tripod' to photographers, and you will often get a mixed array of reactions. I am always amazed by how little coverage tripods receive in photography books compared to other accessories. Unfortunately, many photographers treat them in a similar manner, deeming them less important than, for example, the choice of a lens or another accessory. Photographers often invest significant sums of money on a lens and expect great things from it, but give little consideration to the tripod they are going to place the lens on. What they often forget is that their end result is directly related to methods they employ and the equipment they use.

A tripod is an essential tool in close-up photography and is absolutely necessary if you are serious about the photographs you take. I shoot every exposure where possible on one and only resort to using a monopod when the subject or the terrain dictates otherwise. Every professional photographer I know uses a tripod where possible in all aspects of their work. I have heard many excuses over the years for not using a tripod, but if you want to produce consistency in the photographs you take, you cannot ignore the tripod's significance in the photographic process.

Many photographers think of tripods as an inconvenience and a burden to carry around in the field. Some feel it restricts their ability to operate quickly and spontaneously. They prefer to handhold their camera, even if it means photographing below the minimum shutter speed for the lens being used. At first glance, your images may look sharp at their original size. However, close examination on a lightbox with a loupe will confirm that they are not.

You will never achieve consistency in your work by adopting such an arbitrary approach. The general guidelines are never to handhold a camera at a shutter speed slower than the focal length of the lens being used. For example, the slowest speed at which you can handhold a 100mm lens is 1/125 sec. Projecting images do not verify the sharpness of a transparency either, since the vast majority of projector lenses are of mediocre quality when compared to a camera lens. Remember, also, that enlarging images highlights any shortcomings and defects in your technique. Close-

up photography can be quite unforgiving; it demands meticulous attention to detail and implementation of your technique. Failure on any part will be all too evident in the end result.

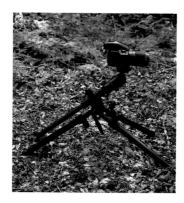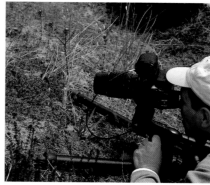

UNILOCK TRIPOD
I use this tripod and two other Benbo models for all of my photography. These are excellent field tripods. They are quick and fast to use once you've mastered the technique. Make sure your tripod can work at ground level and is sturdy and secure at all levels.

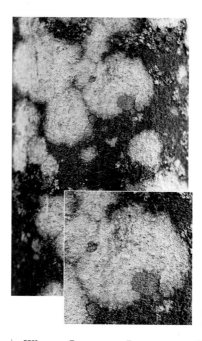

WHITE CRUSTOSE LICHENS ON BARK *PERTUSARIA SPECIES*
As an experiment, I photographed this lichen-covered trunk at the same magnification, shutter speed and aperture. The image above left was the best of several shots that I took handheld at 1/125 sec. The image above right was shot from on a tripod. When the image is enlarged, the difference in sharpness is clear. This is a good reason to work from a tripod as much as possible.
Mamiya 645, 120mm macro lens, Fuji Velvia 100F

Advantages of using a tripod

The benefits gained from using a tripod far outweigh the inconvenience of carrying one with you in the field. For example:

○ It supports the camera and allows you to place it precisely where you want it, making it easy to focus and compose your images accurately.

○ It allows you to make slight adjustments to the composition and compare the difference.

○ You can concentrate on the subject without having to keep your eye to the viewfinder while taking the shot.

○ You can use any combination of shutter speeds and apertures with slow ISO films to achieve the desired result.

○ You can take several shots in succession, producing consistency and accuracy in your framing and composition.

Photographers who choose not to use a tripod severely limit themselves in what they can realistically achieve. For example, you will be restricted to photographing in bright conditions – a situation that is generally not ideal for close-up photography. You will be forced to work at lower magnifications, with a limited range of shutter speeds. You will be restricted to wider apertures, producing limited depth of field, and confined to using medium or high ISO films, with an obvious reduction in colour saturation and quality. With so many restrictions, you cannot hope to deliver consistency, in terms of sharpness, accuracy of framing, focus or composition.

Selection and choice

There is a wide selection of tripods in all shapes and sizes available from many well-known manufacturers. The vast majority of these models, in my opinion, are not ideally suited to nature and close-up photography. Many are fiddly to operate, and some have multiple leg extensions and take too long to erect properly. In nature, many subjects are to be found at various levels, from head height to ground level.

No single tripod can cover every situation efficiently, although manufacturers would have you believe

that they can. Many of the earlier tripod designs had removeable central columns. These were inverted for close-up photography at ground level, which meant that the camera was hanging down between the tripod legs. These designs are totally unworkable when you are photographing in the field.

I currently own two Benbos and a Unilock tripod. The latter I use a lot for low-level work; the other two, which are longer, I use for photographing landscapes and subjects that are at chest height. All three of these models are designed on the central bolt system,

SHAGGY INKCAPS
COPRINUS COMATUS
Working in shaded woodland generally requires long exposure times. Achieving sharp, well-composed images is virtually impossible without a tripod.
Mamiya 645, 120mm macro lens, fill-flash, Fuji Velvia

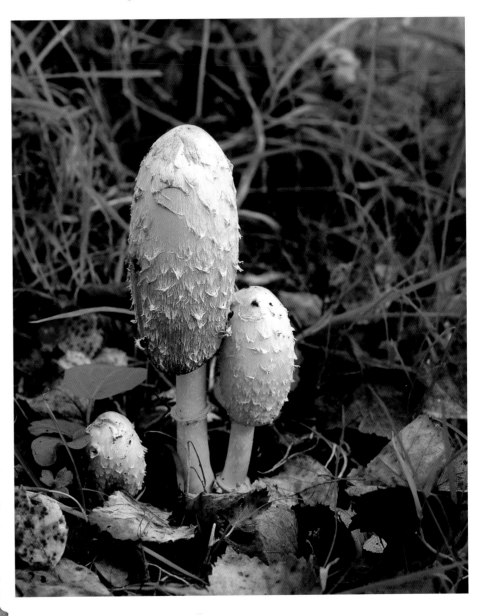

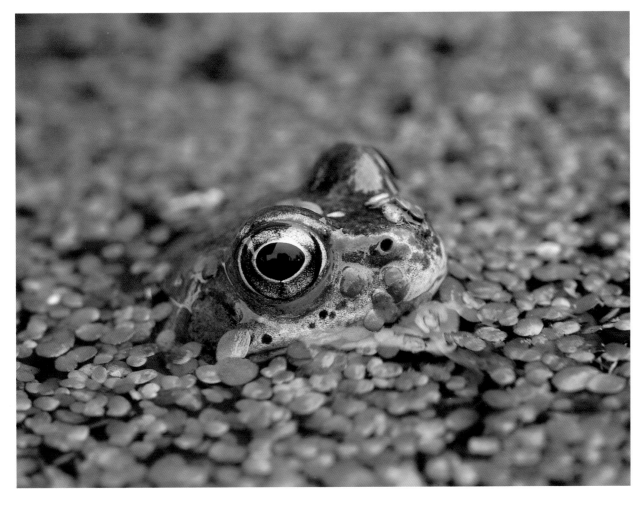

COMMON FROG
RANA TEMPORARIA
When shooting in poor light and in situations where you are forced to use wide apertures, using a tripod allows you to focus precisely and to use speeds that are below the threshold for handholding.
Mamiya 645, 300mm lens plus extension tubes, Fuji Provia 100F

in which all of the legs are locked simultaneously in position by tightening a single lever. I have used these tripods successfully for years without experiencing any problems. They also have single-leg extensions, which are quick to position and secure. Its design is one of the best that I have come across. Its adaptability to most working situations makes it an ideal choice for macro and close-up photography.

Gitzo is another manufacturer that has a good reputation for quality and is well worth considering if you would prefer to use a conventional tripod. Look for a sturdy model without a central column, as this prevents you from getting the tripod down to ground level. Before you purchase a tripod, you should take your camera down to the shop and try it out on different models. Make sure it has the capability to work at ground level without the legs slipping under the weight of the camera. Do not be tempted to cut financial corners and accept less.

Tripod heads

Sturdy, well-engineered heads are not cheap, so don't cut corners. Arca Swiss, Manfrotto and Kirk Enterprises (an American company) are some companies that produce a good range of high-quality heads. Avoid cheap, lightweight models, as these will affect the performance of your tripod and increase the risk of vibration at higher magnifications.

What type of tripod heads you use is a matter of personal preference. The two basic choices are a ball and socket head or a pan and tilt head. My preference is for a ball and socket. It gives you freedom and movement in all directions. The negative aspect is not being able to make fine adjustments in the vertical or horizontal plane, although I have never found this to be a problem in close-up photography. If your preference is for a ball and socket, look for a large-diameter ball with an adjustment screw to alter the drag or tension on the ball to prevent it, and the camera, from flopping

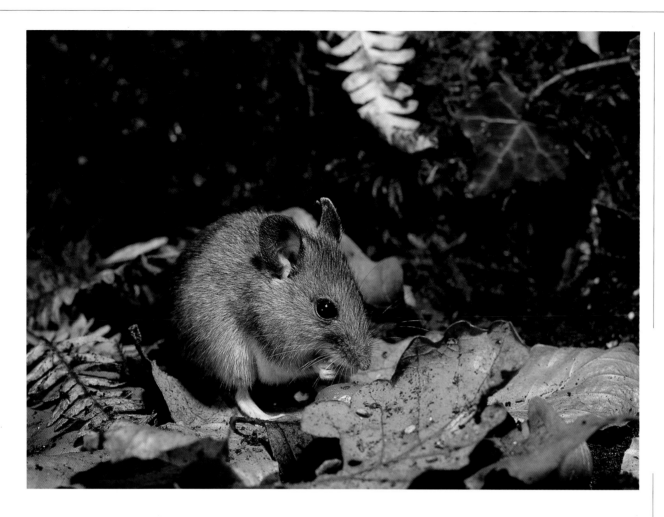

WOOD MOUSE

APODEMUS SYLVATICUS
If you are working indoors in the studio, a tripod is indispensable when precise framing is required. Working with small mammals requires a lot of preparation prior to any photography. It also takes time for the subject to become accustomed to and relaxed in its temporary surroundings. They should always be released back to the spot from where they were captured.

Mamiya 645, 120mm macro lens, flash, Fuji Velvia

down. The measure of a good tripod head lies in its ability to hold the camera firmly in all positions without movement in any direction. If you find that the head moves slightly when tightened after you have removed your hand, then that model is not suitable for use in close-up photography. These minor movements become more of an issue at larger magnifications when you find yourself framing off-centre to compensate for the movement of the camera and lens when your hand is removed. This will become an even greater issue if you are using medium format.

I currently use two Manfrotto heads. One is a heavy-duty model incorporating a customized moveable platform with a built-in focusing rail. It gives me a 2cm (¾in) movement in both directions. The moveable platform has provision for the standard hexagonal quick-release base plates. The platform cuts down on the weight and overall height. I use it mainly for working at higher magnifications when I need to make minor adjustments to the focus and camera position.

The other head is a Manfrotto Pro ball, which I use with my digital set-up and for routine close-up photography. It is more than adequate for low magnification work in the field.

Pan and tilt tripod heads are, in my opinion, slow and not ideally suited for close-up photography. They have very precise movements, each one governed by an individual control. Each control allows you to make precise changes in a particular direction or plane.

TRIPOD HEADS

These are the two heads I currently use for all of my close-up and general photography. The larger Manfrotto head on the right has a custom-milled focusing platform that was specially made for me. This allows fine focus adjustments at high magnifications.

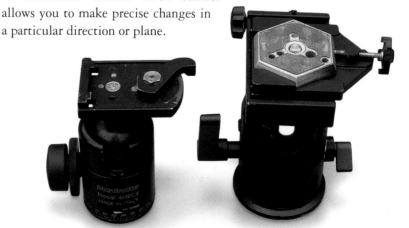

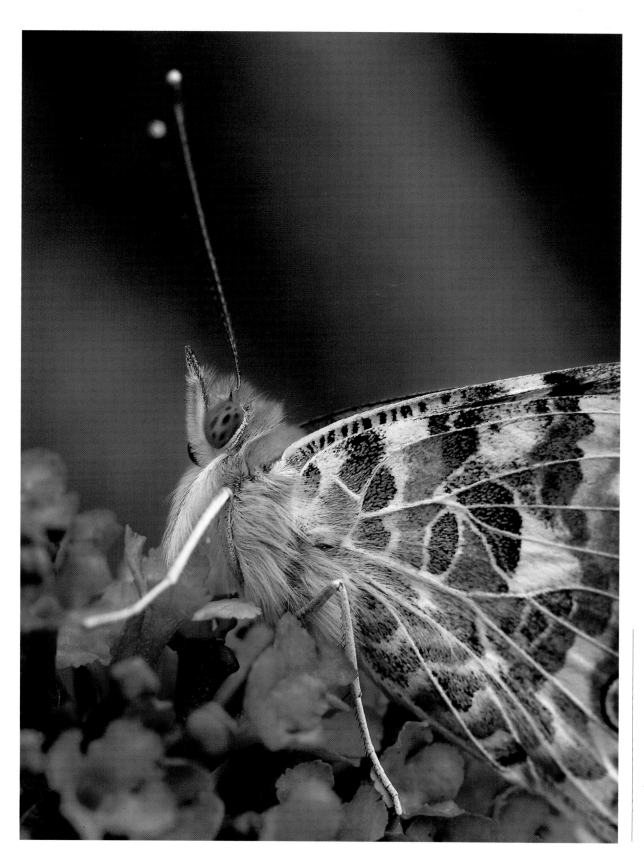

PAINTED LADY

CYNTHIA CARDUI

When working at higher magnifications, moving a tripod or the focusing ring a fraction can have a dramatic effect on the overall appearance of the picture. Here, I used the focusing platform once in position to make fine adjustments.

Mamiya 645, 120mm macro lens plus extension tube, flash, Fuji Velvia

Film

Despite the increasing trend of photographers adopting digital technology, there is still a wide selection of films available for those who want to use film capture.

Transparency film

You need to define what your long-term intentions are regarding your pictures, as this will influence the type of film that you use. If your intention is to market your work, see it published in books or magazines, or perhaps sign up with a photographic agency, then you should choose transparency film. The vast majority of publishers and editors of magazines only accept slide submissions.

One important advantage in using transparency film is that you can examine the exposure and check the colour balance and sharpness of your images on a lightbox. Any adjustments made to the exposure and its effect on the picture can be clearly seen.

You still, of course, have the option of making prints from your transparencies by scanning your slides or sending them to a professional laboratory, where they will produce a digital file to whatever size you require. This approach tends to work out more expensive, but the results are of a high quality and therefore worth the extra investment.

Inkjet prints

Inkjet printers have become extremely popular in recent years. Photographers shooting digital or scanning their transparencies have the benefits of producing their own high-quality inkjet prints from their digital files. This is a very cost-effective method for producing large-sized prints.

Although modern print films have improved greatly in the last several years, they still tend to lack tonal range and contrast when compared to the detail and vibrancy that can be obtained from transparency film. The exposure and sharpness of print film tends to be extremely varied and is entirely dependent on the processing machine and its operator. Another major drawback of using modern print films for your work is that you cannot evaluate exposure and sharpness easily from a negative.

Selection and choice

Having made the choice between transparency and negative film, you need to run some tests on different brands and assess the results. The perception of colour varies between individuals; some photographers prefer well-saturated colours, while others favour a more accurate rendition, which tends to be less saturated.

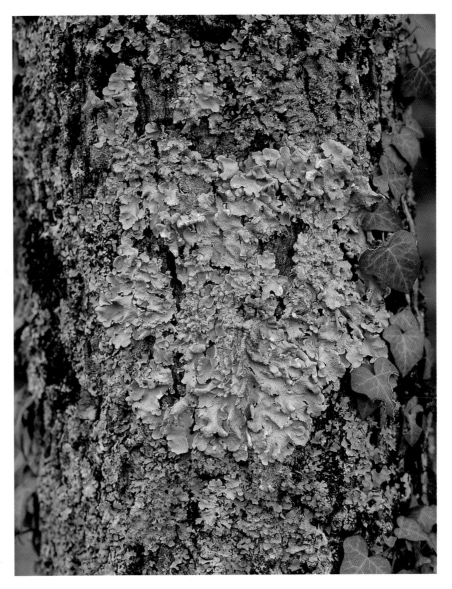

FLAVOPARMELIA CAPERATA
Modern slow fine-grained transparency films deliver maximum detail and colour saturation, as this image clearly demonstrates. These films are ideally suited to macro photography.
Mamiya 645, 120mm macro lens, Fuji Velvia

Film choice is largely a matter of personal taste. Fuji and Kodak are the market leaders and they offer an extremely varied range to suit every photographer's palate. Manufacturers offer some of the most popular films in both professional and amateur versions. Professional films to some extent justify the increased price because they are more rigorously controlled in terms of sensitivity and colour consistency. They also differ from amateur films in that they are only released by the manufacturer when they are at their optimum colour temperature.

Tonal range

Working in close-up and macro demands the highest standards when it comes to rendering fine detail and maximum tonal range. While modern E6 emulsions have greatly improved in the last decade, the exposure latitude of film is still poor when compared to the human eye. Film has to cope with a wide range of tonal variations, from the brightest parts of a scene through to shades of grey to black, and still have the ability to resolve detail in the brightest and darkest parts of the image. The Raw files obtained from digital cameras have a better tonal value over a greater number of stops than film and they therefore tend to cope better with exposure differentials.

Film speed

When it comes to film selection, slow, fine-grained films in the region of 50 to 100 ISO are the best choices for the close-up and macro photographer. These films are better at coping with varying degrees of contrast and light intensities. The vast majority of my photographs are taken on Fuji Velvia film. This is the slowest E6 emulsion, with an ISO of 50 and a diffuse RMS granularity value of nine.

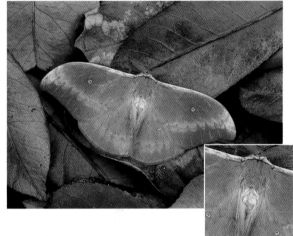
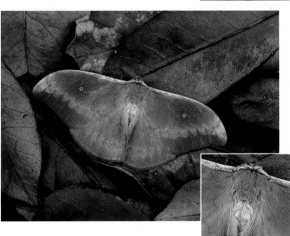

SYNTHERATTA JANETTA
Here are samples of different films from Fuji and Kodak. Top left Fuji Velvia; top right Kodak E100 VS; bottom left Fuji Velvia 100F; and bottom right Fuji Astia 100F. All of these images were taken within a couple of minutes and shot on a tripod at the same aperture, shutter speed and magnification. Note the differences in colour saturation, especially between Velvia 100F and Astia 100F.
Mamiya 645,
120mm macro lens

SPANISH FESTOON
ZERYNTHIA RUMINA
*I tend to shoot most of my
photographs on Fuji Velvia,
which is the slowest ISO
film currently available.
I like the deep colour
saturation of this film
and its ability to resolve
extremely fine detail – as is
clearly visible in this image
of the underside of this
insect's wings.*
Mamiya 645, 120mm macro
lens, Fuji Velvia

When I am shooting in very low light or working off a monopod, I frequently switch to Fuji Provia F, which is one stop faster, at ISO 100. This film has a lower diffuse RMS (root mean square) granularity value than Fuji Velvia, although the latter film has a higher resolving power than the Provia F.

Fuji has also produced an ISO 100 version of Velvia that has many of the characteristics of the standard Velvia with the added bonus of the extra stop. This is proving to be very popular among photographers, particularly those who shoot nature subjects.

I don't normally use multiple film types. I like to achieve continuity and consistency in colour and exposure, which is why I recommend that you run some test shots with different films side by side of subjects in the same light. You should examine colour and saturation and see how the different films perform at slow speeds and in poor and contrasting light and then make your choice.

Many of the major films that are available in 35mm are also available for medium-format cameras in 120/220 roll versions.

Archival quality

Long-term archival storage was a major concern with earlier E6 films. However, modern emulsions are much better at dealing with recurrent exposure to light and long-term storage. Over a period of time, they may (depending on storing conditions) show a slight colour and chemical change, although the current E6 films are much more stable and are said to have good archival stability – or so the manufacturers claim.

Exposure

Most modern SLR cameras have sophisticated TTL (through the lens) metering systems, yet many photographers still lack confidence when it comes to obtaining consistency in their exposures. Having an eye for a great picture will mean nothing if you cannot recreate your visual encounter correctly on film. All too often when our films arrive back from processing, the results are quite different to what we had originally imagined, and all our effort and anticipation turns to frustration and disappointment. Don't despair if this happens – we've all been there.

Knowing when to accept the meter's reading of a scene and when to override it is where many photographers experience the greatest difficulty. Some don't want the burden of dealing with exposure and therefore rely on the camera's meter to arrive at the correct exposure for every situation and in all lighting conditions. Unfortunately, things are very rarely that simple; you need to understand exposure and how to apply it properly to any given situation.

In most cases, exposure meters are accurate and will deliver acceptable results in situations where there are not extreme contrast differences within the overall scene. However, they are not reliable when confronted with extreme differences in tonal values, such as a white butterfly against a dark background or when shooting into the light where the background may be lighter than the subject. You will invariably end up with over- or underexposure, where the highlights are burnt-out or the shadows block up. This is because the meter works on the assumption that every subject is mid-toned or 18 per cent grey. Colours that have a higher reflectance value, such as whites and yellows, are generally underexposed by the meter, which tends to register them as mid-grey, while dark subjects are overexposed and you end up with muted colours that are lacking in vibrancy.

Through experience, you will be able to recognize situations where the meter may prove unreliable, and you can therefore alter your exposure accordingly. I would advise you to carry out a few test shots first using the exposure-compensating dial, which adjusts the exposure in increments of one-third of a stop. Make sure that your subject fills the frame. Take several exposures either side of the recommended reading to evaluate how your meter deals with problematical subjects, and keep a note of the corrections for future reference.

Calibrating your camera's meter

When buying an expensive camera, we naturally assume that the metering system and ISO settings are extremely accurate. This is not always the case. While the latest cameras' ISO settings are generally more accurate than they were in the past, I would always recommend that you carry out an ISO calibration test to determine the accuracy of the meter and to fine-tune the exposure of your films. What you are doing is making fine adjustments to the exposure density of your E6 film with your laboratory's E6 processing unit. This establishes a baseline reference position for rating a mid-toned subject.

I would also recommend you to find a reliable professional E6 processing lab that maintains its processing and chemical replenishment to the highest standards. That way you will achieve consistency in your processing and exposures.

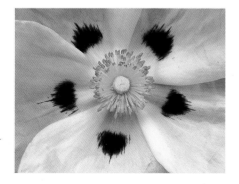
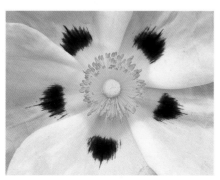

CISTUS FLOWER *CISTUS CYPRIUS*
Certain colours, in particular whites and yellows, reflect more light than others. Your exposure meter tends to register them as grey, which results in underexposure. The image far left is the camera's suggested reading, which is slightly underexposed. In the image left, I compensated for this by opening up one stop from the meter's suggested reading.
Mamiya 645, 120mm macro lens, Fuji Velvia

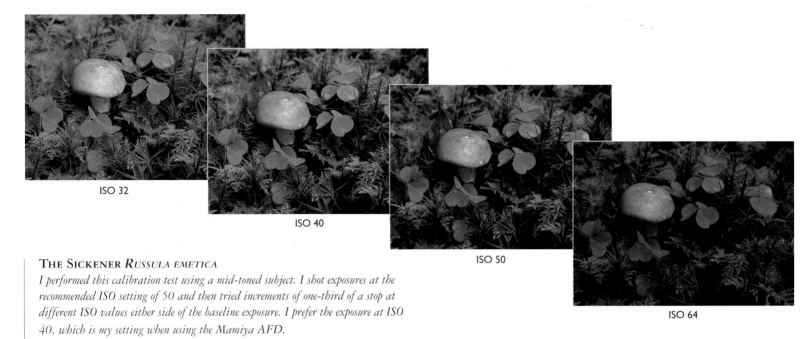

ISO 32

ISO 40

ISO 50

ISO 64

THE SICKENER *RUSSULA EMETICA*
I performed this calibration test using a mid-toned subject. I shot exposures at the recommended ISO setting of 50 and then tried increments of one-third of a stop at different ISO values either side of the baseline exposure. I prefer the exposure at ISO 40, which is my setting when using the Mamiya AFD.
Mamiya 645 AFD, 120mm macro lens, Fuji Velvia

The easiest way to perform the ISO calibration test is to select a subject that has a mid-tone value; one that lies half-way between the five-stop tonal range of transparency film. If we divide the reflectance value up in percentage terms, 18 per cent is our mid-point. Remember that photographic apertures do not work in linear progression, so the full percentage from black would be as follows: 4.5 per cent, 9 per cent, 18 per cent, 36 per cent, and 72 per cent (featureless white).

A good example of a mid-toned subject is green grass or foliage of a similar shade. An overcast day is ideal, as the lighting conditions remain constant. Place your camera on a tripod and focus on the subject. You can use any lens as long as you perform the test without altering any of the settings on the lens and camera body. Set the camera to aperture priority and make sure that your compensation dial is set at zero.

Start with the baseline ISO setting for your chosen film. For example, if you are using Fuji Velvia, its ISO value is 50, so set the ISO at 50. Make a note of the adjustments to the ISO dial or incorporate the exposure details on a piece of paper somewhere in each frame. You will need to refer to these settings after processing your film. Expose the first shot at the recommended setting given by the film manufacturer. Moving up the scale, advance the ISO dial to the next position, which will be 64 and then 80. It's unlikely that any modern

camera's metering system will be that far away from the appropriate ISO number on the dial. Repeat this procedure, moving down the ISO scale at 40 and 32. What you will have now is a range of photographs with incremental changes of approximately one-third of a stop. After processing, select the frame that offers the best exposure in terms of density and saturation. This will be your ISO setting when using this camera and film. Note that the ISO values will not necessarily be the same for each camera.

Digital photographers should also perform an ISO calibration test, only in this case they should evaluate the histogram readings against a mid-toned subject and adjust accordingly. When I am working in very bright conditions, I underexpose slightly to prevent highlights from burning out.

Choice of metering patterns

Most modern cameras have an array of different exposure metering systems and modes, which to some degree take away the decision-making process from the photographer. All modern integrated TTL meters measure the light reflected from the subject and are calibrated to produce an average reflectance value of a grey card, which is 18 per cent.

Exposure meters have a photodiode that analyses the intensity of light reflected off the sensor. Many of

NETTED PUG

EUPITHECIA VENOSATA

From experience, I know that many light-coloured rocks have a higher reflectance value and that exposures tend to be a little on the dark side. The image below right is taken at the suggested meter reading. For the image right, I opened up one stop from the meter's baseline exposure to render this moth at the correct value.

Mamiya 645, 120mm macro lens, Fuji Velvia

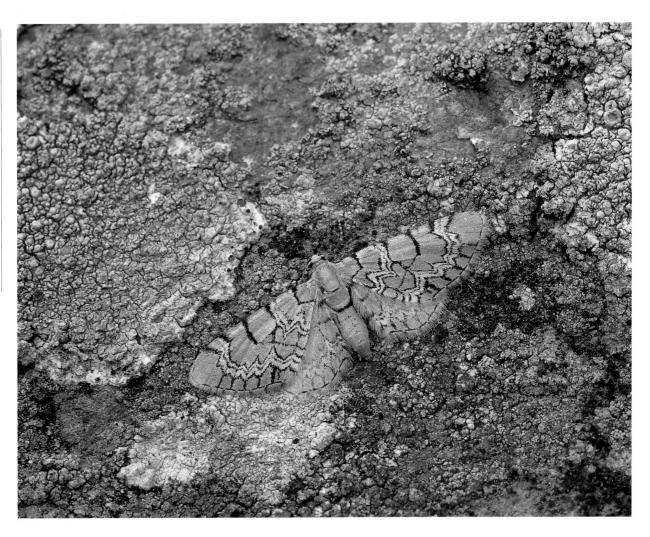

the high-end cameras have a combination of different metering systems that you can select when you are working with difficult lighting situations. The most common metering system is centre-weighted, where the meter evaluates the main central portion of the scene only. The percentage varies between different cameras, but most average around 60 per cent, with the remainder spread along the edges.

Centre-weighted readings are fine if the main part of your subject is always in the centre of the frame. However, it can prove problematical in situations where your subject has a high reflectance value and is off-centre. Most modern cameras now use matrix metering, which is much better at coping with scenes that contain wide tonal variations. The viewfinder is divided into segments; the camera evaluates the brightness of each segment using its own built-in software and equates

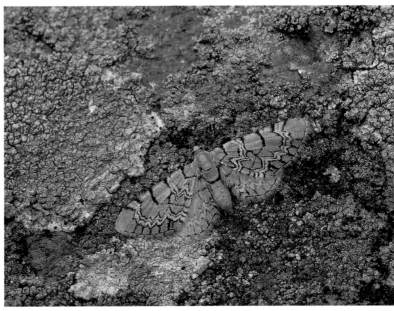

an appropriate value based on the reading from the segments. The pro models generally have more segments and therefore deliver more accurate results in very difficult lighting conditions. It is extremely accurate in most situations.

Spot metering takes a reading from a very small area of the screen. Its angle of view is very narrow, usually between one and five degrees. It is normally located in the centre of the viewfinder. I often use it when I am faced with large tonal variations in an image.

Metering modes

Of all the metering modes, I find aperture priority, in which you set the aperture and the camera selects the appropriate shutter speed, the most useful, especially when photographing static subjects. I can select the appropriate aperture to provide sufficient depth of field to retain the subject in sharp focus, or I can control distracting background highlights by choosing a wider aperture. This gives me the freedom to concentrate on the subject, especially in changing light when the exposure is likely to fluctuate. When photographing moving subjects, I often use shutter priority mode, in which you set the shutter speed and the camera alters the aperture: depth of field becomes irrelevant in this case if your image lacks sharpness.

Aperture priority, like other program modes, renders your subjects as mid-toned. Photographing a subject that is lighter or darker than a mid-toned value requires an exposure adjustment. For example, when working in aperture priority, a pale-coloured subject photographed against a dark background will generally be overexposed.

Many high-spec cameras offer spot metering, which takes a reading from a small area in the centre of the viewfinder. It can be extremely useful in situations where you are faced with multiple tonal values in your picture. I often switch to spot metering and take a reading of a mid-toned subject such as green foliage nearby. I then lock the exposure reading, recompose, and shoot. This works every time since you are taking your reading from a mid-toned subject in the same light. Remember when in aperture priority that any adjustment made to the aperture will not affect the exposure on film, as the camera automatically counteracts your action by increasing or decreasing the shutter speed. In this situation, use the automatic compensating dial on the camera to override the camera's suggested meter reading. The dial allows you to make incremental adjustments to the exposure value in both directions. Remember to reset the dial to zero; otherwise, any subsequent images will be over- or underexposed by the adjusted amount.

Working completely in manual is no longer a popular approach in macro these days. However, being able to alter both the shutter speed and aperture means that you have total control of the whole exposure process. If you have to make adjustments for subjects that are not mid-toned, you simply alter the shutter speed or aperture to your requirements and it will retain its settings irrespective of the changing light. It is a slower way to work, but when lighting conditions are generally stable and you want to bracket your exposures by half a stop either way, it can be quicker than working in automatic. I often use manual when working at very slow speeds and in mirror lock-up. It is also useful with fill-in flash when you want to control the amount of ambient light visible in the background.

HEDGE BINDWEED *CALYSTEGIA SEPIUM*
Here, I was conscious about losing detail in the white flowers and therefore underexposed by half a stop. With experience, you learn when to override your camera's suggested reading.
Bronica SQAi, 110mm macro lens, Fuji Velvia

Lenses

Lenses are one of the most important components in the close-up and macro photographer's kit. In this section, we look at how to get up close to your subject using supplementary lenses, macro lenses, telephoto and zoom lenses.

Supplementary or close-up lenses

The most inexpensive and convenient way of getting a lens to focus closer is to use supplementary or close-up lenses. These are positive lenses that screw into the filter threads of your camera's lens. When attached to a prime lens, they decrease the focal length slightly, which allows the lens to focus closer than its normal working distance, but it will no longer focus at infinity. Their small size and ease of use make them a useful accessory for any travel photographer where weight is a vital factor, or for others who have only a casual interest in close-up photography.

The majority of supplementary lenses are designed to work mainly with a standard lens. This is not ideal in nature photography, since the lens-to-subject distance is so close, making it virtually impossible to photograph most active subjects. Even static subjects such as flowers and fungi can be problematic, as the lens and tripod are virtually on top of the subject. Supplementary lenses are more beneficial when used in combination with short telephotos, especially those in the 150–200mm range, producing greater magnifications and an increase in working distance between the lens and the subject.

Zoom lenses

Zoom lenses are a popular choice among photographers these days. Using one of the high-quality two-element supplementary lenses on a zoom with focal length around 200mm or greater is an ideal combination and offers greater flexibility than working with fixed focal length lenses. The advantage of this combination is having the ability to alter the composition of your subject by zooming through different focal lengths while maintaining the camera position and point of focus. The image resolution with achromatic lenses is excellent, providing you exercise good photographic technique and work from a tripod and use a cable or electronic release and a lens hood.

SUPPLEMENTARY LENS
This is the Pentax two-element close-up lens on a 150mm short telephoto lens on the Mamiya 645.

Lens powers

Supplementary lenses are generally manufactured in different powers or dioptres. The cheaper single-element lenses are usually sold as a set of three, normally expressed as +1, +2 and +3. The greater the number, the higher the magnification. One great advantage of using supplementary lenses is that the camera's metering and autofocus functions are maintained and there is no change in exposure. I do not recommend stacking

WAX CAP
HYGROCYBE SPECIES
Two-element lenses can produce very acceptable results if used at smaller apertures and lower magnifications.
Mamiya 645, 150mm telephoto lens plus Pentax close-up lens, Fuji Velvia

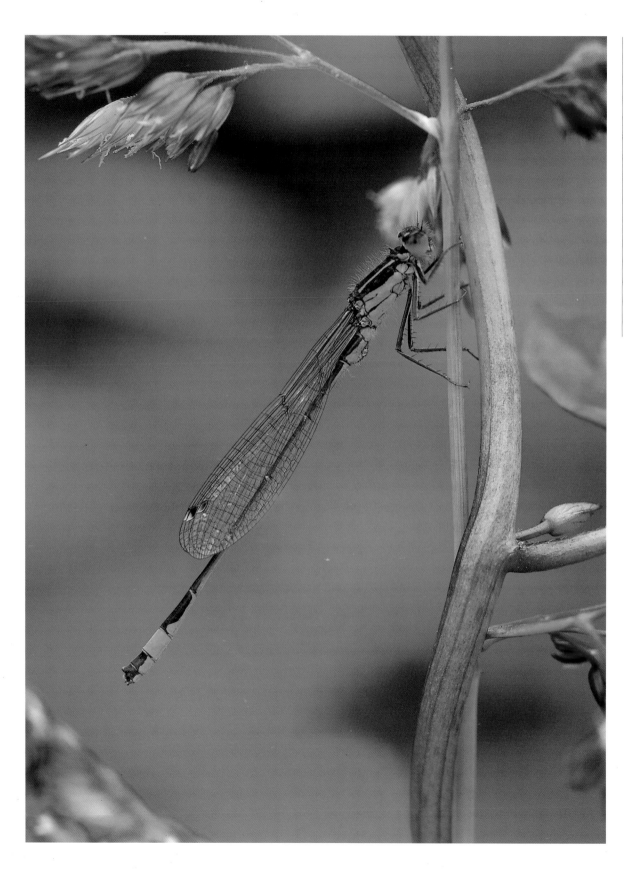

BLUE-TAILED DAMSELFLY *ISCHNURA ELEGANS*

Macro lenses offer the photographer greater control and flexibility when it comes to framing and composition. You have continuous magnification up to 1:1 (life-size) without the hassle of changing extension tubes. I was able to alter the magnification when up-close on this insect to eliminate a bramble branch that rested across the tips of the grass heads just out of view.

Mamiya 645, 120mm macro lens, Fuji Velvia

cheaper lenses to gain additional magnification, as they will show an obvious loss in image quality.

All supplementary lenses when attached to any lens will produce the same working distance if the lenses are set to infinity.

The drawbacks of supplementary lenses

Having discussed some of the advantages for using these lenses, there are, naturally, some disadvantages. These centre mainly on image quality. First, they are really designed for low-level magnifications. Second, there will be a definite loss of image quality, especially at higher magnifications. This is particularly apparent with the cheaper single-element brands, which generally lack contrast and are subject to chromatic and spherical aberrations that degrade the image. This is clearly obvious at the outer edges of the frame.

Leading camera manufacturers like Nikon, Canon and Pentax produce a range of high-quality two-element achromatic lenses that correct any lens aberrations in addition to improving image contrast and reducing flare. For example, Nikon close-up lenses are widely available and are optically designed to be used with lenses within a certain focal range. The 3T and 4T work best with lenses from 85mm to 200mm, while the 5T and 6T are normally used with lenses ranging from 70mm to 210mm. The 5T and 6T lenses have a diameter of 62mm and can be used on other lenses with the appropriate step ring.

All supplementary lenses are interchangeable and can be used with any lens with the appropriate step ring. To improve the image quality, it is normally recommended that you shoot at smaller apertures such as f/8 or f/11. For those of you who thrive on numbers, if you want to calculate the magnification for a given lens and dioptre, you need to divide the focal length of the lens in millimetres by the focal length of the dioptre in millimetres.

Macro lenses

Many photographers believe that the only lenses that deliver high-quality images in close-up are those taken with a macro lens. The photographs throughout this book demonstrate that this is not always the case. Many have been taken with a variety of lenses used in combination with extension tubes. Having said that, I would advise anyone who plans to specialize in close-

up photography to buy at least one macro lens, preferably with a focal length between 90mm and 105mm. When photographing in the field, the convenience of being able to compose and photograph from infinity to life-size without having to add and remove extension tubes is a great advantage, especially when photographing fast-moving subjects such as insects.

Macros are highly corrected lenses, especially in relation to flatness of field. This has more relevance when photographing two-dimensional subjects, such as documents or illustrations, where you need sharpness across the entire frame. When applied to three-dimensional subjects, the slight softness at the edge of a normal lens due to curvature of the glass is of no real significance, since in most cases the subject does not occupy the entire frame to the extreme edges.

Almost all modern macro lenses can focus from infinity down to life-size without the need for additional extension. Contemporary computerized lens designs mean that most 35mm lenses have internal focusing with a floating element system that allows certain lenses within the barrel to change their position. This reduces the need to have large amounts of built-in extension. Many older macros work on a different principle and have an expanding extension tube that increases in size as the focusing ring is rotated. With the exception of a few, most were restricted to half life-size and required an additional extension tube to achieve life-size.

Standard macro lenses

Macro lenses for 35mm cameras come in various focal lengths. The 50mm and 60mm are generally referred to as standard macros, since their focal length is similar to the standard lens on your camera. One of the disadvantages of using such a short focal length is the working distance between the front of the lens and the subject. These lenses can be used for photographing static subjects, such as fungi and flowers, where lens-to-subject distance is not as crucial. However, I would not recommend buying a 50mm lens, for several reasons. First, you are already likely to own a zoom that covers this focal length.

DIFFERENT FOCAL LENGTH MACRO LENSES
This image illustrates three different focal length macro lenses that I currently use: Above left 105mm portrait Micro Nikkor; above centre 200mm Micro Nikkor with tripod collar; above right 120mm macro for the Mamiya 645 AFD. Both Nikon macro lenses are internal focusing, which is a useful advantage.

NIKON'S 105MM MICRO NIKKOR
The 105mm Micro Nikkor is a popular focal length for most close-up subjects. However, I find myself using the 200mm macro for most of my digital work because of the greater working distance and the narrow angle of view.

Short telephoto macro lenses

The most popular macros tend to be in the short telephoto range, from 90mm to 105mm. The 100mm is by far the most common and widely used of all. It will give you twice the working distance of the 50mm at the same magnification, which is a distinct advantage when photographing close-ups of flowers or shy and wary creatures. They are a good compromise and easily managed if you are handholding using a macro flash bracket, compared to the longer telephoto macros, which require tripod support.

Most camera manufacturers tend to produce at least one macro lens. Independent companies such as Sigma and Tamron produce a range of macros that are excellent value if you are on a budget.

Longer focal length macro lenses

A few camera and independent lens manufacturers offer longer focal length macros. Nikon have a 200mm Micro Nikkor, which is a superb lens and widely used by many professionals. Canon also makes a 180mm lens, while Sigma has introduced a new 150mm that is suitable for both film and digital. These lenses are quite expensive and beyond the reach of the average amateur. I find the Nikon 200mm extremely useful for photographing flowers, dragonflies and other timid insects. I use this lens almost exclusively with my digital camera bodies. The flattened perspective is more pronounced with these lenses, and its narrow angle of view helps to create a more diffused appearance to the background, making the subject stand out more clearly.

Using a longer focal length macro offers some other advantages. One is that you have a greater working distance between lens and subject. You also have a tripod collar, which is a godsend for macro photographers.

MONKEY ORCHID
ORCHIS SIMIA
Portrait macros work well with extension tubes when higher magnifications are required. They are light and much easier to handle than the larger 200mm lenses. This focal length is also a good choice for flower photography, as it provides a reasonable working distance from your subject.
Mamiya 645, 120mm macro lens, fill-flash, Fuji Velvia

Second, photographing insects could prove to be frustrating due to the short working distance between the lens and subject. Working off a tripod with a short focal length macro can be quite exasperating, especially with delicate subjects, since you are quite likely to hit the surrounding vegetation with your tripod legs as you try to manoeuvre it into position. Short focal length macro lenses have a much wider angle of view than other short telephoto macros. These lenses include more of the surrounding field of view which often results in the out-of-focus backgrounds having a more untidy appearance. It is also more difficult to create a more diffused, poster-like appearance in the backgrounds when using lenses of the focal length.

NIKON'S 200MM MICRO NIKKOR LENS
One of the biggest advantages in using a longer focal length macro is the greater working distance and the narrow angle of view. Most lenses in this focal length have a tripod collar, which is an extremely useful aid. This allows you to rotate the camera into horizontal format without having to turn the camera on its side. I use this lens almost exclusively now on my digital set-up.

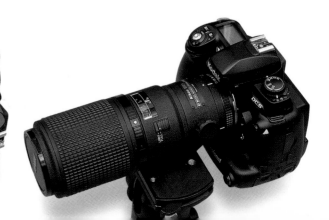

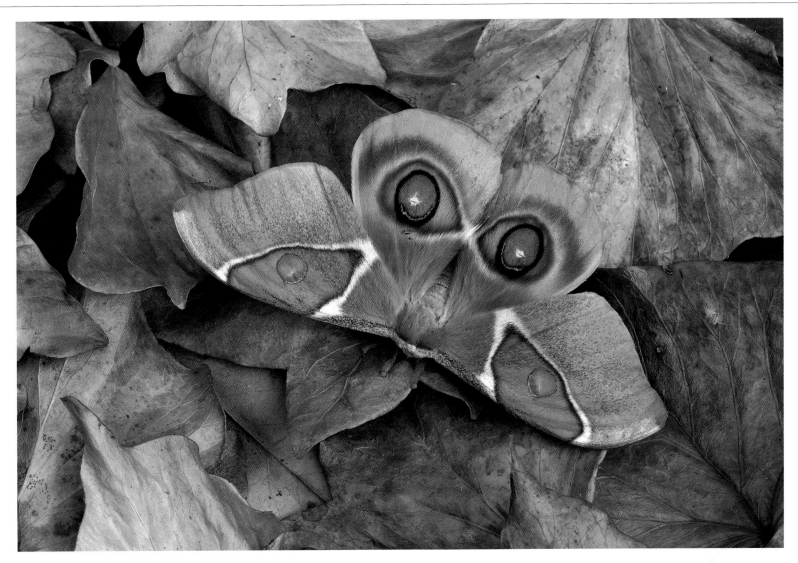

It allows quick and precise changes between horizontal and vertical framing without having to turn the camera assembly on its side, which can lead to an unstable set-up. I find this feature indispensable since I've started to use a digital 35mm for some of my work. Working off a tripod is also much easier, since the increased working distance between the lens and subject means that you are less likely to knock the adjacent foliage or get your tripod legs entangled in the surrounding vegetation. These longer focal lenses are extremely useful for many other aspects of nature photography. They may not have the wider apertures of shorter focal length macros, but this is not a disadvantage since you will be working at smaller apertures for most of the time in any case.

When it comes to medium format, there is less of a choice. Mamiya offers an 80mm and a

SHORT TELEPHOTO WITH TUBE
This is the Mamiya 645 with 150mm telephoto lens plus extension tube. Using short telephotos with extension tubes is an excellent choice for photographing subjects that don't require large magnifications.

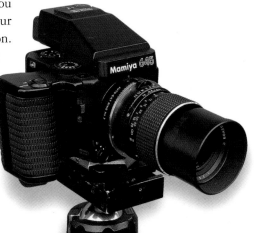

MADAGASCAN BULLSEYE MOTH
ANTHERINA SURAKA
This image was taken with a 200mm macro lens. These longer focal length macro lens are ideally suited for photographing shy and timid subjects.
Kodak DCS Pro 14/nx, Nikon 200mm macro lens, ISO 160, Raw format converted to Tiff

120mm. The latter focuses to 1:1 (life-size); you need an additional tube for the 80mm to reach this. Bronica has a 110mm lens for the SQAi, while Hasselblad has a new macro for the H1. Both of these models focus to life-size. All these lenses deliver superb results, but are a little more bulky. Most equate in focal length between a standard and short telephoto macro in 35mm terms.

Short telephoto lenses

Short fixed focal length telephotos are an excellent choice when used in combination with extension tubes. They are cheaper than buying a long telephoto macro and can ease the frustrations when photographing larger insects. Their greater lens-to-subject distance reduces the risk of hitting the vegetation with your tripod legs and losing your subject. Minor adjustments to framing or tripod position are also more easily accomplished.

WAVED UMBER
MENOPHRA ABRUPTARIA
A zoom lens fitted with a high-quality supplementary lens can produce quite acceptable results. Here I stopped the lens well down and used a lens hood.
Mamiya 645, 105–210mm zoom lens plus two-element supplementary lens, Fuji Velvia

The days of burdening oneself with a heavy bag of fixed focal-length lenses may now be over. Most photographers own zoom lenses, which give them much greater flexibility when it comes to framing and cropping. Many also own a macro lens and habitually use it when taking close-ups without thinking of the possibility of using a longer lens with extension tubes. In addition to the extra working distance, their narrow angle of view makes them extremely useful for many other aspects of nature photography, especially when there is a need to isolate a subject or create a soft diffused background. Evaluation of the subject is important: lens selection, perspective, and controlled depth of field are all important factors that influence the final result.

MARSH FRITILLARY *EURODRYAS AURINIA*
I found this adult in overcast conditions resting among ground vegetation. I photographed it using a short telephoto combined with extension tubes. This is another alternative if you don't own a longer focal length macro lens.
Mamiya 645, 150mm telephoto lens plus extension tubes, fill-flash, Fuji Velvia

Lenses in the 100–200mm range work well with extension tubes. I often adopt this approach when photographing dragonflies and butterflies, especially when using medium format. These lenses are best suited to larger subjects up to a maximum of half life-size. Beyond this, they become difficult and cumbersome to use because of the amount of extension needed to give them 1:1 capability.

Taking verticals can pose some problems (unless your lens has a tripod collar) when turning the whole camera assembly on its side. In addition to the awkwardness, trying to manage a heavy set-up is not particularly practical when working in the field.

When it comes to medium format, most macro lenses when equated with their 35mm counterparts tend to fall into the standard grouping, which is why I often use lenses from 150mm to 250mm or use a 1.4x teleconverter with a macro.

Using zoom lenses

Zoom lenses have now largely replaced many fixed focal length lenses. Having a range of focal lengths contained in one lens is a big advantage for those who need to travel light; it cuts down on weight and allows precise framing of a subject throughout the complete focal range of the lens.

In close-up photography, zooms offer you no real advantage except when they are used in combination with supplementary lenses. Many of the zoom lenses currently available have a macro facility. This is often misleading, however, as it implies that the lens offers true macro capability. This is not the case; it is restricted to about 1:4 life-size, usually at the shortest focal length. This means the working distance between lens and subject is very close, making it more difficult to frame moving subjects.

It is doubtful whether the optical quality in this mode delivers any higher quality than a two-element close-up lens. Adding extension tubes to zooms is not really an ideal approach; they tend to be much heavier than normal lenses and are generally slower to operate. Unlike supplementary lenses, zooms don't retain their focus position while zooming, since you are changing through different focal lengths. You have to refocus the lens each time you zoom or move the camera backwards or forwards to focus and maintain the magnification.

Hairy Dragonfly *Brachytron pratense*
This insect was perched at the edge of a small pool that was difficult to approach due to the boggy ground. I used a longer lens with extension tubes, which gave me a much greater working distance, especially when using a tripod.
Mamiya 645, 210 mm telephoto lens plus extension tubes, Fuji Velvia

Extension tubes

Extension tubes are one of the most versatile close-up accessories you can own. They are essentially black hollow tubes, constructed in different lengths, which fit between the lens and camera body to increase the distance from the rear of the lens to the film plane.

Most extension tubes retain all the automatic functions of the lens. They are usually sold in sets of three. All the major manufacturers of 35mm and medium-format cameras make a range of tubes for their own cameras. Independent companies also produce extension tubes in various camera mounts for some of the more popular brands. Check before you buy an independent make that when stacked together there is no vignetting at the corners of the frame and that you have full integration.

When extension tubes are used in combination with any lens, especially short telephotos, they allow the lens to focus closer than its normal minimum focusing distance. A macro lens may be a convenient way to take close-ups, but if you are working to a tight budget, using your existing lenses in combination with extension tubes works equally as well – you will see no perceptible difference between them. There are occasions when using a longer focal length lens with extension tubes is a better approach, however, as its narrow angle of view and greater working distance can prove to be beneficial.

The effect of extension tubes

When an extension tube is added to a lens, two things happen. First, the lens can now focus closer than its minimum focusing distance, but it will no longer focus at infinity. Second, there is a fall-off in the light reaching the film plane. The amount of light lost is not fixed but varies depending on the focal length of the lens. For example, adding a 25mm extension tube to a 200mm lens will produce a magnification of about one-eighth life-size. This has much less effect in terms of light loss and magnification when compared to adding the same tube to a 50mm lens, which produces a magnification of half life-size with a much greater effect on light loss.

The greater the amount of extension added to a lens, the higher the magnification. As extension increases, the distance the light has to travel to reach the film plane also increases, which in turn requires longer exposures. One of the advantages in using longer lenses with extension tubes is the greater working distance

EXTENSION TUBES
A selection of extension tubes in various sizes for the Mamiya 645 AFD, Mamiya 645 Pro TL, Bronica SQAi and Teleplus (Nikon fit).

YELLOW IRIS
IRIS PSEUDACORUS
Your standard lens used in combination with extension tubes will produce high-quality images. However, with shorter focal length lenses, the angle of view is much wider, which tends to show more of the background.
Mamiya 645 AFD, 80mm standard lens plus extension tubes, Fuji Velvia

EXTENSION TUBES WITH THE MICRO NIKKOR
Teleplus extension tubes used in combination with the 105mm Micro Nikkor. These tubes retain all of the automatic functions of the lens and body. Note that some Nikon auto extension tubes do not have full integration with some of the digital cameras.

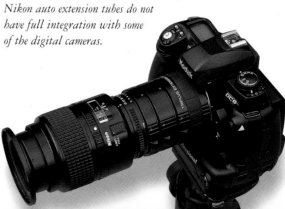

KEELED SKIMMER
ORTHETRUM
COERULESCENS
A longer focal length lens combined with extension tubes helps to isolate a subject from its background, producing a soft, diffused blur.
Mamiya 645 AFD, 210mm telephoto lens plus extension tubes, fill-flash, Fuji Velvia

from the end of the lens to the subject. A 100mm lens will give you twice the working distance from the subject than a 50mm lens at the same magnification. This can be a great advantage when you are trying to photograph larger insects.

How much extension?

The amount of extension you require to achieve a certain magnification depends on the focal length of the lens being used. For example, a 50mm lens needs 50mm of extension to reach 1:1 (life-size). If we double the focal length of the lens to 100mm, 50mm of extension gives us a maximum magnification of half life-size, while at 200mm the magnification rate is quarter life-size. The amount of extension needed to reach life-size increases proportionately with the focal length of the lens. Achieving magnifications up to half life-size in the field

is about the limit with longer focal length lenses. Beyond this it becomes impractical, since 200mm of extension would be required to achieve life-size on a 200mm lens. A set-up such as this becomes almost impossible to work with comfortably in the field.

Should you wish to work out precisely what the magnification rate is, the formula for calculating magnification is:

Magnification = Extension ÷ Focal length of lens used

Many photographic publications like to bombard their readers with calculations and formulas. However, in practice you will rarely ever need to know the precise magnification of a subject when you are able to see clearly in the viewfinder your subject's size in relation to the frame.

Teleconverters

Teleconverters, or multipliers as they are frequently called, are essentially extension tubes containing optical elements that magnify the image in front of it. They are generally manufactured in two powers: 1.4x and 2x. Advances in optical design mean that the quality of teleconverters has greatly improved in recent years. When using medium format, I frequently use a 1.4x or 2x converter with shorter focal length macros; this increases my working distance between lens and subject and reduces the angle of view, which can help control distracting highlights in backgrounds.

High-quality converters when used in combination with a good lens show practically no discernible difference in image quality, except perhaps a slight reduction in overall contrast. Using converters is the easiest way to obtain magnifications beyond life-size. Macros are highly corrected lenses. When combined with converters, they deliver excellent results at magnifications above life-size, providing you apply the same meticulous approach to technique.

Most lens manufacturers produce converters that are optically colour-matched to their own range of lenses. This makes them more expensive, but I would advise you where possible to buy these units, as they maintain the optimum in terms of contrast and colour accuracy with the original lens. If you are working to a budget,

independent lens manufacturers such as Tamron, Tokina and Sigma make universal multi-element units that can be used with any lens.

Effect on image quality

All teleconverters, irrespective of their price, will have a slight effect on image quality, although this tends to be less of an issue with modern units. Since teleconverters are essentially high-power optics, they will magnify your mistakes, along with any optical defects or aberrations present in a lens. This is why it is important to use high-quality lenses.

Teleconverters also reduce the intensity of light reaching the film; the amount of light loss varies depending on the power of the converter used. For example, a 1.4x added to a 200mm f/4 now becomes a 280mm f/5.6 – there is a reduction of one stop. A 2x unit added to the 200mm f/4 now becomes a 400mm f/8 – a two-stop reduction. Adding a 2x teleconverter to a 100mm macro focused at life-size doubles the magnification (not the focal length) to twice life-size. Focusing becomes more difficult because of the reduction in light reaching the viewfinder.

If you require additional magnification, you can add extension tubes. Where you place them affects the magnification. If magnification is your main objective, place the extension tube next to the lens followed by the converter. This arrangement produces the highest magnification, as the converter magnifies everything in front of it. Reversing this arrangement results in a slightly lower magnification, but increases the lens-to-subject distance. When a lens is focused at infinity, adding a 2x converter doubles the focal length of the lens and reduces the angle of view. It still retains the original minimum focusing distance.

Obtaining higher magnifications

The last ten or fifteen years have seen the introduction of many ground-breaking changes in camera design and optical advancements in lens construction and function. As a result, some of the traditional methods of obtaining higher magnifications, although they are still effective, seem outdated by today's standards. For example, reversing a standard or wide-angle lens

FROSTED NETTLE

Using the shorter focal length macro on the image below left included too much of the surrounding background when the lens was stopped down. For the image below right, by adding a 2x teleconverter, the angle of view was reduced and the background became darker and well diffused.

Image below left Mamiya 645, 80mm macro lens, Fuji Velvia

Image below right Mamiya 645, 80mm macro lens plus 2x teleconverter, Fuji Velvia

on bellows or extension tubes to achieve magnifications greater than life-size was a technique that was widely practised by photographers during the 1970s and 1980s. This was because there was no real alternative available for obtaining magnifications beyond life-size when working in the field.

Camera manufacturers suggested reversing the lens to improve optical quality, since they were designed to deliver optimum performance when the distance from the rear lens element to the film plane is shorter than the lens-to-subject distance. When you add extension to a lens, you effectively change this relationship. This is especially apparent at higher magnifications where the

PIPUNCULUS CAMPESTRIS
Shots of small subjects are achievable using this type of set-up, although it requires much more effort on the photographer's part.
Mamiya 645, 80mm lens reversed on the auto bellows, flash, Fuji Velvia

SPANISH FESTOON ZERYNTHIA RUMINA
Adding a 2x teleconverter to a macro is an excellent way to achieve higher magnifications without having to sacrifice the working distance between lens and subject, which remains the same. In this image, I was able to render the fine detail on the hindwings of this butterfly with no appreciable loss of detail.
Mamiya 645, 120mm macro lens plus 2x converter, Fuji Velvia

TELECONVERTERS AND 120MM MACRO LENS
Top: 2x and 1.4x teleconverters for the Mamiya 645 Pro TL and the Bronica SQAi, Bottom: the 2x teleconverter in combination with the 120mm macro lens on the Mamiya 645 Pro TL. This doubles the focal length of the macro lens when focused at infinity and doubles the magnification to twice life-size when the lens is focused at life-size.

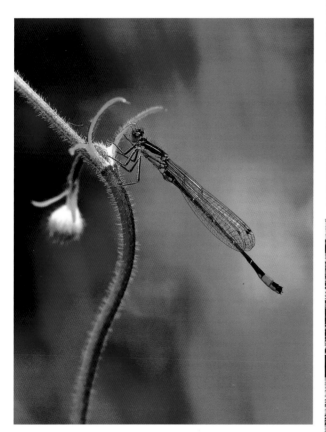

BLUE-TAILED DAMSELFLY ISCHNURA ELEGANS
A teleconverter used in combination with a macro lens reduces the angle of view, which helps create softer diffused backgrounds. Using a 1.4x converter on the macro and selective depth of field helped me to keep the background diffused, making the subject stand out clearly.
Bronica SQAi, 110mm macro lens plus 1.4x converter, Fuji Velvia

MADAGASCAN COMET MOTH *ARGEMA MITTERI*
Working at high magnifications reveals a world of intimate detail, as can be seen on the forewing of this magnificent moth.
Mamiya 645, 80mm lens reversed on auto bellows, flash, Fuji Velvia

MAMIYA AFD AUTO BELLOWS UNIT
This is the Mamiya 645 AFD with an 80mm lens reversed on the auto bellows. The AFD retains all automatic functions when the lens is reversed using the special reversing ring. This is a great advantage when working in the studio.

distance between the lens and subject is smaller than the distance between the rear of the lens and the film plane. By adding additional extension in the form of tubes or bellows, magnifications in the region of three to four times life-size are possible using wide-angle lenses; however, the working distance between the lens and subject is very close.

Using bellows

The biggest disadvantage with bellows (apart from their general ineptness and fragility) was the loss of automatic functions, particularly open aperture viewing and TTL metering between the camera body and lens when reversed. In most cases with static subjects you could revert to stop-down metering. However, this approach, in addition to close working distances, fragility and the sheer awkwardness of the set-up, was generally impractical for fieldwork involving moving subjects. Anyone who ever used a bellows unit will know what I mean.

Outside the studio, bellows become difficult and awkward to use, slow to operate and, because of their fragile nature, easily damaged.

A few camera manufacturers still make bellows; some of the modern units such as the Mamiya bellows retain all automatic functions even when the lens is reversed, which is an advantage for anyone working in studio set-ups with static subjects. For units that are not fully automated, some of the major camera manufacturers produce an adaptor or z-ring for their bellows unit. When connected to the rear lens mount, it allows open aperture viewing using a double cable release. Most photographers who use bellows frequently ignore the meter and work purely with flash.

I seldom use bellows these days as it is possible to achieve magnifications of around three times life-size by utilizing converters in combination with macros and high-quality two-element close-up lenses. This has the advantage of maintaining all automatic functions, speed and ease of use. When I want to reverse a lens,

I occasionally use the connection lead and rings from the Mamiya bellows unit in combination with extension tubes. This gives me the same options as bellows and is easier to manage.

I now consider around twice life-size to be the limit that can be achieved in the field. If you try to go any higher than this, you will experience major problems in focusing and overall stability of your set-up. Magnifications beyond this should be carried out in the studio.

Stacking lenses

Stacking or joining two different focal length lenses together to attain higher magnifications was a popular practice among some macro photographers in the early 1990s. The technique had some merit at that time. However, the greatest disadvantage was vignetting of the image at the corners, which was nearly always present to some degree irrespective of the lens combination used.

The main lens (often referred to as the prime lens) is usually in the region of 200mm and is attached to the camera body in the normal way; lenses around the 200mm range are generally the most suitable and make the best prime lenses. A standard or short focal length lens is reversed and attached to the front element of the prime lens using an adaptor ring. This can be made using filter or step-up rings and gluing them together. As a temporary measure, you can tape the lenses together. The aperture is controlled from the prime lens in the usual way. The aperture on the attached lens is set wide open and plays no part in the exposure process.

High-quality supplementary lenses in combination with converters and short telephotos have now largely superseded this approach. Working in the field at magnifications in excess of 2:1 brings its own challenges. I seldom need magnifications beyond this level. Your technique is tested to the limit at these extremes, and what are considered minor focusing errors at low-level close-ups become disasters at these magnifications.

COUPLING RING AND STEP-UP RINGS, 200MM MACRO PLUS 80MM STANDARD LENS
Nikon 200mm macro with a Bronica 80mm standard lens reversed using a male-to-male coupling ring and the appropriate step-up ring. No vignetting occurs with this combination since the medium-format lens is of a larger diameter than a 35mm equivalent.

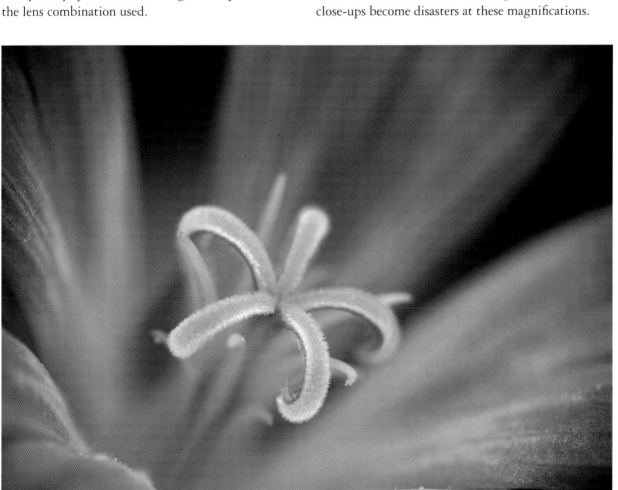

MAYFLOWER
GERANIUM
SYLVATICUM
The central stamens of a small geranium flower at approximately three times life-size.
Kodak DCS Pro 14/nx, Nikon 200mm macro lens with 80mm Bronica lens reversed, ISO 160, Raw converted to Tiff

Magnification

Magnification, reproduction ratio and life-size are terms that photographers coming fresh to macro photography often find confusing. Macro is a word that is often loosely applied to close-up photography, as well as being frequently misused by manufacturers to describe additional features on a lens such as 'macro mode'. The definition of macro photography in the true sense relates to photographs taken at life-size up to approximately 20 times.

It was common practice in the 1990s for photography books to fill pages with formulas and equations that were seldom read or even understood by most photographers. However, trends change and I feel in most cases that the average photographer can visually assess the effects of magnification in the viewfinder or look at the reproduction ratio on the barrel of the lens if he or she needs to know the reproduction ratio. Few people, with the possible exception of forensic and scientific photographers engaged in research, need this kind of information.

Understanding magnification

Magnification in the context of close-up and macro photography essentially describes the association between the actual size of the subject that you are photographing and its reproduction size on film – not its enlarged or finished size on a print. The reproduction rate is defined as the ratio between the two. This is normally expressed as a percentage such as quarter, half, three-quarters and 1:1 (life-size, as it's often referred to), where the subject is reproduced on film at its true size.

The percentage figures etched on the barrel of most macro lenses indicate the magnification rate on film. Photographing below 1:1 means the final image reproduced on film is, in reality, smaller than its actual size. Unlike conventional photography, where we habitually photograph subjects from a distance, in close-up and macro, the camera-to-subject distance is not the main factor that determines the final image size of an object on film; magnification is. For example, when you photograph a subject at 1:1 that is 2cm (¾in) long, it will appear to be 2cm (¾in) long on film.

Magnification and format

Another important factor to consider is that life-size varies according to the camera format being used. For example, life-size on a 35mm transparency measures 24mm x 36mm. You can photograph any subject that conforms to this measurement, and all of it will appear within the frame. Subjects whose dimensions exceed the format frame will need to be photographed at a reduced magnification if you want all of it to appear inside the frame. However, most D-SLR sensors are generally smaller than a full-frame 35mm camera. As a consequence of this, life-size is further reduced to the dimensions of the sensor – which, in my opinion, has some disadvantages.

On medium format, life-size is greater due to the larger film area. This allows you to shoot at 1:1 in the case of the Mamiya 645 AFD, and up to a maximum of 6 x 4.5cm and 6 x 6cm on the square formats. Subjects that are smaller than the dimensions of the format still appear at their actual size on film. Working with a larger format has many advantages in close-up photography, especially when working at lower magnifications. The larger film area, if fully utilized, permits you to photograph subjects at increased magnifications,

RANGE OF MAGNIFICATIONS
This series demonstrates a range of magnifications. Far left: quarter; centre left: half; left: life-size or 1:1. At 1:1 the subject appears at its true size on film.
Mamiya 645, 120mm macro lens, Fuji Velvia

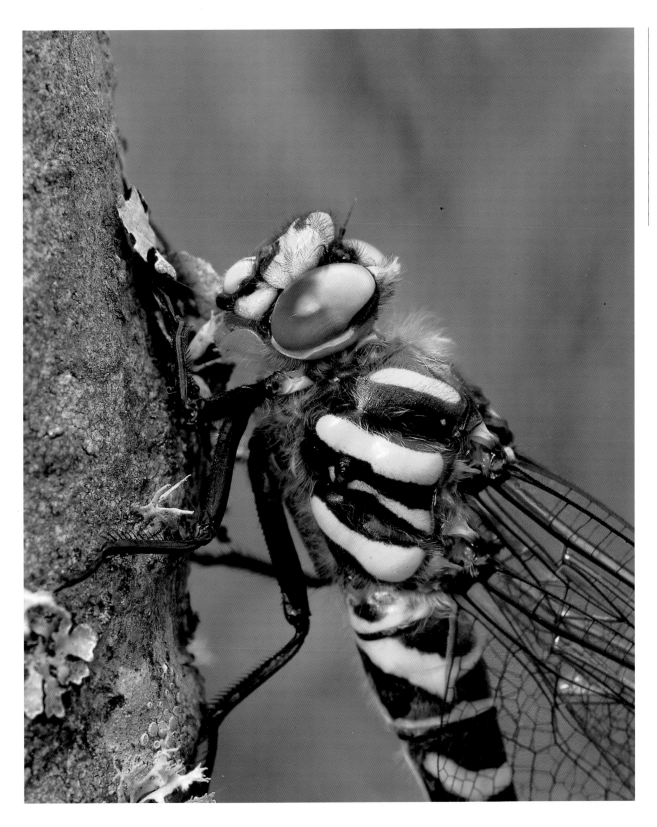

GOLDEN-RINGED DRAGONFLY
CORDULEGASTER
BOLTONII

This newly emerged dragonfly gave me the opportunity to get in close and fill the frame. I photographed the insect at life-size, illustrating the fine detail in the head and upper part of the thorax.

Mamiya 645, 120mm macro lens, fill-flash, Fuji Velvia

resolve greater detail in the subject, and produce better colour saturation and larger prints compared to 35mm. This is a proven fact irrespective of what some photographers or manufacturers claim. Subject in situ shots also work well with medium format, as increased magnifications allow a larger subject image, but not at the price of reducing the surrounding habitat too much. However, at higher magnifications, the depth of field does decrease. This can be overcome in medium format by using smaller apertures.

In my experience, the differences between 35mm and the 645 formats do not pose a major problem in terms of depth of field. This is because the magnification differential is not that dramatic below 1:1, as many of the images in this book testify.

Higher magnifications

Life-size or 1:1 is often referred to as the boundary line of where close-up ends and true macro photography begins. Photographing at this level means that you are magnifying the object or part of the object on film. For example, if you photograph a subject that measures approximately 1cm (⅜in) at a magnification of 2:1 (twice life-size), you have doubled it in actual size and your subject will appear to be 2cm (¾in) long on film.

PANTHERCAP *AMANITA PANTHERINA*
Working with medium format lets you use higher magnifications, obtaining greater detail and saturation while allowing more of the surrounding habitat to be incorporated. You can see from the white line the dimensions of the 35mm format.
Bronica SQAi, 110mm macro lens, Fuji Velvia

Working at magnifications beyond life-size is mentally challenging and physically demanding, so be prepared for a high failure rate. However, observing the intricacies of nature beyond the normal field of vision provides a unique and fascinating insight into another world where few people care to venture.

Vibration can be a formidable problem at higher magnifications, especially in the field, as you are often working with set-ups that are potentially awkward and unbalanced. Focusing becomes critical; the slightest fraction of movement either way will translate into a series of major errors in your images. Viewfinder brightness is greatly diminished at higher magnifications, as is depth of field, which is extremely shallow even when working at apertures of f/16 and f/22. Selection of the appropriate subject and meticulous execution of your technique is absolutely critical at this level if you are to obtain successful images.

When photographing static subjects, you can use a tripod combined with a focusing rail to make minor adjustments. When pursuing active creatures, working off a monopod gives additional support to a point. Focusing is achieved by slowly moving the entire assembly in and out – not by rotating the focusing mount. At higher magnifications, the lens-to-subject distance is extremely close, so that many active subjects will not tolerate your presence, especially in the heat of the day. Working in early morning or late afternoon is a better approach.

Observation is the key to success and selecting subjects that are at rest is a good starting point so that you can familiarize yourself with your set-up and approach. At these magnifications, you will be working with flash to freeze movement, as available light has no influence on your exposure.

Focusing rails

Focusing rails seem to have slipped out of popularity in recent years. Of the well-known camera manufacturers, only one or two still make them. This is a pity, as they are an essential accessory for photographing at magnifications beyond life-size. Manfrotto have an excellent unit that is suitable for both 35mm and medium format. Novoflex also produce a slightly cheaper model that is mainly suitable for 35mm users.

Focusing rail design

The vast majority of focusing rails use a rack and pinion design. They fit between the tripod head and camera lens assembly. The rail moves independently from the tripod head, allowing you to fine-focus on your subject by moving the whole camera assemblage forwards or backwards.

In most cases, you will be working in the field at magnifications below or up to life-size; you normally place the tripod and camera into position and focus by rotating the lens-focusing mount. What you're actually doing here is changing the extension on the lens, which in turn alters the magnification and composition. At lower magnifications it is easier to make the corrections by fine-tuning the focus ring, since this has little effect on the overall composition. However, at magnifications above life-size it becomes more of a problem, since any alteration using the focusing ring will drastically change the composition as well as altering the subject size.

Making any adjustment with the tripod at these magnifications in the field is virtually impossible, since the nature of the terrain plus the slightest movement from the subject or camera assembly puts the entire image out of focus.

While it is possible with some subjects to photograph beyond life-size in the field, in general if you want to achieve consistency in your images you will have to revert to photographing in the studio. I have heard many people claim to have captured successful images of three and four times life-size in the field, but I feel this is pushing your luck. I occasionally work up to twice life-size, which is what I consider to be a sensible limit for outdoor work.

COMMON HAWKER
AESHNA JUNCEA
When working at higher magnifications around life-size and above, focusing is best achieved by moving the camera assembly in or out rather than altering the focusing ring, which results in drastic changes to composition. A focusing rail makes it easier to make fine adjustments without having to move the camera and tripod assembly.
Mamiya 645, 120mm macro lens, fill-flash, Fuji Velvia

Working with a focusing rail

Working with a focusing rail in the field requires patience and practice. In the vertical format, it becomes rather awkward to use as the weight load is unevenly distributed and the risk of vibration is greatly increased. Another disadvantage is the increase in height when attached to the tripod head. This is not too inconvenient if your subject is a metre or so off the ground. However, working at ground level becomes more problematical – the increased height of the assembly makes it difficult to keep your camera back parallel to the subject. The success of focusing rails in the field largely depends on the choice of subject. Don't expect to get a pin-sharp image of a dragonfly's eye at twice life-size on a bright sunny day with a breeze. I always advise photographers to perfect their techniques at lower magnifications first before embarking into the realms of true macro – any flaws in your technique will be clearly evident at these magnifications.

TYPICAL FOCUSING RAIL
Mamiya 645 on a typical focusing rail.

Depth of field

PYRAMIDAL ORCHID

ANACAMPTIS

PYRAMIDALIS

You can see from this series of photographs how the choice of aperture affects the overall sharpness and the background appearance of the image. The smaller the aperture, the greater the sharpness, which allows more of the foreground and background to appear in focus. Image above left f/4; above centre f/16; above right f/22.

Mamiya 645, 120mm macro lens, Fuji Velvia

Depth of field and magnification in close-up photography are inextricably linked – as magnification increases, depth of field decreases. Smaller apertures increase depth of field while larger apertures reduce it. Magnification is the controlling factor and has a direct bearing on how much of a subject you can keep in acceptable focus. In theory, true focus is only achievable on one plane – that on which the lens is focused. However, there is a zone either side of the point of focus that is not clearly sharp. Since the fall-off in sharpness is a gradual one, the area in front and directly behind the point of focus still remains reasonably sharp. This range or zone is defined as the depth of field.

Understanding depth of field

It's a common misconception among photographers that long focal length lenses have less depth of field and wide-angle lenses have more. This is not necessarily the case, as the amount of acceptable sharpness is controlled by a number of different factors: the aperture selected, the focal length of the lens being used, magnification,

and camera-to-subject distance. If the magnification and aperture remain constant, all lenses will deliver the same depth of field. If you photograph a subject at 1:1 with a 50mm macro lens and again using a 200mm macro lens at the same magnification you will achieve the same depth of field in both cases.

In normal photographic situations we refer to depth of field in terms of metres, because most of the time the subjects that we are shooting are a considerable distance away. For example, a subject that is photographed at 5m (16ft) away at f/22 will have substantial depth of field. Any slight focusing error at this distance will have less effect on the final image, since a small aperture would normally be sufficient to retain the subject in focus.

In close-up and macro photography, the situation is rather different. If we photograph a subject at 50cm (16in) at f/22, the lens-to-subject distance is now significantly reduced – the depth of field in these situations can be measured in millimetres. Any movement in the camera or focusing at this level becomes a disaster. When using medium format, depth

of field is further reduced since the magnification tends to be larger to take advantage of the greater film area. This can usually be compensated for by using smaller apertures. The only way you can increase depth of field is to use smaller apertures or reduce the magnification of the subject.

Working in the field

When photographing in the field, you should try to select a viewpoint where you can keep the film back as parallel as possible to the plane of focus. In that way you will be able to maximize on the depth of field for the chosen aperture. This is not always easy to achieve and therefore compromises have to be made. Photographing subjects head-on creates one of the biggest problems, since you will not be able to retain total sharpness from front to back. At magnifications above 1:1 it becomes extremely difficult to maintain sharpness throughout the entire subject. Photographic magazines habitually repeat the position adopted by many photographers, suggesting that you should always use the smallest apertures possible to extend the depth of field coverage. This may seem like the most sensible approach to adopt. However, there are other issues to consider before you accept this regimented way of working.

First, let's examine some of the effects that can arise as a result of adopting this method. Photographing in natural light using smaller apertures means slower shutter speeds. This increases the risk of movement either from the subject or from the elements. The choice of aperture has an important bearing on the background behind the subject. This is especially pertinent at lower magnifications where the surrounding vegetation can often be overpowering and in danger of competing with the subject. Magnification and focal length of the lens also affect the background, as we've already mentioned. Check your depth of field preview and look carefully at the background and select the aperture that will give you enough depth of field to keep your subject in focus. Don't force yourself into using slower shutter speeds when it is not necessary to do so, as this will increase your chances of getting vibration. Remember images that appear slightly soft are useless in terms of printing and sales.

Another option is to use flash. This permits photographers to use smaller apertures and freezes

subject movement. However, the downside is that it can often produce black backgrounds if the surrounding vegetation is not in close proximity to the subject. To counteract this, you can reduce the magnification and select a wider aperture, which would reduce the exposure differential between subject and background. However, the subject will appear much smaller in the frame, which may be unacceptable in some situations.

Remember, an image that you look at through the viewfinder is going to appear differently on film unless you are photographing with the lens wide open.

LARGE RED DAMSELFLY

PYRRHOSOMA NYMPHULA
I was careful here to select an aperture that gave me just enough depth of field to keep the damselfly sharp while keeping the background soft and diffused.
Mamiya RZ67, 140mm macro lens, Fuji Velvia

Mirror lock-up

With the exception of some of the more expensive camera bodies, many modern 35mm cameras no longer offer you the facility to lock up the mirror prior to making an exposure. This is largely due to improvements in design and the mechanisms that help to reduce the effects caused by mirror and shutter bounce.

With modern 35mm cameras, the mirror lock-up facility is no longer essential. When using medium-format cameras, it becomes more of an issue, however, especially with focal plane shutters, which at slower speeds can cause vibrations that result in unsharp images. Medium-format cameras with shutters incorporated into the lenses produce virtually no vibrations when the mirror is locked up because of the smooth action of the shutter. Shutter bounce can be one of the most irritating problems with medium-format cameras. Therefore, great care must be exercised at all stages when using speeds in what I call the vibration zone from 1/15 to 1/2 sec.

All SLR cameras raise the mirror prior to exposure. This is a very rapid procedure, and the force of the mirror hitting against the base of the pentaprism can produce a vibration, especially if the camera is not securely attached to the tripod head. A flimsy or inadequate tripod will compound the problem. At high shutter speeds, it does not pose a problem as the duration of the exposure is brief and above the speeds most associated with vibration. Mirror lock-up is only feasible when using a tripod; once it is raised you cannot view the image until the exposure is made. Raising the mirror also eliminates the time delay between pressing the shutter and making the exposure. If you have this feature on your camera, I would strongly recommend that you get into the habit of using it whenever possible.

When combining autoexposure with mirror lock-up, you will need to lock the exposure value prior to raising the mirror otherwise you will have an incorrect reading. I generally prefer to use mirror lock-up when I am working in manual metering mode, as it is much less hassle. There are other methods that help to reduce the effects of vibration; for example, avoid using small lightweight tripods, especially with long lenses or medium-format cameras, as this will compound the problem. Positioning the tripod on a good solid foundation will also be beneficial. Try where possible to avoid the offending shutter speeds by choosing a wider or smaller aperture, which will help to reduce the risk.

Mirror lock-up photography is beneficial with static subjects; it has a limited use in photographing active subjects such as insects. I try to employ it where possible, especially when I'm using slower shutter speeds. If there is a lot of subject or wind movement, then it is not practical to adopt this approach. I do, however, apply it religiously when photographing landscapes, plants and other static subjects.

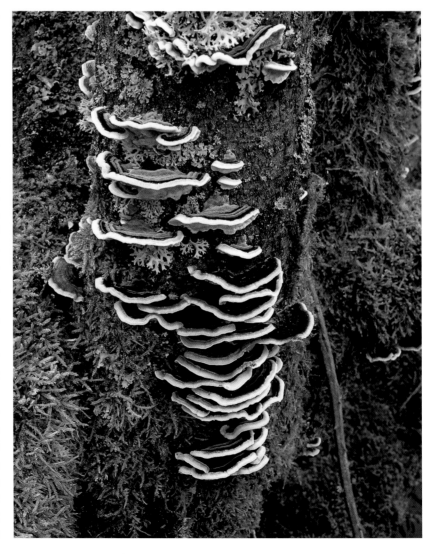

TURKEYTAIL
TRAMETES VERSICOLOR
When working with static subjects, I always lock up the mirror to prevent any vibration. This is especially important when working with larger-format cameras and at higher magnifications.
Mamiya RZ67, 140mm macro lens, Fuji Velvia

Filters

I don't support the frequent use of filters in close-up or macro photography because I want to document what I see in the natural world as accurately as possible. I'm not saying I never use filters; I do, but I use them sparingly, mainly when I want to bring about subtle colour change without altering the mood or the overall appearance of the image.

I normally carry two warming filters with me: an 81A and an 81B. I tend to use the 81A more frequently because it has a mild effect on film, adding just a little warmth to the overall image. It is useful for removing the bluish cast that you often get in overcast light. It works particularly well with subjects that are strong in yellows, oranges and browns. It proves useful with autumn foliage and fungi growing among leaf litter, where it can add a little vibrancy and warmth to the scene, especially when working in shade or in overcast conditions. I seldom use an 81B nowadays since most of the current films are already well saturated and on the warmer side. When using the warm-up filters, there is approximately one-third of a stop exposure increase, which is automatically compensated for by the camera's metering system.

I also carry a polarizer, which I find useful in overcast lighting or fine rain for removing reflections and the glare of foliage and for increasing colour saturation. With a polarizer there is an increase in exposure. This can be as much as two stops, pushing your shutter speed down and increasing your risk of wind movement. I don't use filters in any other situation or on subjects photographed in early morning, when the temperature is distinctly cooler; I feel the image should convey the ambience that one associates with this time of day.

Filter quality

I recommend you buy the best quality filters that you can – I would rather use nothing than degrade the image quality with a cheap piece of glass. If you put quality first, then Heliopan and B+W are among the best, although Hoya is probably the most popular brand among photographers.

Another point worth bearing in mind is the filter diameter. Buy one that covers your widest lens; you can use stepping-down rings to cover the others. I don't own, and would not consider buying, a UV or skylight filter to protect my lens – that's what my lens cap is for. Good lenses are expensive; I don't want to compromise that quality except when I feel it is absolutely necessary. All filters, irrespective of their quality, will degrade the image to some extent.

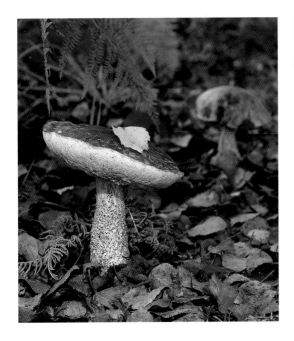
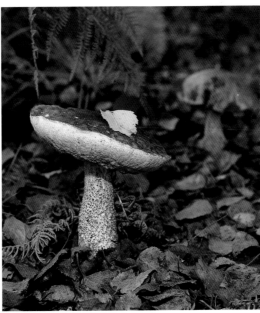

BROWN BIRCH BOLETE
LECCINUM SCABRUM
These photographs illustrate the effect of adding an 81A warming filter to the lens. The image far left was taken without the filter and the image left with the filter in place. Note the subtle warming of the birch leaf on the top of the mushroom.
Image far left Mamiya 645, 120mm macro lens, Fuji Velvia
Image left Mamiya 645, 120mm macro lens, 81A filter, Fuji Velvia

Useful accessories and equipment field kit

I find that some photographic accessories are often more of a hindrance than a help. I occasionally get demos and prototypes to evaluate. I have often come to the conclusion that many so-called custom-made devices manufactured to aid macro photographers have never been tested properly by someone with genuine field experience. For example, I've found some of the flash brackets I've had are impractical to use in the field. In macro photography, there are probably more home-made devices and set-ups than in any other photographic discipline. Many photographers, myself included, seem to be happiest when we are stripping down and modifying a new piece of equipment that we have bought or when we are designing our own.

Most photographers would admit to being equipment junkies, and I'm no exception. But having the best that money can buy is no guarantee that the results will justify the expenditure. Any equipment used poorly, irrespective of its cost, will deliver disappointing results. When things go wrong, photographers are sometimes inclined to look for an answer that doesn't implicate them as the cause. Your technique has to be up to scratch to get the most out of whatever equipment and accessories you own.

Throughout my photographic career, I have used many different systems and accessories. I have always favoured medium format in preference to 35mm, for reasons already stated. Although I have different medium-format systems, I use Mamiya equipment for most of my work. Its versatility and comprehensive range of lenses and accessories suit my needs. I chop and change lenses and camera bodies periodically when improvements in design are of particular benefit to me and what I photograph.

The following list of equipment is what I currently use for close-up and macro work in the field. My typical field kit usually consists of the Mamiya 645 AFD and the Kodak DCS Pro 14/nx with a selection of lenses in a Lowepro Pro AW Trekker.

MY FIELD KIT FOR MACRO WORK

This is what I normally carry when engaged in routine close-up photography. I have a smaller, lighter bag into which I can transfer equipment when I need to travel light – for example, when I'm photographing insects.

ELBOW BRACKET

One of the most frustrating aspects of the rectangular format is having to turn the camera on its side to take vertical shots. This can often unbalance the tripod and camera set-up. Using a custom elbow bracket eliminates this problem and keeps the centre of gravity over the apex of the tripod. This is a universal prototype that Manfrotto sent to me to evaluate. It was modified to fit the new rectangular quick-release plates.

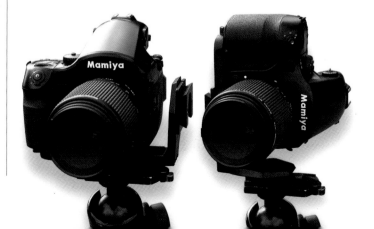

Camera bodies

I use a Mamiya 645 AFD and Mamiya 645 Pro TL. I also have a Bronica SQAi (6x6) that I occasionally use in some situations. I use a Kodak DCS Pro 14/nx (sensor upgrade) digital camera for all of my digital work and a Nikon D100 as a back-up.

Lenses

I use the following selection of lenses:
- Mamiya: 120mm macro, 35mm wide-angle, 55–105mm zoom, 150mm, 210mm and 300mm.
- Nikon: 105mm macro, 200mm macro and 24–120mm zoom.
- Bronica: 110mm macro, 40mm, 50mm wide-angles, 80mm and 250mm.

Accessories

The other important accessories that I use most frequently are:
- Tripods: Unilock and two Benbos, two Manfrotto ball and socket heads, and quick-release plates on all camera bodies.
- Extension tubes: Mamiya complete set, two 36mm tubes for the Bronica and a set of Teleplus extension tubes (Nikon fit) for the Kodak DCS Pro 14/nx.
- Teleconverters: 2x teleconverter for Mamiya 645 Pro TL and 1.4x for the Bronica.
- Flash: Metz Two MZ40s, MZ32, 2CL-45s. Two Nikon DX80s (with off-camera flash cables) and SB29s macro flash unit. I also carry one of my flash brackets and a custom-designed ground spike with a flash shoe for holding a flash unit near ground level.
- Filters: 81A and 81B warm-up filters and a polarizer.
- Sekonic L-608 handheld light meter. I occasionally use this, mainly when taking subjects in close-up in their environment using wide-angle lenses.
- Kodak grey card.
- One electronic release for the Nikon and two manual cable releases for the Mamiya.
- Lastolite 24-inch diffuser and reflector.

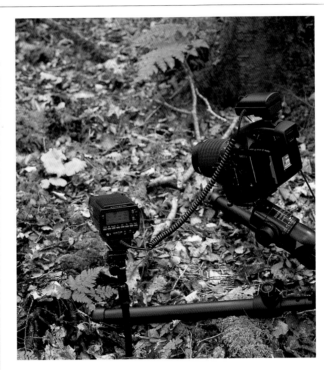

GROUND FLASH SPIKE

I made this up from a few simple components. It is extremely useful when photographing fungi and other static subjects where you require flash. The image above right shows the ground spike fitted with a hot shoe. It holds the flash exactly where I want it, freeing my hands and allowing me to keep my eye to the viewfinder. The image above left shows the flash in position and linked up to the camera.

- Plastic ground sheet. This is an important item when working in damp areas.
- Bean bag. This is useful when you want to get the camera right to ground level.
- Lowepro Pro Trekker AWII and Photo Trekker AWII photographic bags. I also have two custom-made bags with foam inserts.

Other kit

I also take these useful items out with me when I'm working in the field:
- Multipurpose knife
- Black tape
- Scissors
- Plastic self-sealing bags
- Blower brush and lens tissues
- Crocodile clips and string for holding back small branches
- Notebook for recording details of habitat, abundance and date, etc.

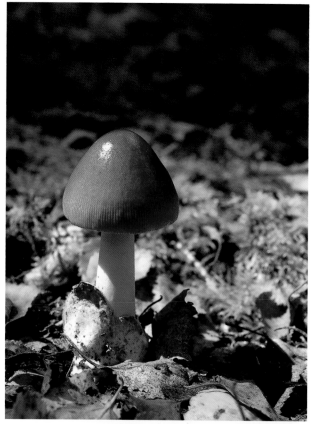

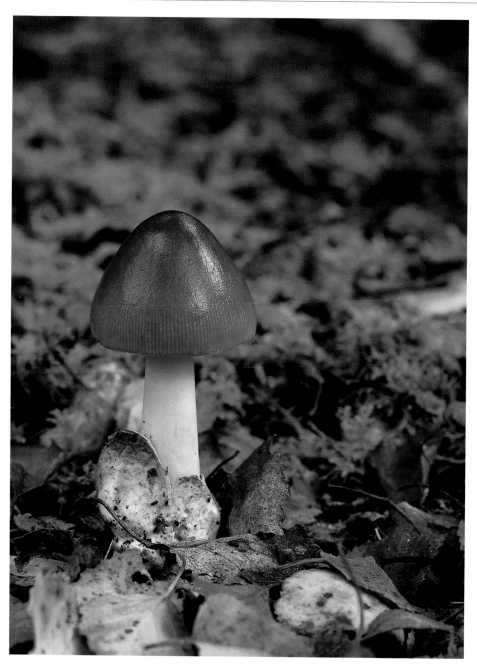

TAWNY GRISETTE *AMANITA FULVA*

A diffuser is an essential piece of kit for the macro photographer. Working in bright sunlight increases contrast and shadow detail, which in most cases does not make for pleasing photographs. We can't control the weather, but there are ways in which we can improve the situation. The image above left was taken in natural daylight without a diffuser. The image above was taken with the diffuser. The contrast is greatly reduced, producing a more balanced photograph. The image left shows the diffuser, a Lastolite model, in place.

Mamiya 645 AFD, 120mm macro lens, Fuji Velvia

Working with flash

Flash is an essential accessory for the macro photographer and is indispensable for certain types of photographs. Having an independent light source allows you to operate in difficult situations and achieve results that would be impossible using only natural light. Flash arrests subject movement and permits the use of small apertures combined with slow fine-grained films for maximum quality and saturation. It also helps to increase tonal contrast on film while adding additional sparkle and vibrancy to the image, especially in poor lighting conditions.

When it comes to photographing small active insects at higher magnifications, flash gives you total freedom and the ability to operate tripod-free.

PEACOCK *INACHIS IO*
I was photographing this butterfly in early morning and in heavy overcast light. I used fill-flash to increase the vibrancy and add a little sparkle to the photograph.
Mamiya 645, 120mm macro lens, fill-flash, Fuji Velvia

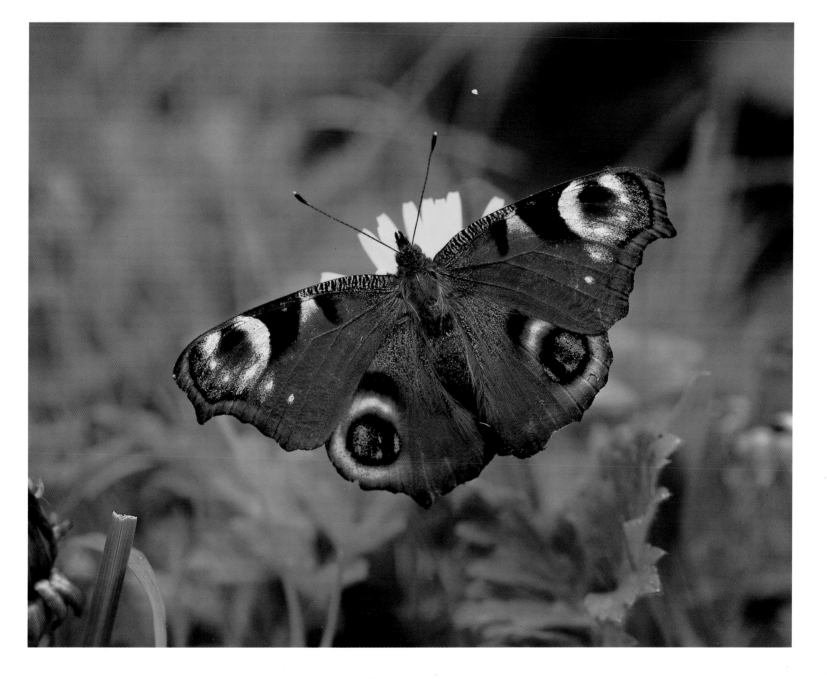

Even with today's sophisticated units, some photographers still have an aversion towards using flash. However, learning how to use and control flash is absolutely crucial if you are to progress as a macro photographer. Obtaining consistency in exposure with flash is one of the most common problems that photographers face. To master it, you have to understand how light works and the effect it has on the subject. Learning to recognize situations where flash can help improve the quality of the photograph is essential.

Despite the importance of flash in macro photography, its use does have some negative points; namely, harsh

FROSTY WEBCAP
CORTINARIUS HEMITICHUS
These two photographs illustrate the advantages of using fill-flash when conditions are far from perfect. In the image above, the harsh sunlight created distracting shadows on these small fungi. For the image left, I balanced the flash output to add just enough light to reduce the shadows without overpowering the photograph.
Mamiya 645, 120mm macro lens, fill-flash, Fuji Velvia

shadows and black backgrounds. These problems can be overcome or controlled with care and attention. Other criticisms levelled against flash in the past included the necessity of calculating your exposures manually and the unpredictability of the results. This hit-or-miss approach was a constant source of frustration for many photographers. Today's modern cameras, however, offer unprecedented levels of sophistication, and they have taken much of the difficulty out of calculating exposure with flash.

Beginners coming fresh to macro photography have greatly benefited from this innovative technology and have missed out on all the formulas and mathematical calculations that were the norm during the 1980s. Virtually all modern cameras support TTL flash to different levels of sophistication. If you still use an older camera system and you want to specialize in macro, I would advise you to upgrade your current system rather than working manually. As a medium-format user, I worked with a manual system for years with perfectly acceptable results. However, I no longer feel it necessary to do so.

Working with TTL flash

TTL flash works on the principle of reading the light reflected back from the subject at the film plane. A sensor located in the camera body analyses the light at the moment of exposure and quenches the flash when the correct value is achieved.

In theory, this sounds like the answer to a prayer – no more badly exposed slides or complicated procedures – or so manufacturers would have you believe, in any case. However, TTL flash, like any other metering system, is certainly not foolproof; you will first need to run some test shots with a mid-toned subject in order to establish what your baseline exposure is. In situations where your subject is distinctly lighter or darker, you will need to experiment and make the appropriate adjustments, otherwise your photograph will be over- or underexposed.

Remember also when working in aperture priority mode that you cannot alter your exposure by adjusting the aperture. Since the flash is the only light source, it will compensate by increasing or decreasing the light output accordingly. Adjustment can only be made by altering the autoexposure dial on the camera, or reducing the output on the flash unit.

Exposure problems can also arise if the subject is positioned off-centre or if it occupies a smaller portion of the frame in comparison to the background. Centre-weighted metering systems can be influenced by a larger background area, which often leads to the overexposure of your subject.

Many of the latest cameras, in addition to centre-weighted metering, use advanced metering modes, such as segmented or matrix. These use comparative analyses between selected areas of the frame to evaluate the exposure. It is essential to familiarize yourself with your camera and flash unit's instruction manuals in order to understand fully how they function together.

Using a flashgun

To benefit from TTL flash, you must use a flashgun that is specifically dedicated to your own camera. Many of the leading camera manufacturers make their own units. Some of the independent companies offer cheaper flashguns that will integrate with many leading camera brands with the appropriate dedicated module. I would advise you to buy the top-of-the-range unit made by your own camera manufacturer if you can; this will give you extra power as well as total integration with your camera.

When using flash outdoors, the manufacturer's guide number is no longer valid; consequently, the output value is much lower. If you intend to use a diffuser on the head of the unit the output is further reduced – hence the advisability for buying a top-of-the-range flash. Some independent units do not have total integration in all aspects, so check it with your camera before you purchase.

For medium-format users, Metz manufactures professional flash units that integrate via the appropriate SCA adaptor for Mamiya 645 Pro TL, Mamiya 645 AFD, Hasselblad H1 and Bronica. One advantage with medium format is that you can change your system without having to change your flashguns. They can be used with other camera systems with the appropriate module.

Having explained the basic concept of TTL flash, how do we get the best out of it? First of all, there are two methods of using flash. You have to familiarize yourself with the concepts of both and how to apply them properly to a given situation.

BONNET MUSHROOM
MYCENA SPECIES
By altering the ambient light and fill-flash ratio, you can make the flash more dominant without the background becoming too dark. I lit this subject from a low angle, creating a rim-like effect around the periphery of the mushroom head.
Mamiya 645, 120mm macro lens, fill-flash, Fuji Velvia

When working in close-up, placing the flash on the hot shoe causes problems. The close working distance between the lens and subject effectively blocks the light from illuminating your subject evenly. To rectify this problem, you need to work with the flash off camera. The ideal position for the unit is above the end of the lens, at roughly 45 degrees to the subject. You will need an off-the-camera flash cable and some sort of bracket to hold the flash precisely where you want it. Some photographers handhold the flash above the lens. I don't favour this approach as it's awkward and unbalanced; it can also affect your ability to support the whole assembly properly.

MADAGASCAN BULLSEYE MOTH
ANTHERINA SURAKA (**LARVA**)
In this example, I used full flash to freeze movement. You can see that the fall-off in light has produced a black background.
Mamiya 645, 120mm macro lens, flash, Fuji Velvia

Full flash

When we refer to full flash, we are talking about using flash as the major light source on the subject overriding the ambient light. This is generally the preferred method when we are working at higher magnifications and stalking small and active subjects. Most of the recent cameras have flash-synchronizing speeds in the region of 1/125 sec – this adequately freezes any movement and permits you to use slow ISO film and small apertures. Photographing active subjects in natural light would be impractical since the increased magnification would necessitate the use of slower shutter speeds, producing soft pictures.

On the negative side, full flash can produce black backgrounds and harsh shadows when used with small apertures. If used in combination with lower magnifications and at wider apertures on bright sunny days, the sun acts as a second light source and reduces the effect of flash fall-off on the background.

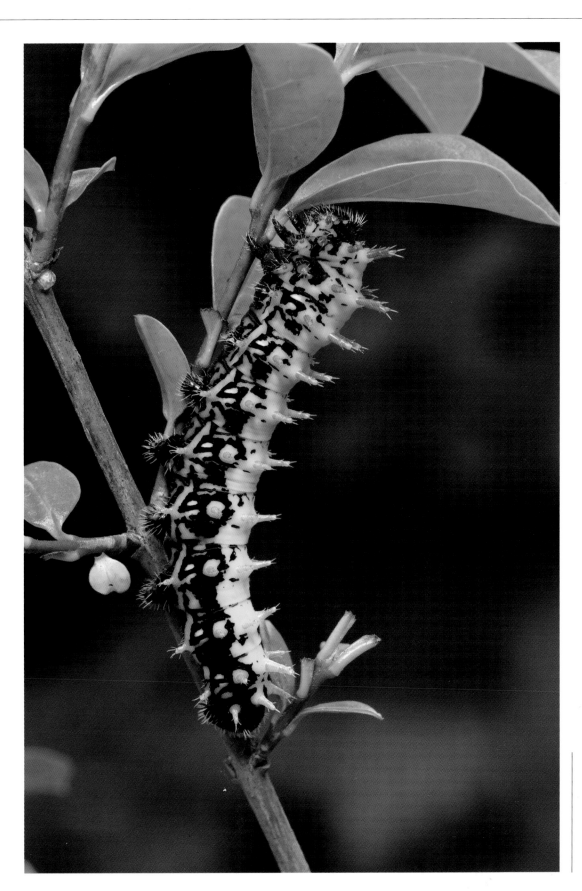

MADAGASCAN BULLSEYE MOTH
ANTHERINA SURAKA (**LARVA**)
*In this case, I balanced the flash with
the daylight. This gives a more pleasing
appearance overall and allows the detail
in the background to register.*

Mamiya 645, 120mm macro lens, fill-flash,
Fuji Velvia

Fill-in flash

When you photograph a subject using ambient light (daylight) as the major light source, and you decide to add flash to the picture, this technique of mixing flash and daylight is commonly referred to as fill-flash. The flash itself does not become the major light source; it provides supplementary lighting to the darker or shadow areas of the picture in a similar manner to a reflector. When applied correctly, it can be a useful aid in controlling contrast in photos on bright sunny days. It can also work in reverse by adding sparkle to an image in dull, overcast conditions when film colours often lack vibrancy and look flat. Unlike full flash, which is the main light source, fill-flash works in harmony with the ambient exposure.

One important issue to bear in mind when using fill-flash is the fact that you are not using flash to arrest movement, but to provide supplementary lighting to brighten the shadow areas of the picture. The controlling factor here is the lighting ratio; in other words, how much light to add. Gauging the balance between flash and daylight is often confusing to many people. In order to understand this concept, you must think of flash in terms of stops.

Many of the bigger brand names in flash offer what is called automatic fill-in, where the unit works in conjunction with your camera body. It decides the amount of flash to output. You can alter the intensity of light by adjusting the compensation dial to fine-tune the balance. Alternatively, you can alter the output directly on the flash unit in incremental values of one-third of a stop. You need to run some tests with your own camera and flash set-up, changing the values by increments of one-third to establish the preferred ratio. For example, when working with fill-flash digitally with my Kodak DCS Pro 14/nx, I normally reduce the output value on the Nikon Speedlight SB-80DX between –1 and –1.8. I find that most of the subjects I photograph work well within this range. For example, dialling in –1 on my flash unit means that it will output around one stop less light than the ambient reading.

Working with my Mamiya 645 AFD, my fill-flash settings are usually between –1.3 and –1.7. The higher setting works well when I am photographing fungi and moths in shaded woodland conditions.

It adds just enough light to increase the contrast on film. The correct application of fill-flash is achieved when you can detect only a subtle presence; it should not be too obvious.

When it comes to mobile subjects, fill-in flash has a more limited use. Photographing insects with fill-flash on an overcast day will only work if the subjects remain absolutely still. This is often difficult to achieve. Any movement will register on film, producing a second image commonly referred to as ghosting. Working in early morning and in overcast conditions, especially when temperatures are low, will present some opportunities. However, diligent searching is often required since many insects retire deep into the vegetation. Some photographers have recommended chilling subjects or subduing them with carbon dioxide. You will never obtain natural-looking images of active creatures immobilized in this way. If you plan on selling your work, this practice will be obvious to any experienced naturalist or entomologist, who can soon tell that the insects' postures are the result of unethical practices.

Flashgun size and position

There are two types of flash unit to consider: the large hammerhead type, or the smaller compact unit. In close-up and macro, size is less of an issue; lightness and adaptability are more important factors to consider. The smaller lightweight guns can be positioned up close to the subject. The actual size of the reflector appears large in comparison to the subject you are photographing and as a result produces a more diffuse, even light with softer shadows. One of the disadvantages is that the fall-off in light is more rapid with a smaller unit when positioned up close. Using high-powered units up close has several disadvantages, namely weight and holding the unit in the correct position so that it can illuminate the subject evenly. A heavy and cumbersome set-up is difficult to carry and to operate quickly and effectively.

Another important factor with powerful units is that they need to be positioned much further back from the subject. As a consequence, they produce a point light source that delivers strong directional light with much harsher shadows. However, unlike the small lightweight guns, the greater flash-to-subject distance means that the fall-off in light is less apparent with larger units,

MAIN FLASH UNITS
These are a few of the main flash units that I currently use for different set-ups. I use the Metz hammerhead units (left) mainly for tank photography. Their greater light output is useful when working at smaller apertures and with subjects that are in medium-sized tanks. I use the Metz MZ40 (top right) with the Mamiya AFD for general close-up work and the Nikon SB-80DX (bottom right) for my digital set-up using the 105 and 200mm macro lenses.

Commercial and custom-made macro flash systems

When photographing in the field, the last thing a macro photographer wants is to be burdened with complex set-ups and equipment that is either too fiddly to operate or that lets you down at the crucial moment. Throughout my photographic career, I have always made and modified equipment in an attempt to make life easier in the field. I have never quite found the definitive piece of equipment that answers all my needs. When it comes to flash systems and brackets, I have tried and modified many systems over the years.

Commercial macro flash systems are expensive. They offer convenience at a hefty price, but they also have shortcomings. Most commercially made units are generally underpowered and overpriced for what they are. Some of the earlier designs screwed into the filter threads of the lens, which made them less adaptable. The extra weight put additional strain on the lens mount. The shortcomings of this type of system become more obvious when using a longer focal length macro – or when you want increased lens-to-subject distance and need smaller magnifications. The flash units are now much further back and lack the output to light the subject adequately at small apertures. Since the flash units are normally fixed, you are forced into using wider apertures and consequently reduced depth of field.

If you own a Nikon, the SB29s macro flash unit has dual rotatable flash tubes, offering a choice of frontal or selected relief lighting. You can also adjust the light output ratio of each unit, which is quite a useful feature. However, the SB29s does not have digital TTL capability. You have to reduce the power manually when using it with a digital camera.

Few independent companies make flash systems. However, Sigma recently released a ring flash, the EM-140 DG, which is compatible with D-SLR cameras. It has similar features to the Nikon unit and is compatible with most TTL flash protocols from major brands such as Nikon, Canon and Pentax.

Commercial flash systems perform reasonably well at magnifications approaching life-size and above because the flash units are located close to the subject and appear large in comparison. However, flash fall-off at these distances will be more apparent, so backgrounds need to be fairly close.

NIKON SB29S IN THE FIELD
This unit is light and portable in the field. It works fine for magnifications around half life-size and up to 1:1 (life-size) if it is used in conjunction with the 105mm Micro Nikkor lens.

NIKON SB29S MACRO FLASH
This is currently the best of the commercial flash brackets available. However, it does not have digital TTL integration with any of the Nikon or Kodak D-SLRs, which means that you have to reduce the power output on the unit.

meaning that the background vegetation shows less of a differential in terms of exposure. Working with higher magnifications where the lens may be only a few centimetres from the subject can create problems in illuminating the subject evenly, as the end of the lens can sometimes obscure the light from the unit.

Where you position the flash unit in relation to the lens and subject is important, as it will greatly affect the outcome on film. The ideal position is just above the lens at about 45 degrees to the subject. This position is favoured by most macro photographers and delivers very acceptable results in most situations. It gives a pleasing sense of balance in terms of shadows, with most falling directly behind the subject. In the case of insects or other creatures, shadows will be more apparent with subjects that are resting on leaves or other vegetation than those that are clear or perched on the top of foliage. In most cases, the high axial lighting produced by the position of the flash is a suitable compromise irrespective of the position of the subject. Deviating from the vertical axis greatly emphasizes texture and detail, at the price of strong directional shadows, which do not make for a pleasing picture. In most situations, I prefer to use one flash. I seldom ever need to use a twin set-up in the field these days.

Custom-made flash brackets

If you like a challenge and you're an enthusiastic do-it-yourself boffin, you can construct your own flash brackets with a few bits and pieces from the nearest DIY store. The flash brackets illustrated on this page are based on my own designs. I have found these to be adequate in most field situations.

Commercial flash brackets are generally unsuitable for macro, as they do not allow the flash unit to be positioned close to the end of the lens, where the subject can be evenly illuminated. Placing your flash in the hot shoe causes problems with illumination. It also causes a parallax problem, as the lens is pointing at the subject while the flash is looking straight ahead.

The bracket illustrated on the Mamiya 645 Pro TL is constructed from a piece of light aluminium bar formed into a circle and secured to a small rectangular block by grub screws. Two lengths of bar protrude from the main block. Attached to them is a moveable platform that is secured to the base of the camera body. The length of the bracket is adjustable and will accommodate most lenses simply by loosening the screws underneath the block and sliding it forwards or backwards. There is provision for two arms that can hold two flash units if required, or alternatively it can be used with a single unit in any position.

This design allows the flash units to be moved into any position around the ring of the bracket, while still maintaining the flash-to-subject distance accurately. The front ring can be adjusted to variable lengths in order to accommodate different lenses. This design is attached to the camera body only and puts no additional strain on the lens mount.

I generally use this set-up when working at higher magnifications in TTL mode with a single unit positioned above the lens. This design has worked well and seems adequate in most situations. The vast majority of my work in the field is done with a single flash unit. I seldom use a dual flash set-up these days except when working indoors in the studio, or at higher magnifications where I can be more critical with the position of the lighting. One of the tell-tale signs of a twin flash set-up is a double highlight seen in the eyes of insects. This can look quite unnatural, but little can be done to avoid it.

Beetles and the transparent wings of dragonflies are highly reflective and prone to flare or flash 'hot spots', especially with a twin set-up. Some photographers diffuse the light emitted from the flash. You can purchase a plastic diffuser or, as a temporary measure, tissue paper secured with an elastic band will suffice. This softens the light and removes some of the harshness; the downside is a reduction in the output of your flash unit by at least one to two stops.

The other flash bracket, illustrated on the Kodak DCS Pro 14/nx, is made from an adjustable flash bracket found on a typical hammerhead flash, which normally attaches to the camera base. A flexible gooseneck is used for the main supporting arm, which can be bent in any direction. It is secured to the base by a bolt. A universal joint, commonly

KODAK DCS PRO 14/NX WITH UNIVERSAL FLASH BRACKET
I use this design mainly with the digital camera. If attached to a macro with a tripod collar, the camera body can be rotated for vertical framing without having to change the flash's position.

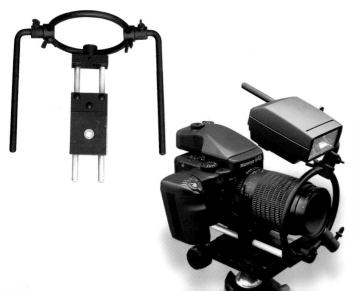

MAMIYA 645 PRO TL WITH FLASH BRACKET
This is one of my two custom-made flash brackets. I tend to use this design with medium format.

used on flash brollies, provides the flexibility and adjustment for the position of the flashgun. The cable is secured onto a custom-made base on the top of the universal joint. The flash connects via the hot shoe – I can raise or move the flash in any direction.

This simple design is easily constructed and will work with any make or model of camera. The base of the bracket is secured into the tripod socket on the base of the camera with the accessory tripod screw. You can get these from any good photographic shop. When finished, the whole unit is sprayed black with car accessory paint.

Ring flash units

These circular flash tubes have fallen out of favour in recent years. I never particularly liked using them, although many photographers recommend them as the ideal flash unit for macro. Ring flash units usually have a low guide number, lack power to illuminate all but the closest of backgrounds, and provide shadowless lighting that produces dull, flat and uninteresting photos lacking in texture and detail. They are, however, ideally suited for intra-oral photography in dentistry and medicine, where you generally require even and shadowless lighting.

HEDGEHOG
ERINACEUS EUROPAEUS
Working in heavy shade usually produces a green cast. Flash in these situations is extremely useful. It boosts the contrast and adds vibrancy to the image. I used the flash bracket to hold the gun in position so I could concentrate on the subject. Mamiya 645, 150mm lens plus extension tube, fill-flash, Fuji Velvia

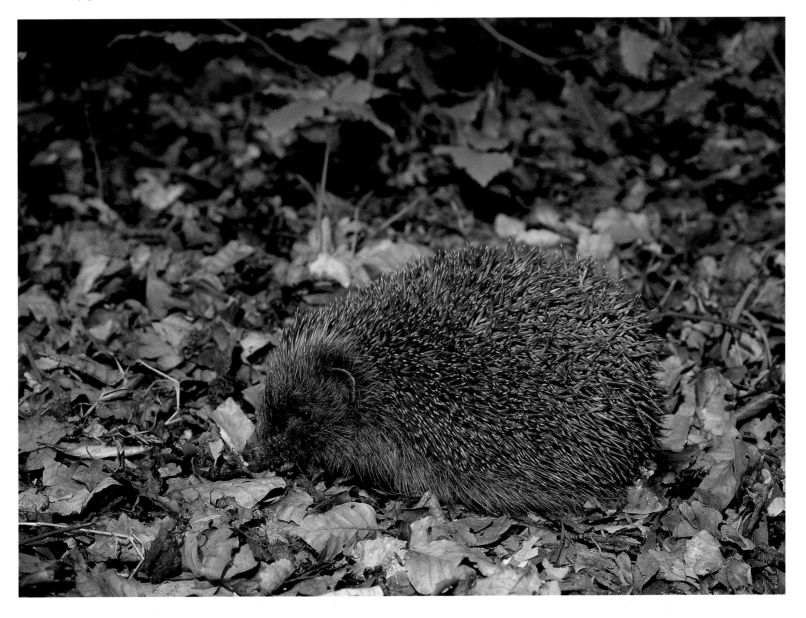

PART TWO

Putting it into practice

Composition and design

Being technically competent in your procedures and techniques is fundamental to producing correctly exposed photographs. However, this in itself doesn't guarantee visually dynamic images that captivate the viewer.

Composition is primarily about the arrangement of the components that constitute your image. How you organize these elements within the viewfinder frame will greatly influence the outcome and the pictorial appeal of the finished photograph. Overfilling the frame or placing a colourful subject such as a flower head in the centre often creates initial impact. However, central placement is often not the most dynamic or creative way to portray a subject. Lateral or asymmetric placement offers greater potential and creates a more visually pleasing composition that has greater impact.

Rule of Thirds

There are many theories regarding compositional do's and don'ts. Perhaps the most widely known of these compositional theories is the Rule of Thirds. Photography books often place particular emphasis on this well-known compositional rule, which originates from ancient Greece.

The concept is a simple one. By dividing the frame horizontally and vertically into thirds, the parallel lines form four key points where the lines intersect. Placing the main subject, or part of the subject, at one of these intersections is said to create a more visually pleasing composition with additional depth and impact. This alone does not guarantee a winning composition, however; lens selection, choice of aperture, film type and perspective are all important components that have a bearing on the end result.

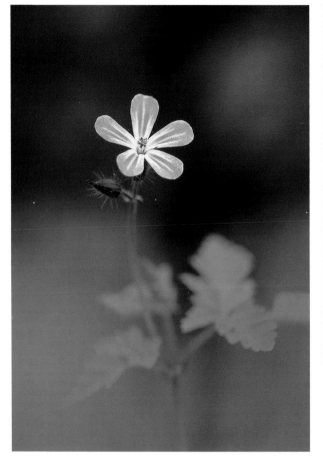

HERB ROBERT
GERANIUM
ROBERTIANUM
This pretty little woodland flower is a common sight throughout spring and summer months. What attracted me was its isolation from the rest of the clump. I wanted to emphasize the delicate nature of its flower and used a 2x teleconverter to increase my focal length and reduce the angle of view on the 120mm macro lens. I shot through the foreground foliage to create a soft blur and used selective depth of field to keep the background diffused.
Mamiya 645, 120mm macro lens, 2x teleconverter, Fuji Velvia

BROWN BIRCH BOLETE *LECCINUM SCABRUM*
Placing your subject off-centre often creates a more dynamic and interesting composition than positioning it in the centre of the frame. Asymmetric compositions tend to work in harmony better with the surrounding negative space.
Mamiya 645, 120mm macro lens, Fuji Velvia

Positive and negative space

'Positive' and 'negative' space are other commonly used terms in photography and art. These terms refer to the space within the frame. Positive space is, in effect, the subject itself, while the remaining empty space around it can be described as negative space. While there are no hard-and-fast rules about the association between them, or to how much of the frame each should occupy, both need to complement each other for a photograph to be successful.

The origins of many strong pictorial photographs stem from a simplistic approach. Developing an eye for subjects that produce the most attractive photographs is not a precise procedure that you can glean from a book – rather, it is the result of practice, experience, and a planned and methodical approach to your work. Inexperienced photographers initially lack this and tend to end up with visual clutter and confusion in their images.

It is important to identify your subject first, and to keep an open mind when it comes to framing and composing your shot. Keep your composition simple and avoid peripheral material that bears no relevance to your subject, as it may conflict with, or dilute the impact of, the final photograph.

Explore the subject in both vertical and horizontal formats. Many photographers habitually compose most of their photographs horizontally without exploring other options. If you don't believe me, look at a cross-section of your work. Viewing large numbers of images concurrently allows you to see and evaluate current patterns and trends in your work.

Vertical or horizontal

Vertical compositions are generally more uncomfortable to work with, as camera information in the viewfinder is more awkward to read and tilting the tripod head on its side also adds to the frustration. Perhaps our natural field of vision makes it easier for us to work in a horizontal format.

Whatever the reasons, be mindful when working on a subject and explore all the options. When I am carrying out commission work, I occasionally use a 6 x 6 format where appropriate, as it gives the client greater flexibility when it comes to design and layout. When using rectangular formats, I frequently shoot both; I can always analyse after processing. Adopting a flexible approach increases my potential for sales to prospective clients as I can offer them a choice.

When it comes to cover shots, vertical compositions dominate the magazine market. However, having said that, don't get too hung up on theories – develop your own style and approach. Don't feel that you must shoot every image vertically or horizontally; there are many intermediate positions. I have often heard the comment that vertical photographs convey greater impact than those taken horizontally; personally, I disagree. The structure and position of the subject is your best indication as to the choice of format.

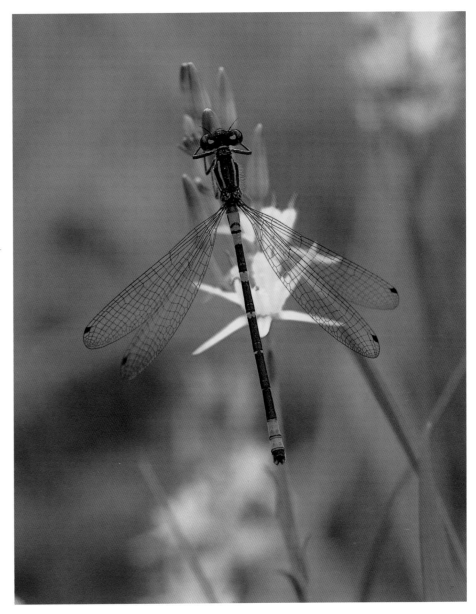

IRISH DAMSELFLY
COENAGRION
LUNULATUM
Long-bodied insects generally lend themselves to vertical framing. I photographed this mature male in early morning at the edge of a small pool using the monopod with an adapted spike, which I can push into the soft ground for extra stability.
Mamiya 645, 120mm macro lens, Fuji Velvia

Backgrounds

Many photographers underestimate the importance of backgrounds and how they can affect the overall impact of an image. This issue only becomes apparent when films come back from processing with out-of-focus highlights, blades of grass and other vegetation that have suddenly appeared from nowhere. An experienced photographer generally analyses the image carefully by scanning his or her eye around the viewfinder and using the depth of field preview to see how the final image will appear on film; most distractions can be identified and dealt with at this point.

Natural backgrounds

I prefer to photograph subjects against their natural backgrounds. Where possible, I try to incorporate the surrounding features into the overall picture. This makes the image more valuable, since it shows the subject in relation to its environment. There are

MOORISH GECKO
TARENTOLA MAURITANICA
I wanted to include some of the habitat where this species was resting. I used a short telephoto with extension tubes to increase my working distance.
Mamiya 645, 150mm lens plus extension tubes, Fuji Velvia

exceptions to this rule, of course; for instance, when photographing small insects using full flash on isolated flowers. The fall-off in light creates a black background unless there is vegetation sufficiently close to receive some light from the flash. I try to reduce this as much as possible by targeting subjects that have background foliage fairly close.

The problem is more easily solved when dealing with static subjects such as flowers and fungi – you have time to assess the lighting and background vegetation and its impact on the final image. It is good practice to analyse your subject and its surroundings before pushing the shutter. When working in the field, you have to learn how to deal with clutter and distracting elements in a background. When not in focus, they can often distract the viewer away from the main subject. A little judicious gardening or perhaps tying intruding foliage back from the field of view is all that's needed. Even a slight shift in position is enough to eliminate potential highlights, while switching to a longer lens often helps by reducing the field of view. You can use your depth of field preview button to assess how the final image is going to appear; this will often reveal elements in the background that might cause problems.

If your aim is to achieve poster-like images where your subject is isolated against a soft, diffused background, there are several things to consider. First, the position of your subject in relation to the background is important – vegetation in close proximity may appear partially in focus, causing a distraction. Try to select an angle that creates distance between your subject and its background. You still want to try to keep your camera back parallel to your chosen plane of focus to maximize on depth of field for the selected aperture. A soft, diffused background accentuates sharpness and detail in a subject, making it stand out. This effect is more naturally achieved in macro than in other types of photography, since the depth of field is so shallow that most objects are rendered out of focus. When photographing insects or similar creatures, always make sure that the eyes are sharp, even at the expense of the abdomen appearing slightly out of focus towards the tip. This is a more acceptable compromise. It does not matter how sharp the rest of the photograph is, it will be of no value if the eyes are out of focus. They are always the focal point of any photograph. With static subjects, reducing the magnification slightly may help.

FLY ORCHID *OPHRYS INSECTIFERA*
I wanted to keep the background well diffused to accentuate the two flowers on this orchid. I opted for a telephoto with a narrow angle of view and used extension tubes to reduce its focusing distance.
Mamiya 645, 210mm lens plus extension tubes, Fuji Velvia

ELEPHANT HAWK-MOTH
DEILEPHILA ELPENOR

These two shots illustrate what effect the background has on a subject. In the image below, I held back the surrounding stems with crocodile clips and used fill-flash on this moth, which had settled during the night in the honeysuckle beside the moth trap. For the photograph right, I changed the fill-flash ratio and reduced the ambient light by around three stops. The distant foliage was too far away to receive any light.

Mamiya 645, 120mm macro lens, fill-flash, Fuji Velvia

Artificial backgrounds

Some photographers choose to spray different coloured paints onto card to simulate out-of-focus backgrounds. This approach requires careful choice of colours that harmonize with the subject and that do not detract from the overall image. You can often spot these backgrounds, however – the light makes them appear different. Natural foliage in daylight varies tremendously in colour and shade, and when it is placed against an artificial background there can be obvious differences in the absorption of light that can be quite apparent in the finished photograph.

One important point to remember is that you need to produce a wide variety of backgrounds, or all your images will look the same. One method for creating artificial backgrounds is to photograph some vegetation out of focus and then either print it yourself or send it to a professional laboratory to have it printed and laminated. This offers protection to the print, although if you have several enlargements done, this can prove quite costly. They can also suffer from reflectance problems.

I don't recommend photographing against plain single-coloured backgrounds, although this was something that was fashionable some years ago, especially in studio photography. However, trends change and a much greater emphasis is now placed on photographs that are captured in the wild and show the subject behaving naturally in its own environment. If you want to sell your work, you will need to keep this in mind.

Black backgrounds

Black is perhaps the only single-coloured background that can be used effectively when you are trying to convey an artistic approach in an image rather than a conventional impression.

The easiest way to obtain true black is to use full flash precisely positioned to avoid lighting the background or to have your subject well isolated and away from any nearby vegetation. Trying to achieve pure black by artificial means is quite difficult. Sprayed backgrounds nearly always reflect light, making them appear greyish in colour on film. Black velvet is another popular choice, but any specks of dust or fluff can be quite apparent in the background.

Flash fall-off

The appearance of black backgrounds is a common problem when using flash in close-up photography. This is commonly referred to as flash fall-off, where the surrounding vegetation is outside the range of the flash to light. This has always been a contentious issue and one that has raised many debates. In my opinion, there is no right or wrong way; it's a personal decision, and if you find it acceptable then it's okay. However, having vast numbers of images depicting, for example, insects or flowers that look as if they have been taken in the middle of the night is repetitive and unnatural. I try to portray subjects in a way that reflects their habit or nature. I'm not saying that you can prevent a dark background in every case, but there are situations where it might work to your advantage, or there may be ways to lessen its effect. The following points may help in some situations, although not in all:

❍ If your subject is static, you might be able to place something appropriate behind it for the flash to illuminate. However, in most cases this necessitates placing it very close to the subject so sufficient light from the flash unit can illuminate it adequately. In some situations it may now be a partially out-of-focus distraction.

❍ In the case of active subjects, placing any type of background behind them is impossible to do in most cases, unless they remain still when at rest.

❍ Placing a second slave flash unit at the same distance from the background as the main unit is from the subject would result in the background receiving the same exposure. This is possible with many static subjects and also some insects that are at rest, providing that the background is not too far away.

❍ Using a more powerful flash unit positioned further away from the subject, thereby increasing flash-to-subject distance, will reduce the fall-off in light and show less exposure differential on the background vegetation.

❍ You could also use a wider aperture to compensate for the increased distance that the flash has to travel. The disadvantage here is the loss of depth of field. However, it does show less variation in flash exposure between background and subject.

Achieving consistency

Producing successful photographs time and again relies on a combination of many different factors. No photographer would claim to create visually stunning photographs with every push of the shutter. However, the success of any good photograph relies on the amalgamation of key photographic components, such as light, lens selection, a dynamic composition and, of course, an interesting subject. Getting all of these ingredients to gel in a single image is a tall order even for the most accomplished photographer.

Learning to recognize subjects that are pictorially or graphically strong comes with practice. As your perception and photographic skills develop, your ability to analyse the potential of a subject will become more focused and instinctive. Some photographers would

have you believe that luck is the key factor behind a great photograph. This is not strictly true. Luck may play a part, but only to a point. Having a discerning eye and being able to recognize the potential of a subject and how to portray it in a pictorial or graphic setting is where the real skill lies. Have you ever asked yourself why the best nature photographers produce good images time after time? The answer is simple: practice. This is fundamental to achieving consistency in your work. Empathy with the subject is also vital if you are to succeed, as is familiarization with your equipment and the execution of your technique – all three of these factors are inextricably linked.

For me, photography has always been about the end result; the means of documenting my encounter with nature. I have always been fascinated with the natural world, especially the hidden one that lies beyond our normal vision. Photographs express our inner thoughts; the results symbolize our emotional engagement with the subject. The most accomplished photographers are those who can successfully amalgamate artistic vision with technical competency. The latter, however, is where many photographers seem to fail. The reason is that the majority are what I term casual or sporadic photographers. They never progress beyond the point of elementary knowledge. Whatever information and experience they acquire is quickly lost due to lack of practice or periodic dormancy.

Evaluating your work

If you seriously want to develop your skills as a nature photographer, you must engage with your equipment frequently, evaluate your results critically and adjust your techniques accordingly. Competent photographers are masters of both aesthetics and procedure; they channel their thoughts and emotions into creating the picture without having to worry unduly about the technical aspects.

Photography is a continual learning curve for all of us. There are no short cuts that can be taken. It is only through practice that you can hope to master the techniques necessary to translate what you see correctly onto film or screen.

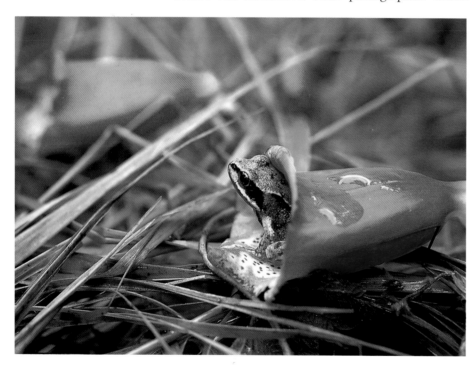

COMMON FROG *RANA TEMPORARIA*

This photograph is an amalgamation of luck and opportunity. I had been photographing foxgloves in a nature reserve near my home. It began to rain just as I was about to take my shots. I sat down beside the plant and noticed that one of the fallen bells was moving. I had assumed it was a bumblebee that had become trapped, as they sometimes do when entering the bell. I was about to pick it up when I noticed a tiny frog's head peering out from the bell. There was no time for a tripod, so I grabbed the camera, forced my elbows into the ground and managed two shots. The first exposure was the best in terms of appearance and position.

Mamiya 645, 120mm macro lens, Fuji Velvia



Finding subjects

One of the advantages of macro photography is that you don't have to travel far to find interesting subjects to photograph. The profusion of subject matter around us is inexhaustible. Who could look through a lens and not be captivated by the beauty and complexity of the miniature world?

The potential for artistic ingenuity is endless, restricted only by the photographer's imagination and creativity. Gardens, woodlands, meadows and wetland habitats provide the beginner with infinite opportunities to explore and experiment with various techniques. Being technically competent in itself does not guarantee success. Photographers who have a natural history background will always have an advantage; they will be accustomed to researching the behaviour and habits of their subjects. Having some elementary knowledge of the biology and habitat requirements of your intended subjects is vital, in my opinion, if you want to locate and portray them in a way that reflects their behaviour and surroundings.

Seasonal subjects

The macro photographer's year is varied and wide-ranging in terms of subject material. Like wildebeest, photographers migrate with seasonal change. Each season has its own character and specialities.

Spring heralds the start of the photographic year. Frogs and other amphibians reappear after hibernation and congregate at ponds and other wetland habitats. Increasing day length and water temperatures means that aquatic creatures become more active and move towards the shallows, where it's a few degrees warmer. Hibernating butterflies reappear and can be seen along with other early species on warm sunny days feeding at spring flowers and resting on stones and paths, where the temperature is a few degrees warmer. The air temperature is naturally cooler at this time of year, which can work to your advantage; many subjects are more tolerant of approaching photographers.

The arrival of summer marks the pinnacle in the macro photographer's calendar. Flowers are in full bloom and insect activity is at its peak. Butterflies, moths, dragonflies and a multitude of other small insects are copious at this time. With an abundance of subjects to choose from, many inexperienced photographers actively pursue their quarry on impulse rather than having a planned and methodical approach. The results are often as unpredictable as their methods.

As autumn approaches, insect activity quietens, and most species die off – with the exception of a few hibernating butterflies that persist in their activities until the cold forces them to retire for the winter. As the days lengthen and become cooler, many macro photographers turn their attention to fungi, which appear in large numbers and in all manner of shapes

FROSTED ANGELICA
ANGELICA SYLVESTRIS
Heading out early in the morning is often productive after a frost. The shafts of sunlight were just beginning to strike this seed head. I underexposed by one stop, keeping the background dark and the frost from overexposing.
Mamiya 645, 120mm macro lens, Fuji Velvia

COMMON SPANGLE GALLS

NEUROTERUS QUERCUSBACCARUM

Examining fallen leaves during the autumn will often reveal galls attached to the underside of the leaf. Here, the moss-covered tree trunk helped to accentuate the leaf and the galls.
Mamiya 645, 120mm macro lens, fill-flash, Fuji Velvia

WATER MEASURER

HYDROMETRA STAGNORUM

Early spring is an excellent time for photographing aquatic creatures. As the temperature rises, many species begin to emerge or move in from the deeper parts of the pond to the shallows.
Mamiya 645, 120mm macro lens, flash, Fuji Velvia

and sizes, in a wide variety of woodland habitats. Reflections in water and fallen leaves in a variety of shapes and colours also provide endless possibilities for abstract compositions.

The onset of early frosts quells the flush of fungi and things turn quiet for a while. During the winter months, photographic activity is reduced, but there are still good opportunities to be had. The dull, overcast days of winter work well for lichens and mosses, many of which produce fruiting bodies at this time of year. Early-morning frosts provide excellent opportunities for abstracts of frosted leaves and other vegetation embedded in ice.

I would urge you to keep your photographic activity up during these quieter months. It's easy to slip into apathy, as many photographers do, until the return of spring coaxes them out of hibernation. While the winter months may be less exciting in terms of subject material, they still have a lot to offer to those who like a photographic challenge.

Learning from others

Photography is never static; it is constantly changing. Whatever your level of expertise, there is always more to see and learn. Photographers who have mastered the technical essentials of macro, such as focusing, lighting, depth of field and flash, will want to emulate the masters of macro. Having the practical competency without understanding the subject won't guarantee inspiring images. The same can also be said for the naturalist who understands the biology and ecology of his or her subjects, but lacks artistic sense and sound photographic technique. The outcome is the same – a collection of images that are prosaic, with little or no artistic imagination.

There is a wealth of photographic talent about these days, so making your mark in the photographic world is perhaps more difficult than ever. Great photographs are the result of several factors, such as time, effort, a creative mind and patience. Developing your own unique style and approach in what you do is important if you want to be recognized. In order to achieve this, you must practise and study the work of other accomplished photographers. I sometimes feel that modern camera technology has taken much of the control and the learning process away from developing photographers. As a result, the importance of acquiring knowledge and understanding through experience and trial and error has taken a back seat. We all need inspiration at times. Looking at images in books and magazines is an important part of photographic development for everyone, no matter what your level of accomplishment. The fact that we buy photographic books and magazines every month bears testament to this.

There are more nature photography books published than ever before. The majority are one-off reads and mediocre in terms of interest and content. However, a few always stand out from the rest in terms of quality and content. Stephen Dalton, John Shaw and Frans Lanting are perhaps the best examples of photographers with exceptional abilities in terms of technical competency and artistic vision. Their work is the benchmark in their respective fields. One important fact that makes them different from the rest is their ability to convey a sense of empathy with their subjects; this quality is often lacking in many other photographs.

Knowledge and practice are fundamental to achieving great images. Avoid the old cliché of 'it's just a record shot', otherwise your filing cabinets will overflow with banal images that are lacking in any imagination and aesthetic appeal.

Scarce Swallowtail *Ephiclides podalirius*
While I was leading a photo tour in France, I stayed at a little hotel that had a few buddleia bushes in the garden. Several species of butterfly, including swallowtails, came there regularly to feed, a sight that offered me much enjoyment in the evenings. To capture this shot, I used the monopod for additional support and the flash bracket.
Mamiya 645, 120mm macro lens, Fuji Velvia

Travelling abroad

Travelling to foreign destinations has never been easier. However, planning a successful photographic trip requires careful research and good organization if you want to capitalize on your time abroad and justify your outlay. I normally plan my foreign trips each year well in advance. You need to define your purpose and identify the subject material that you want to photograph. Make a detailed checklist. If you want to shoot flowers or insects, you will need to gain information about sites and the optimum dates of flowering and flight periods. This information can be researched and accumulated during the winter months.

The Internet can be useful source of information, as can reference and guide books; they often provide information on localities and habitat preferences. Contacting the relevant embassy or other photographers who have visited the region can also be helpful.

LADY'S SLIPPER ORCHID *CYPRIPEDIUM CALCEOLUS*
This is probably one of the most beautiful and most photographed orchids in Europe. No matter how many times I see this plant, I still have the desire to photograph it again. Most grow in shady parts of the woodland, so a tripod and cable release are essential.
Mamiya 645, 120mm macro lens, Fuji Velvia

Make sure that you have obtained all the necessary documentation before you travel. For the beginner, visiting well-known counties or national parks is a good way to start. There are often booklets and leaflets available on most of the well-known regions, which may contain contact details and small maps of the area. Photographic magazines occasionally publish features on well-known photographic haunts. Contacting the national park's office is helpful – they can advise you on timing and any other relevant information. If you're still unsure, you can always join a photographic tour.

Airline restrictions

Airline restrictions on cabin baggage are one of the biggest problems facing photographers who work abroad. The days of taking large amounts of gear as cabin luggage are well and truly over. It takes very little equipment to exceed the miserly regulation of between five and seven kilograms. I sometimes use a photographic vest, which will carry additional lenses and other small accessories, or a regulation photo bag, which I can use to carry the most important items onboard with me as hand luggage. That way, no matter what happens, I can still function should the rest of my equipment be stolen or damaged.

No photographer ever feels entirely comfortable about placing his or her valuable equipment in the luggage hold. When I need to take large amounts of equipment with me, I use a Peli 1600 carrying case. It can withstand the rigours of the baggage hold. Some photographers place their case inside a larger suitcase to avoid attention and to thwart any potential thieves. Keep your luggage identification tags plain and refrain from advertising your profession or anything else that might draw attention to your baggage. Make sure that your insurance covers you in the event of theft during airline travel.

I remove all my film from their protective wrappers or canisters and politely ask for a hand search. I have been rather fortunate and have only been refused on a few occasions. Remember, having your film x-rayed once or twice at low power does not normally affect slow ISO films. However, increased scanning does have a cumulative effect.

Photographing flowers

One of the advantages of living in a temperate climate is seasonal diversity. Spring is often referred to as the season of renewal and regeneration, and is very much associated with flowers. Woodlands come alive with colour after months of dormancy; celandines, bluebells, wood sorrel and the early-flowering orchids bring welcome vibrant colour to the woodland landscape. This succession of colour continues well into the summer as other habitats reach their floral peak, providing opportunities for an array of photographic approaches, including portraits, close-ups, abstracts and coloured landscapes.

If you live near woodland or other similar habitat where wild flowers are found, then relatively little planning is necessary. You can monitor their progress and choose your own time, when weather conditions are ideal and plants are at their best.

Many photographers incorrectly assume that flowers, because they are static subjects, present little or no challenge when compared to photographing wildlife or other natural history subjects. This is not the case, however. Having spent many years working in both fields, I find photographing flowers and other similar subjects extremely challenging.

Approach and technique

Flower photography can be a frustrating experience, in which you are battling against the wind and other elements. There is no one method or procedure that works in every situation. Your approach and technique is largely dictated by the subject, its position, the weather and lighting conditions at the time, and the equipment at your disposal.

As you become more technically proficient, you will want to expand your horizons by travelling to photograph other species. Planning and preparation is an essential part of any trip if you are not to waste your time and money. Flowers are ephemeral, and timing is crucial if you want to be there at the peak of the flowering period. If you plan your visit poorly, you may have to wait until the following year for another opportunity. In addition, you have to be aware that weather and seasonal variability all affect the flowering times of plants.

I have a particular interest in orchids and often visit Europe and the Mediterranean in early spring. I plan my trips carefully, drafting a checklist of key species that I want to photograph. It's important to research likely sites and the flowering times of the plants you want to see prior to your visit. Many botanical journals publish accounts of field trips to various countries, particularly ones in the Mediterranean region. There are also a number of field guides available for Europe

WOOD-SORREL

OXALIS ACETOSELLA
I took this shot in a hazel woodland in spring. Droplets had formed from very light mizzle. I took several shots to be sure of success, as this plant vibrates in the slightest breeze.
Mamiya 645, 120mm macro lens, Fuji Velvia

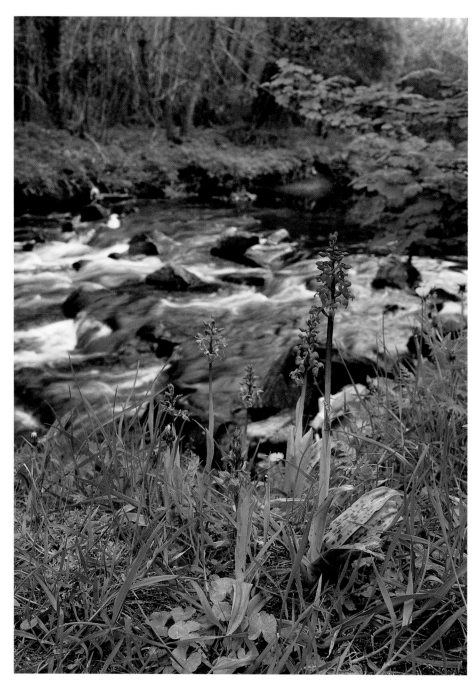

CRETAN TULIP *TULIPA CRETICA*
When photographing abroad, you have to deal with the conditions at the time. The bright sun was creating heavy shadows on the ground. I used fill-flash to reduce the contrast and underexposed by half a stop.
Mamiya 645, 120mm macro lens, fill-flash, Fuji Velvia

Selecting the right subject

Initially, it may seem absurd to talk about finding the right subject to photograph when standing in a field surrounded on all sides with numerous possibilities. Many inexperienced photographers rush around producing frame-filling portraits of everything they encounter, not paying much attention to the condition, position or pictorial qualities of the plant. Selecting subjects that make good photographs is more difficult than you might think. Inexperienced photographers often settle for the first plant they see; I have fallen into this trap many times myself, having shot a roll or two of film on a subject only to walk further on to find a much better-looking specimen in a more ideal setting.

Before you squeeze the shutter button, step back for a moment and consider some important points relating to the subject you're about to photograph.

EARLY PURPLE ORCHIDS
ORCHIS MASCULA
I spotted this clump of early purple orchids at the edge of a river bank. I used selective depth of field to keep the stream just out of focus.
Mamiya 645, 80mm macro lens, Fuji Velvia

and the Mediterranean that give the flowering times for orchids and other well-known plants. Popular botanical haunts like Crete, Corfu and Cyprus have specialist publications with information on localities that are good places to begin your search. The roadside verges in many of these places often have an abundance of the more common species and are worth investigating. Knowing someone who has experience of the area is useful; they can advise you on the best time to visit.

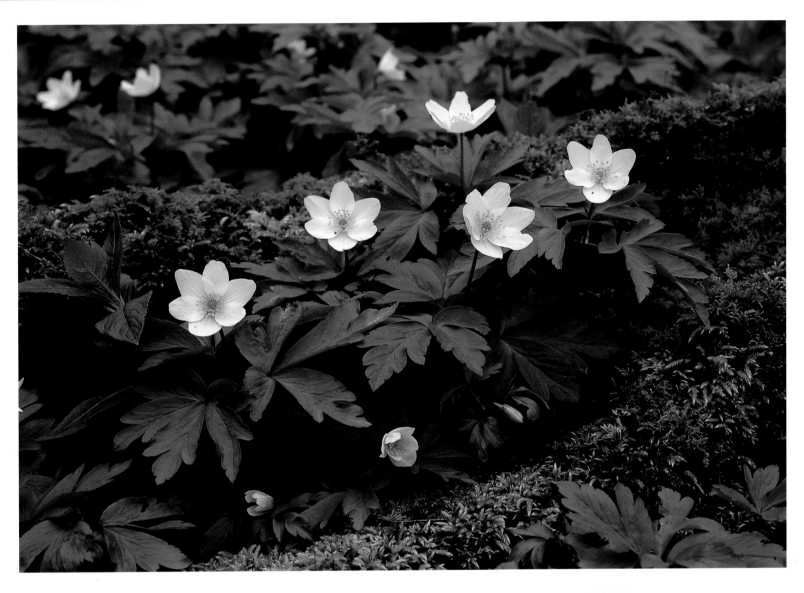

Professional tips

- Explore your subject from all angles, including close-up; pay particular attention to the background.
- Select plants that are in their prime and that are growing in a good position that makes for a strong composition.
- Cluttered backgrounds conflict with the subject and lead your eye away from the focal point.
- Mark the position of suitable plants to save time trying to find them again.
- Flowers growing amongst grassy vegetation will produce multiple shadows when exposed to direct

sunlight. Pale-coloured flowers also burn out in these conditions and may require the use of a diffuser.
- As a rule I don't do much gardening around the subject; I will, however, remove light-coloured foliage and any other distracting bits of vegetation, which might cause an unsightly highlight in the background.
- Check your depth of field preview to access the final image before you expose it. As your experience grows, you will devise a more logical and systematic approach to your flower photography.

WOOD ANEMONES

ANEMONE NEMOROSA

Choosing the right subject when confronted with hundreds of plants can be perplexing. I spent 15 minutes looking at dozens of plants before I came across this attractive group. A persistent light wind forced me to take practically a whole roll of film to ensure that I had at least one or two acceptable shots.

Mamiya 645, 80mm macro lens, Fuji Velvia

part of the flower with minimum depth of field to emphasize blur. This seems a contradiction to the sharp, well-exposed images that were deemed to be the norm not so long ago. Working at higher magnifications (beyond half life-size) opens up a new possibilities. We begin to see the bizarre forms and floral structures that are normally beyond our field of vision. In contrast, early-morning dew and light rain can produce interesting results, while slow shutter speeds accentuate movement and create multiple images. Blue skies, which are not conducive to close-ups, make an interesting backdrop for mass floral shots, adding colour and vibrancy to landscape images.

Choice of lens

Other factors that will affect the final image on film include the camera format, focal length of the lens, the selected aperture, lighting and film. Your choice of lens will largely dictate the type of photograph that you wish to capture. Telephotos are ideal for creating portrait shots of flowers, as their flattened perspective and narrow angle of view help to isolate the subject from its background.

Zooms are a useful alternative to fixed focal length lenses; their variable focal length offers a more precise approach in terms of cropping and composition. They also prove useful for photographing plants growing in inaccessible areas, such as cliff ledges, rivers and other wetland habitats. Wide-angle lenses are ideal for depicting plants in relation to their habitat. The conventional approach is to photograph them from a low angle, usually with the plant offset to the left or right, showing the habitat as an attractive backdrop. When used close up, wide-angle lenses distort normal perspective. Subjects that appear closest to the lens are exaggerated and seem larger and out of context in relation to the rest of the picture. With flowers, this embellished approach can be used effectively, especially if you shoot from a low viewpoint.

Recording colour

In the vast majority of cases, the colours of most flowers reproduce well on transparency film. However, certain blue flowers – bluebells in particular – are especially difficult to record accurately. The vivid carpets of blue that make woodlands so attractive during early spring often appear to be tinged with pink on film. This is because many blue flowers reflect more red and infrared light. Since our eyes are more sensitive towards blue light than red, we tend to see the flower as blue. Film in general is more sensitive to red light, hence the pink or mauve tinge that appears in the photographed flowers.

There are various ways of approaching the problem. Photographing in early morning in overcast conditions is one suggestion, since this lighting normally has a blue cast. If you are photographing the flower in close-up, you can use a diffuser to change the colour temperature. You could also try a pale blue colour-correction filter. However, bear in mind that it will have an effect on other colours within the image.

Using a tripod

I would strongly recommend that you work from a tripod at all times if you want to achieve consistency in your work. Use a cable or electronic release to reduce the risk of vibration.

When it comes to lens selection, a macro is an ideal choice if you are contemplating doing any plant photography. Having the benefits of continuous magnification is a useful feature, since you will not have to continually add and remove extension tubes – something that can affect your composition. Aim to use a macro lens with a focal length of around 100mm; avoid the shorter 50mm lenses. A longer focal length will give you a greater working distance and variable magnification up to 1:1 or life-size with virtually all of the latest lenses. This will allow you to vary your photographic approach by taking portrait shots, close-up studies of individual flowers and abstracts.

If you can't justify the expense, don't despair, as there are alternative ways of making the lenses that you have focus closer. Supplementary or close-up lenses (see pages 37–39) produce reasonable results if used with zooms at smaller apertures for flower portraits. Extension tubes (see pages 44–45) are another alternative. They can be used singularly or in combination with prime and zoom lenses for increased magnifications. Remember when using them on zooms that you will have to refocus each time you zoom, since you are changing the focal length of the lens.

Other essential accessories are a diffuser and a reflector for controlling natural light, and a polarizing filter to reduce reflections on shiny vegetation and to increase colour saturation. You should also carry a flash unit

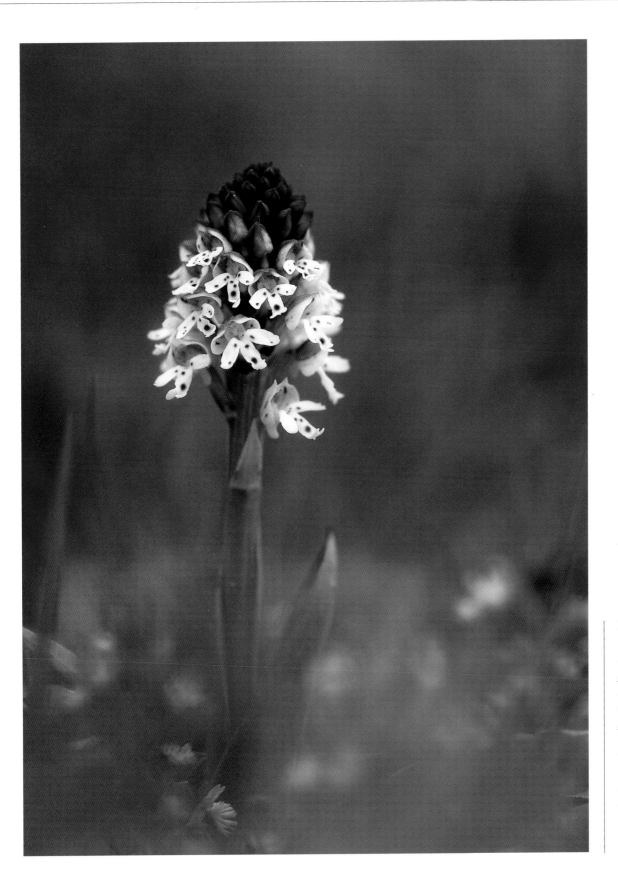

BURNT ORCHID
ORCHIS USTULATA
I often spend time in France photographing orchids in the late spring and early summer. I was attracted to a number of stunted plants in a small nature reserve in the Averyon. I had the camera virtually on the ground and shot through a profusion of milkwort to create a soft blur. I used selective depth of field to keep the background diffused.

Mamiya 645, 210mm lens plus extension tubes, Fuji Velvia

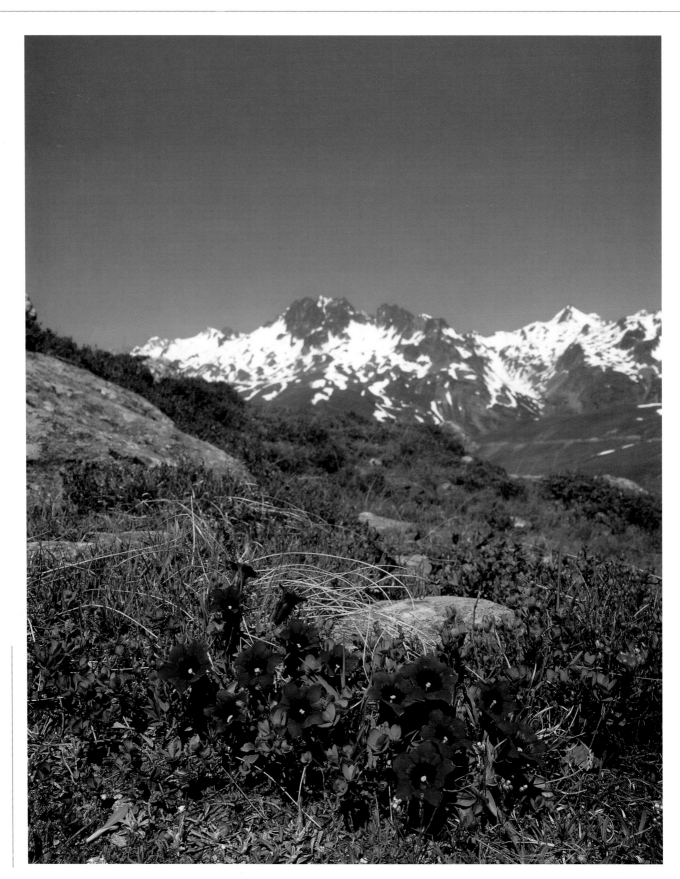

**TRUMPET
GENTIANS**
GENTIANA CLUSII
*I often use a wide-angle
lens to illustrate plants
in relation to their
natural environment.
This works especially
well when you have an
attractive backdrop,
such as the French Alps
in this case.*
Mamiya RZ67, 50mm
wide-angle lens, Fuji Velvia

at all times for reducing shadows and contrast. Make sure it's a dedicated unit that integrates fully with your camera.

Dealing with the elements

One of the biggest problems facing any macro photographer when you photograph in natural light is wind and subject movement. This is especially the case when photographing flowers. There are no magic solutions that work in every situation, but I can offer some suggestions that might help.

Light, intermittent winds don't pose too much of a problem, since there are always brief pauses in between breezes. I often use a home-made wind shield constructed from heavy clear polythene that I hold in position with light aluminium rods. This can be effective in light winds and when the plant is quite short.

The Lastolite Cubelite is another useful piece of equipment that can help you to overcome wind movement. It can be used effectively on bright sunny days; it helps to scatter harsh directional light, thereby reducing the contrast on the plant.

PORTABLE WIND SHIELD
In temperate climates, there are few days when you get absolutely perfect conditions to photograph flowers. In a light breeze, a wind shield will often help. I constructed this one using plastic sheeting and aluminium rods that screw together. The whole thing when packed fits into a small bag 45cm (18in) long. In bright conditions, I can also hang on the reflector to bounce light back into the shadow areas.

LASTOLITE CUBELITE
This is a one-piece device that folds down into a bag. I made a few modifications to the cube to make it suitable for the field. I also added loops on the base so I could peg it to the ground. You can also remove the back to shoot straight through. It works okay with small plants and in conditions where there is only a slight breeze. It is also useful in sunny conditions, as it acts like a giant all-round diffuser.

STEM STABILIZER
This is a useful device when photographing flowers in close-up. It's constructed from a small gooseneck with a crocodile clip with the teeth flattened to prevent them from perforating the stem. It can be placed just outside the field of view and keeps the flower head steady in a light breeze.

Another useful device is what I refer to as a stem stabilizer. It's a simple device with a spike attached to a small gooseneck and a crocodile clip with the teeth flattened so as not to damage the plant stalk. The clip is placed below the flower head just out of the frame. It can be quite effective and will save you time waiting for that momentary pause in the wind. The same effect can be achieved using two small forked branches from a nearby tree. Remember there is little you can do when faced with persistent wind or rain, except stay at home and try another day.

Professional tips

- ○ Experiment with flowers in the garden first to perfect your techniques and make notes on different set-ups to help with the evaluation of your images.
- ○ Don't photograph the first plant you see; explore the surrounding area first. Chances are that there will be other, better plants nearby.
- ○ Explore the flower from all angles and pay attention to the background behind the plant.
- ○ Keep the camera back parallel to the subject to maximize your depth of field.
- ○ Check your depth of field preview before you push the shutter.
- ○ Keep gardening to a minimum and survey the area around the plant for any distracting debris.
- ○ Plan your trip in advance and check the flowering times of plants to save disappointment.
- ○ Explore areas close to home or visit local nature reserves. The warden will be able to advise you on what plants occur in the reserve.
- ○ Check out coastal habitats and roadside verges where the vegetation is not affected by artificial fertilizers.
- ○ If you are unfamiliar with key sites in your area or require information on specific flowers, your local natural history society will be able to provide checklists or recommend good botanical areas that you can explore.
- ○ Pay particular attention to the weather forecast. There's no point in making a long journey if it's blowing a gale.
- ○ Be conscious of the adjacent flowers and the surrounding vegetation, which are easily flattened when photographing a subject. Try to keep your disturbance to a minimum – this is especially important in public places.
- ○ It is a useful exercise to record some details about the flowers such as location, date, and the flowering condition. This will prove useful if you want to return to the area at some time in the future.
- ○ Achieving good images of flowers is not merely down to luck; timing, perception, a good artistic sense, and imagination are the real secrets.

WOODCOCK OPHRYS *OPHRYS SCOLOPAX*
I wanted a frame-filling close-up shot of the individual flower of this orchid. I added an additional extension tube to the macro lens to take it above life-size.
Mamiya 645, 120mm macro lens plus extension tube, Fuji Velvia

Photographing insects

Insects are the most successful and abundant creatures in the world. They are extremely adaptable and have succeeded in occupying virtually every type of habitat on the planet. Their diversity in size, shape and colour provides endless scope for photographers. Butterflies and dragonflies are perhaps the most challenging insect subjects, but they are extremely popular among photographers because of their beauty and their dazzling array of colours.

All insects are cold-blooded, which means that essential activities such as feeding and courtship are controlled by the ambient temperature and the weather. Many insects have a tolerance zone; when you invade this space, their perception to any sudden movement is heightened. Bright sunny days with high temperatures means increased activity, which in turn means that insects are more abundant and easier to see. They are also more wary and difficult to approach. Photographing in these conditions can be quite challenging even for experienced nature photographers. Many insects have a very close association with particular plants; most are inextricably linked to them through the various stages in their lifecycle. Insect distribution in most cases is controlled by climate and the availability of their food plants.

Approaches to insect photography

Achieving high-quality photographs of insects can be extremely challenging and time-consuming. Many conservationists and entomologists are of the opinion that the only ethical way to photograph insects is in their natural environment. This is the best approach, in my opinion, and it works for most larger insects.

The studio, however, is the best option when you want to have total control over lighting and the final appearance of the image. It is the best approach when high-magnification shots are required of tiny subjects or parts of their anatomy.

Working in the studio is also useful for documenting the life histories of different species. You can rear them and photograph them in controlled conditions, thereby attaining a level of consistency throughout all of the shots. Studio photography requires a lot of preparation to achieve the desired result, however.

COMMON HAWKER *AESHNA JUNCEA*
Insects can be difficult to approach at the best of times. Dragonflies are by nature extremely wary. I often use short telephotos combined with extension tubes to increase my working distance and my chances of success. This male had settled in the vegetation beside a small sheltered pool.
Mamiya 645, 210mm lens plus extension tubes, Fuji Velvia

AUTUMN HAWKER LARVA *AESHNA MIXTA*
The studio is the best place for photographing aquatic creatures, as you have total control over the structure, lighting and composition of the image. The eyes of this dragonfly larva are large and designed for hunting. The shot was lit using two flash units placed at each side of the tank.
Mamiya 645, 120mm macro lens, two flash units, Fuji Velvia

Photographs of insects taken in their natural environment usually look much better than contrived studio shots. Many indoor photos portray the subject placed on plants or against a background that is not in keeping with the subject's normal environment or behaviour. This is often evident in images taken by inexperienced photographers, who just use the nearest available plant. In any case, the emphasis now in nature photography seems to be on showing the subject in the context of its natural habitat. Having a basic understanding of the biology and the needs of your subjects is fundamental to producing good photographs in the field or the studio. There are no magic formulas or quick solutions, just perseverance and dedication. Failure to recognize your shortcomings will be reflected in the images you produce.

Finding subjects

Many insects have a relatively short flight period – in some cases it is only a few weeks in any one year. Obtaining information in advance on known localities will save you valuable time in searching areas that may not be productive. Inexperienced photographers often try to photograph every type of subject using every technique, in one short season, which just leads to frustration and disappointment. Concentrating on one group at a time is a more rational approach; it will help you to gain experience and confidence in using your equipment.

Insects in your garden

A good place to start photographing insects is your back garden. Planting flowers and shrubs that attract butterflies will provide opportunities to experiment and refine your techniques. Most gardens will support only a limited number of species, most of which are casual visitors in search of nectar and members of the opposite sex. Checking plants in early morning can often be productive; some of the common species that frequent gardens often rest overnight. Check positions where the early-morning sun will light first.

If you're interested in photographing other species, visit the appropriate habitats where their food plants occur. Each habitat type supports its own range of species. Woodlands and coastal grasslands generally contain the greatest diversity of species, especially areas where the vegetation contain no artificial fertilizers.

GOAT MOTH
COSSUS COSSUS
This moth is one of the largest species found in the UK. The larva bores into the wood of trees and may take several years to reach maturity. I found this adult very early in the morning at rest on part of an old tree trunk close to the light trap. Moths often settle close to the light but don't always enter the trap. If you rise early in the morning, you can photograph them where they rest before the sun forces them to seek cover. The light was quite low, so I used fill-flash to add a little vibrancy to the photograph.

Mamiya 645, 120mm macro lens, fill-flash, Fuji Velvia

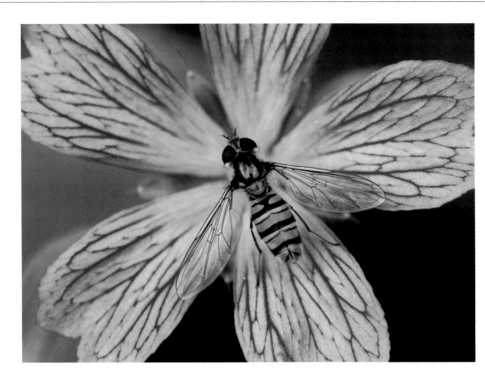

HOVERFLY *EPISYRPHUS BALTEATUS*

The geraniums in my garden were attracting several hoverflies. I took a few shots with the digital camera and made a few adjustments. Once I was happy with the result, I waited until they returned. I used flash and a telephoto macro mounted on the tripod for extra working distance.

Kodak DCS Pro 14/nx, 200mm Micro Nikkor lens, ISO 160, Raw format converted to Tiff

Baiting is another useful method of attracting insects. Placing decaying fruit in an open area in your garden will often attract several species of butterfly and other smaller insects.

Moths and butterflies

Moths, like many other insects, are attracted to light. Some are common visitors to gardens; many of the larger species, like the Hawk-moths, are eagerly sought after by photographers because of their attractive colours. A strong light from an open bathroom window during a warm humid night in summer will often attract moths and other insects inside. Many entomologists conducting research on moths use a Robinson light trap, either powered from a generator or the mains via a choke. This is a highly effective method for obtaining specimens. However, moths often get damaged in the trap, which renders them unsuitable for photography.

Placing a light trap in an open area in woodland close to the trunks of trees is a good method of obtaining photos of resting adults that have not entered the trap. The drawback is that you have to get up very early in the morning to examine the light trap and the nearby trunks for adults, before the sun forces them to seek shelter. It is a misconception that all moths fly at night. There are many species of moths that are day-flying and that occur in similar habitats to butterflies.

The larvae of butterflies and moths tend to be more elusive than their adult counterparts. Some are occasionally found by chance, but the majority remain concealed and are seldom ever noticed. With a little knowledge and practice, you can find some of the more common species by carefully examining the leaves and

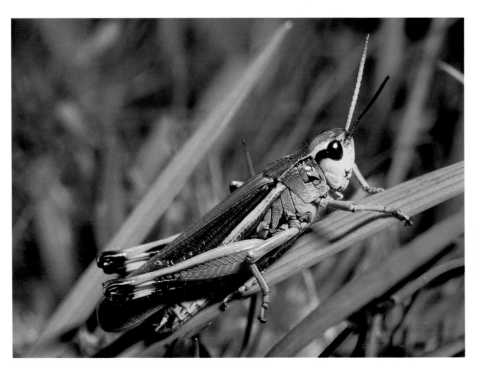

LARGE MARSH GRASSHOPPER

STETHOPHYMA GROSSUM

Grasshoppers can sometimes be difficult to locate. If you move in close and then watch where they jump, you can often get a reference point. Here, the sunlight was directional and produced quite a noticeable shadow. I used the flash bracket handheld to photograph this adult male specimen.

Mamiya 645, 120mm macro lens, flash, Fuji Velvia

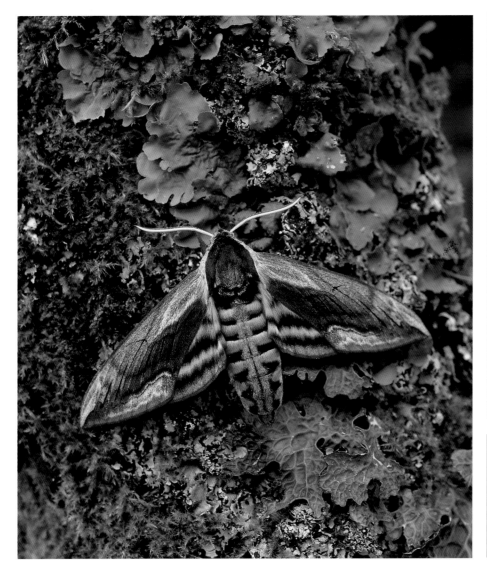

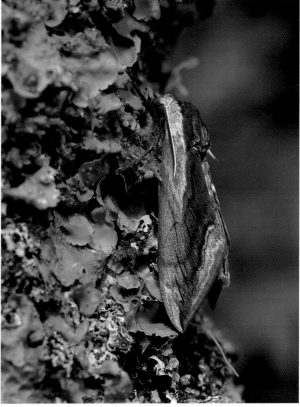

PRIVET HAWK-MOTH *SPHINX LIGUSTRI*
This large moth is occasionally found in gardens. When in its normal resting posture, as in the image above, it folds its wings tightly over its abdomen and tucks its antennae along its body. For the image left, I touched the head of the moth with a blade of grass and it assumed its threat posture, revealing the vibrant pink and black banding on its hindwings and abdomen.
Mamiya 645, 120mm macro lens, fill-flash, Fuji Velvia

branches of small trees and shrubs. The most productive time is generally from late spring until early autumn.

Some entomologists collect the larvae of many butterflies and moths and rear them through the remaining stages in their lifecycle. This is an interesting approach to take, since you learn about the biology of your subject and at the same time document all of the stages photographically.

Dragonflies

Many people consider dragonflies to be one of the most attractive insects. Their iridescent colours and aerial skills are captivating to watch. Creating a garden pond will attract a few common species, but most require specialized wetland habitats for their survival. Bogs, ponds and other pristine wetland habitats are the best areas in which to see and photograph dragonflies. Visiting a site very early in the morning and examining the vegetation carefully around a small pool or the sheltered bay of a lake will often produce resting adults from the night before.

Damselflies are more frequently encountered than the larger dragonflies. They often rest communally and are much easier to find. If the temperature is below the threshold for flight, these insects remain grounded until the air temperature rises, which means you can move in close and, in most cases, use a tripod. Wetland habitats harbour many other types of smaller aquatic insects, which, due to their behaviour and activity, will require flash to arrest movement.

WHITE SATIN LARVA
LEUCOMA SALICIS
Trying to photograph caterpillars can sometimes be a frustrating experience. Once disturbed they start to wander and can take quite a while to settle down again. I find the best approach is to leave them alone and let them settle naturally. Only when they feel comfortable with their surroundings will they settle down.
Mamiya 645, 120mm macro lens, fill-flash, Fuji Velvia

There are many other insects that are equally attractive but, due to their smaller size, are less well known. These include beetles, hoverflies, mayflies and leafhoppers. Many of these insects can be found when they are visiting flowers or resting among vegetation and are well worth pursuing.

Photographic suggestions

There are many approaches to photographing insects; there is no one technique that works for every situation. There are many factors to consider, such as the size and habits of the insect, the equipment at your disposal, and the weather conditions at the time. Watching the behaviour of different insects is fundamental to achieving good photographs in the field. Many butterflies and dragonflies, for example, exhibit characteristic behaviour, so patience and careful observation will often reveal their habitual patterns. Some butterflies have a preference for certain flowers and will ignore others, while certain dragonflies habitually return to the same prominent perch beside a stream or pond. Even a basic understanding of the behaviour and habits of your subjects helps to improve your chances of success.

It is worth searching ground vegetation for larger insects on dull overcast days when the temperature is low. Many larger species often rest concealed among the leaves and foliage. It is often possible to work your subject with a tripod providing you don't hit adjacent vegetation. If this happens, the subject often drops deep into the vegetation. At higher temperatures, insects become more active and difficult to approach. Some photographers have in the past covered the surrounding flowers to try to encourage an insect to a particular plant where they had pre-focused. Targeting other insects that rest for long periods of time on the vegetation may be more productive, especially when perfecting your techniques. Some shots are a combination of chance and luck, however; many experienced insect photographers would say it's a combination of fieldcraft and observation.

Using a monopod

Switching to a monopod is one option worth considering when working in difficult terrain. It will give you greater mobility and provide additional support to the camera. It can prove useful with larger insects such as dragonflies, which tend to perch near the top of the

Grasshoppers and crickets

Other insects that make interesting subjects include grasshoppers and crickets. They are essentially summer species and can be found in a variety of habitats. They spend most of their time amid dense vegetation. The easiest way to locate them is on warm sunny days, when the males sing by rubbing different parts of their body together. This behaviour is known as stridulation. The distinctive sound is unique to each species; with experience, you can learn to distinguish between them. Disturbing them from the low vegetation and trying to encourage them into shorter, more open, areas where photography is easier is a better approach – you are less likely to have distracting vegetation in the foreground.

HONEYSUCKLE MOTH *YPSOLOPHA*

DENTELLA

Micro moths are generally nervous little insects to photograph – any movement in the surrounding vegetation usually means a hasty exit. Here, I used a long focal length macro, which gave me greater working distance and meant less chance of hitting the surrounding vegetation

Mamiya 645, 120mm macro lens, fill-flash, Fuji Velvia

vegetation where the heat reflection is reduced. Using a slightly faster film will give you an extra stop, which will help to keep your shutter speed up. Naturally, there are always trade-offs that have to be made. Using the monopod ties you to lower magnifications and certain aperture/shutter speed combinations. You may also need to switch to a higher ISO film.

Longer focal length lenses

If you plan on doing a lot of insect photography, you should consider a longer focal length macro lens. It will give you a greater working distance between camera and subject and a reduced angle of view. This is useful when you want to isolate a subject, or create a soft diffused background. A cheaper alternative is to use a short telephoto with an extension tube (see pages 44–45). They can deliver excellent results if they are used for larger subjects.

COMMON COCKCHAFER BEETLE *MELOLONTHA*

MELOLONTHA

These insects are found mainly in woodland, hedgerows and gardens. They swarm around trees and are attracted to light, often crashing into windows. Since the wing cases of many beetles are highly reflective, I used the flash bracket with a diffuser on the flash to minimize hot spots.

Mamiya 645, 120mm macro lens, flash, Fuji Velvia

Narrow-bordered Bee Hawk-moth

Hemaris tityus

This moth mimics the shape and structure of a bumblebee. It flies in sunny weather and is extremely difficult to approach. In overcast weather it rests concealed low down among the vegetation. I used fill-flash to add a little punch to the image and shot off a tripod.

Mamiya 645, 120mm macro lens, fill-flash, Fuji Velvia

I have used different lens and extension tube combinations quite successfully with different camera systems. However, this approach is not suitable for small insects, as the amount of extension needed to achieve 1:1 capability makes them too awkward and cumbersome in the field.

Working with smaller subjects

Photographing smaller insects requires a different approach in terms of equipment and technique. In most cases, you will be working at higher magnifications and using flash as the main light source to freeze subject movement. Using a tripod with small, highly mobile, subjects is in most cases impractical. Flash gives you the freedom to respond quickly without the burden of having to use a tripod. It also allows you to use low ISO films, which will render the fine detail in your subjects and produce well-saturated colour.

With experience, you can learn to recognize some of these difficulties in advance and be selective in terms of the subjects you choose. For example, on bright sunny days look for insects that rest or perch on the top of vegetation. That way, you will avoid distracting shadows among the foliage. Look carefully at the background behind and try to select subjects that stand clear from cluttered vegetation. This is not always possible, but as a compromise use selective depth of field and a slightly lower magnification to control it; you can always crop the image later.

Studio photography

Collecting insects for studio photography is not so widely practised now, since many species can be photographed successfully in their own natural surroundings. If you do want to collect specimens for indoor photography, bear in mind the following points:

○ Taking male specimens is preferable to taking females.
○ Keep specimens in a well-ventilated container in cool conditions away from sunlight.
○ When you have taken your photographs, release the insect back to the area it came from.
○ Do not collect from nature reserves or similar protected sites. Most require a permit for collecting and some may contain species that are protected by legislation.

Professional tips

○ Try photographing species that frequent your garden – you can experiment with your equipment and techniques.
○ You can encourage insects into your garden by planting flowers that attract butterflies and other insects.
○ Join your local natural history society. There are always experts who will be able to give you information on sites and species in your area.
○ Explore the vegetation carefully, especially on dull overcast days; many insects conceal themselves among foliage.
○ Examine the flower heads of umbelifers, as they often attract small beetles and other similar-sized insects.
○ Explore the bank-side margins of small ponds and pools early in the morning for emerging dragonflies.
○ Don't confine your photography to the middle of the day when temperatures are high; go out very early in the morning or early evening when temperatures are cooler. You will find insects are more tolerant of your presence then.
○ When in difficult terrain, use a monopod for additional support, even when using your flash bracket.
○ In bright sunny conditions, look for subjects perched on prominent bits of vegetation, as there will be fewer shadow areas to deal with.
○ Try using longer lenses with extension tubes in really bright or hot conditions. This will increase your working distance between the lens and the subject. This is only practical with larger insects at magnifications up to half life-size.
○ Use flash to help control shadows and contrast when working in bright sunlight especially if there is a lot of surrounding foliage. It can help to produce a more balanced exposure by reducing the harshness of shadows.
○ Examine paths and tracks where the vegetation is short; some species, particularly butterflies, bask on bare ground in early morning where the temperature is a couple of degrees higher.

**FOUR-SPOTTED
CHASER *LIBELLULA
QUADRIMACULATA***
*This species of dragonfly is
particularly fond of perching
on prominent vegetation.
They make frequent patrols
of their territory, engaging
with other dragonflies that
encroach on their airspace.
They habitually return
to the same perch. Here,
there was no distracting
vegetation that would cause
unwanted shadows. I used a
long telephoto with extension
tubes and chose a wider
aperture to balance the flash
with daylight.*

Mamiya 645, 210 mm lens
plus extension tubes, fill-flash,
Fuji Velvia

Photographing fungi and lichens

Fungi are a large and diverse group of organisms that are normally categorized according to their structure and biological differences. Along with lichens, they are one of the least photographed groups of organisms when compared to flowers and insects. Their lack of popularity among photographers may stem from the difficulty in identifying all but the most common species.

Fungi and the closely related slime moulds have a close association with plants. However, they lack chlorophyll and are therefore unable to manufacture carbon compounds necessary to life. They obtain nourishment either as saprophytes feeding on the remains of plants or animals, or exist as parasites. The mushroom is the reproductive part, or fruiting body, of the organism, produced from a fine network of tiny cobweb-like threads or strands (known as mycelium) that exist in the soil.

Fungi

Many species of fungi have a close association with certain habitats and, in many cases, to a single host species. Prior knowledge of their requirements is often essential if you want to photograph them successfully. Information on particular species and their association with certain habitats and host trees can be found in good guidebooks. When weather conditions are right, many of the common species are easily found. Most fungi (with the exception of bracket fungi) start to decay within a couple of days after emergence; it is therefore essential to photograph them immediately as and when you find them. In addition, slugs and other small animals often damage fungi quite quickly after emergence, which renders them useless for photography.

Lichens

Lichens, unlike most fungi, can be found all year round. They often grow in similar habitats to mosses and were once classified with them, even though they have a different structure. Lichens are composed of two plants, a fungus and an alga, which exist together. The algal cells contain chlorophyll and are therefore able to manufacture food. The fungus cannot provide food, but offers shelter and moisture for the algal cells in return.

FLY AGARIC *AMANITA MUSCARIA*
This is perhaps the best known and most widely illustrated of all fungi. It has a close association with birch and is usually seen from late summer onwards. I found this specimen growing at the edge of a path. I was surprised that it had not sustained any damage, even from slugs. I worked off a tripod and locked up the mirror prior to tripping the shutter.
Mamiya RZ67, 140mm macro lens, Fuji Velvia

OAK BRACKET FUNGUS *INONOTUS DRYADEUS*

Fungi come in all manner of shapes and sizes. The majority are found in the ground, while others grow on the trunks and branches of trees and shrubs. I wanted to include the surrounding habitat with this fine specimen. I chose a wide-angle lens and a small aperture. Using a tripod meant that I could evaluate the composition and fine-tune my framing. I used mirror lock-up for the exposure.

Mamiya RZ67, 50mm wide-angle lens, Fuji Velvia

Lichens are widely accepted as biological indicators of environmental pollution; they live and survive in some of the most extreme environments on earth, from the Antarctic to the high alpine zones on mountains, from sweltering hot deserts and rocky sea coasts, where they flourish. Their success at adapting to different habitats lies in their ability to lose water quickly and enter dormancy. Lichens thrive in moist conditions, but can equally survive in hot, dry environments for long periods of time. They are very slow-growing and in some cases very long-lived, with some species existing for 80 or 90 years.

Although they are able to survive in extreme climates, most lichens are highly susceptible to atmospheric

PARMOTREMA PERLATUM
This is typical lichen found growing on the trunks of trees. Their delicate texture and structure show any shortcomings in focusing errors or vibrations caused by inadequate camera support.
Mamiya 645, 120mm macro lens, Fuji Velvia

Finding subjects

Fungi can be found in a wide range of habitats. Deciduous woodlands containing birch, beech and oak, or an amalgamation of different species, are among the richest and most diverse. Conifer woodlands generally have less variety, but pine woodland has many interesting species. Other suitable habitats worth investigating include coastal dunes, roadside verges, grassland and even gardens. Most fungi produce fruiting bodies from late summer until the onset of winter. September and October are normally the peak months; most species die off quickly when the first frosts begin to appear. A small number of fungi can be found throughout the winter months into early spring.

Finding suitable specimens

One of the most challenging problems facing fungi photographers is finding perfect examples free from slug damage; even among common species, it can be difficult to locate pristine specimens. Many of the larger gill fungi (mushrooms) are easily spotted close to the trunks of trees or along the root structures, whereas bracket fungi grow on the trunks and branches. Fallen or decaying tree trunks and stumps may prove to be good sources for bracket fungi and other interesting species. The smaller decaying moss-covered branches often have smaller cup fungi and some of the finer antler-like species.

Superficially, many fungi look similar and cannot be reliably identified from a single photograph. Taking a specimen is often essential to confirm identification and does no harm to the underground mycelium. Many other factors assist identification, such as habitat, host tree or plant, and the date. Incorporating leaves and other ground vegetation is useful and often gives a good indication of scale.

Preparing the subject

It is not uncommon to find your subjects surrounded, or partially obscured, by vegetation. The dilemma you face is how much to remove. I tend to be selective and only remove bright pieces of vegetation that might create an unsightly highlight in the background. Bear in mind that neatly pruned foregrounds are clearly obvious in the final photograph. If in doubt, take a shot before and another one after you have removed the vegetation. That way you can choose which you prefer.

pollution, especially to sulphur dioxide. Many species avoid growing near towns, cities and in areas with high levels of industrial pollution, which is why most of the trees in urban parks and old stone walls in built-up areas are devoid of species.

Lichens can be divided into three basic growth forms. Crustose lichens appear crust-like, forming mosaic-like structures that are tightly attached to the substrate. Foliose lichens have a leafy appearance and spread horizontally across the surface of the substrate attached by tiny threads. Fruticose lichens grow either vertically or hang downwards and are attached only at the base.

CEP *BOLETUS EDULIS*

This is a common and widespread species found in a variety of woodland habitats. It is widely eaten in Europe and used as a flavouring in soups. In these two photos you can see how the focal length of a lens affects the background coverage. For the image right, I used a standard lens. The image far right shows the amount of background coverage that you take in using a wide-angle lens.

Image right Mamiya 645, 80mm macro lens, Fuji Velvia

Image far right 50mm wide-angle lens, Fuji Velvia

exposure. Long exposures are quite normal for this type of photography, especially on dull overcast days, as wind has little or no effect on rock-growing species. Use small apertures and make sure your camera back is parallel to the rock face, as any focus discrepancy will be clearly visible with these subjects. On bright sunny days when contrast is high, you may need to bounce some light back into the shadow areas or use fill-in flash.

As a rule, I don't use filters when photographing lichens. I see no need to do so. Most of the modern film emulsions are quite warm to begin with. I want to depict the species as accurately as possible, although I may occasionally use a polarizer to remove glare and increase saturation.

You should try experimenting with different lenses. Wide-angle lenses are useful for setting the subject in the context of its environment. This works well for species attached to rocks on the shoreline. The fruiting bodies of some species make for interesting abstracts. It's always worth experimenting with different compositions; your choice of lens and approach will to a certain extent be governed by the suitability of the surrounding habitat.

DEVIL'S MATCHES *CLADONIA FLOERKEANA*
This species is often referred to as 'devil's matches' on account of the red apothecia. It is commonly found in large patches on heathland in the autumn and winter.
Mamiya 645, 80mm macro lens, Fuji Velvia

YELLOW STAGSHORN
CALOCERA VISCOSA

Photographing subjects in heavy shade using natural light and long exposures often produces images that look flat and lack contrast – as depicted in the image above. In the image right, I used balanced fill-flash to increase the vibrancy of the colours and boost the contrast on film, creating a more pleasing image.

Image above Mamiya 645, 120mm macro lens, Fuji Velvia

Image right Mamiya 645, 120mm macro lens, fill-flash, Fuji Velvia

Professional tips

- Check out woodland sites in your area. Old established woodlands such as birch, oak and beech are the most productive, especially after rain followed by warm mild conditions; this often triggers a fresh emergence of fungi.
- If you are just starting out, it is worth joining your local natural history society; most run at least one or two fungal forays in the autumn.
- Many fungi are relatively short-lived, so they need to be photographed fairly quickly.
- Keep a note of the date and the host tree or plant. This will prove useful if you want to return in the future.
- Be careful of dark-coloured lichens on light-coloured rocks; meters often underexpose in these situations.

- Don't photograph the first subject you see.
- Handhold your camera and experiment with different compositions before you set up your tripod.
- Don't take shortcuts with your framing and composition; compose the image as the subject dictates.
- Avoid photographing subjects that are in bright, contrasty positions.
- Keep 'gardening' to a minimum and survey the area around the subject for any distracting debris.
- Use a slow ISO film to maximize colour saturation and sharpness.
- Use a tripod and cable release and check the depth of field preview before you push the shutter.

CRUSTOSE LICHENS
PORPIDIA TUBERCULOSA
& PERTUSARIA
CORALLINA

I was attracted to this sandstone rock at the edge of an oak wood; it had several species of lichens growing on it. In most cases, lichens are easy to photograph in situ. I recommend you work from a tripod and cable release at all times with these species if you want to obtain sharpness in the finer structures.

Mamiya 645, 120mm macro lens, Fuji Velvia

Patterns and abstracts

One of the most fascinating aspects of close-up and macro photography is looking through a lens and seeing a hidden world that lies beyond our normal range of vision. Working at higher magnifications reveals a world of exquisite beauty, with a variety of shapes and patterns that are vibrant in colour and rich in texture and detail.

Composition is all about the arrangement of shapes and colours within a predefined space, which in the photographer's case is the viewfinder. Being able to recognize what constitutes a good composition, or what to include or leave out, is an important part in the design process of any image. The photographer must learn to look beyond the routine approach and recognize colour, pattern and symmetry. An appreciation of colour and of how lines and shapes are organized is the key to creating successful images. Our eyes are naturally drawn to vibrant colours, especially if set against a darker background.

Lens selection, choice of aperture, composition and perspective are all important elements that influence the final result. With experience and practice, you will recognize key elements that you can incorporate within the overall composition and add visual impact to your photographs.

Suggestions

Patterns are basically the repetition of shapes and structures in a subject. They exist everywhere in nature; they are obvious in some subjects but hidden in others. When you become familiar with patterns, you begin to see them everywhere in nature. This is especially the case when working in close-up.

Photographs that depict strong graphic content are generally more appealing than cluttered images that convey little to the viewer other than confusion. Reducing an image to its essential components is a useful discipline that helps to focus the mind directly on the subject. In this way, we can view the subject as a series of shapes and colours that are potential photographs in their own right. For example, experimenting with the texture of bark or the veining in leaves offers tremendous scope for originality. These are popular subjects for study, as are spiders' webs, pebbles and the

MAPLE LEAF
Autumn is the time for photographing leaves, as the cold brings about the chemical changes within the leaf that gives us the wonderful colours of the season. Macro lenses are corrected for flatness of field and are ideally suited to this type of photography, as you can precisely frame your subject and retain sharpness right to the edge of the leaf. I collected a number of leaves and examined them carefully until I got one that met my requirements. Choose ones with no holes or marks. I used flash and backlit the leaf; you can also use a lightbox to the same effect.
Mamiya 645, 120mm macro lens, flash, Fuji Velvia

FLY AGARIC
AMANITA MUSCARIA
I habitually look for patterns within a subject that would make strong stand-alone shots. The white velar scales (the remnants of the veil) on this agaric mushroom made an interesting abstract.
Mamiya 645, 120mm macro lens plus extension tubes, Fuji Velvia

Scots Pine Bark
Pinus sylvestris
Developing an eye for abstracts takes time and practice. I find the bark of trees has great potential. I spent over an hour at this old pine tree looking for an image. I took three rolls of film but kept only four images.
Mamiya 645, 120mm macro lens, Fuji Velvia

scales on a moth or butterfly's wing. The list is endless; all inspire creative ingenuity.

Abstracts are essentially component parts that, when viewed in close-up, conceal the identity of the subject. Focusing one's attention on the subject's colours, texture or form are ways to inhibit recognition. For example, from a distance we can appreciate the beauty of a flower or an insect in its entirety. Viewed in extreme close-up, the diminutive size of their individual component parts makes identification much more difficult. Generally speaking, the most successful abstract compositions are usually simple in design, but have a strong visual quality that baffles and intrigues the viewer.

Equipment for abstracts

It is possible to take good close-ups of patterns and abstracts with relatively little equipment. Working at higher magnifications makes things more difficult if you have to keep adding and removing extension tubes. A macro lens is indispensable for this type of photography. Its ability to focus to life-size gives you much greater freedom and versatility when it comes to composing and isolating a subject from a more general scene.

Depth of field issues

Careful consideration has to be given to depth of field. Shooting all of your photographs at f/16 will convey little imagination on your part, and all of your images will have a likeness about them. Books often emphasize the importance in close-up photography of using small apertures to gain maximum depth of field. This approach is fine when photographing a subject from a scientific approach; complete sharpness is important since identification of your subject is your main goal. However, when photographing patterns and abstracts this is not necessarily the case. You do not need to have total sharpness throughout the subject. Selective

MADAGASCAN BULLSEYE MOTH
ANTHERINA SURAKA
Silkmoths are one of the most attractive families of moths in the world. Many have wonderful colours and eye spots on their hindwings, which they conceal when at rest. Once alarmed, they flash these in front of a would-be attacker in the hope of scaring it off. Here, the strong vibrant colours that made up the eye spots made an interesting abstract.
Mamiya 645, 120mm macro lens, Fuji Velvia

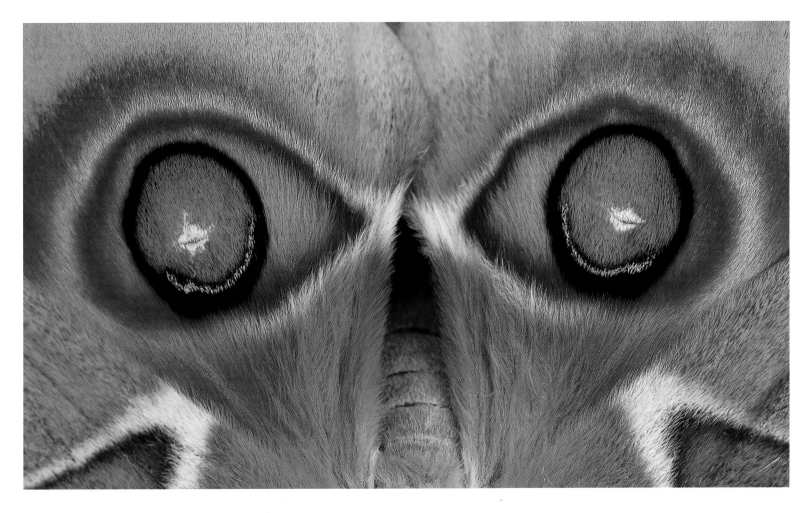

MADAGASCAN MOON MOTH *ACTIAS MAENAS*
I used a long telephoto macro combined with extension tubes
to isolate a small section of this moth's wing. I tried several
different compositions and felt this one worked best.
Kodak DCS Pro 14/nx, 200mm Micro Nikkor lens plus extension
tubes, ISO 80, Raw format converted to Tiff

focus combined with shallow depth of field can help to impart mood and atmosphere to an image. This approach is particularly effective when photographing flowers in close-up. It is a useful exercise to photograph at selected apertures and then analyse your results. You will see that the choice of aperture greatly affects the overall appearance and the degree of sharpness throughout the subject.

When working in close-up, the focal length of the lens greatly affects the appearance of the background. A 200mm macro, with its narrower angle of view, produces a more flattened and condensed perspective, rendering a more diffused appearance to the background than a shorter focal length lens. These lenses are extremely useful when you want to control the amount of blur in the background.

Working from a tripod is absolutely essential; it gives you the freedom to compose precisely and allows you to view the subject clearly. Working at increased magnifications requires a clear methodical approach and attention to detail.

Professional tips

- ○ Analyse the subject first from different viewpoints and with different lenses before mounting on a tripod.
- ○ What you leave out is as important as what you include.
- ○ Keep your compositions simple; eliminate anything that is not essential, as it will only lead to confusion.
- ○ Avoid distracting backgrounds, as these will detract from the main image.
- ○ Don't shoot everything from the same position; vary your approach.

TULIP *TULIPA SPECIES*
The centres of flowers often make interesting photos
in their own right. I often experiment with different
compositions and apertures and analyse the results;
sometimes you get more than you expected.
Mamiya 645, 120mm macro lens plus extension tube,
Fuji Velvia

Photographing in the garden

For photographers who are coming fresh to close-up and macro photography, the back garden is perhaps the best the place to begin. It provides good opportunities and instant access to a variety of different subjects conveniently placed right on your own doorstep. The pressure on the countryside has never been greater; dwindling hedgerows, ponds and meadows means that gardens are becoming important places where wildlife can take refuge. Being on hand means you can observe at close quarters any interesting behaviour or activity in your subjects and be in a position to act quickly. You can also choose your own time, when the weather conditions are ideal for close-up photography.

PAINTED LADY
CYNTHIA CARDUI
I have some buddleia bushes that attract many insects in the summer. This adult was engrossed in feeding and was easily approached.
Mamiya 645, 120mm macro lens, fill-flash, Fuji Velvia

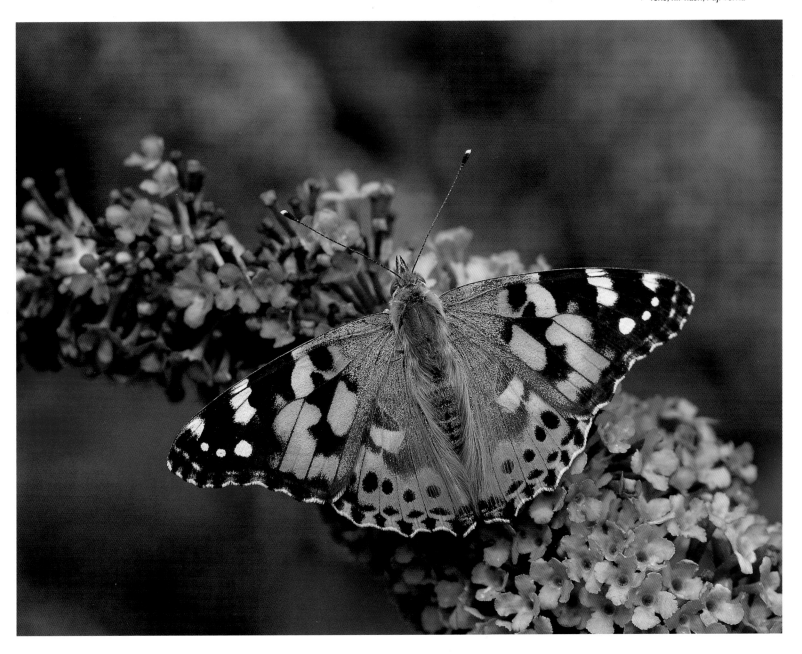

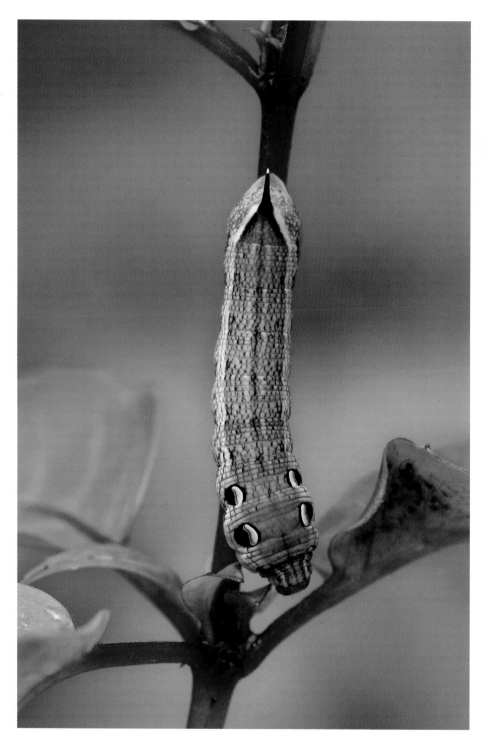

ELEPHANT HAWK-MOTH LARVA *DEILEPHILA ELPENOR*
The larva of this handsome moth is just as attractive as its adult counterpart. It is found in a variety of habitats and occasionally in gardens. The larvae feed mainly on willowherb, but will also feed on fuschias. I found this one among my garden fuschias.
Kodak DCS Pro 14/nx, 200mm macro lens, fill-flash, ISO 160, Raw format converted to Tiff

DEW DROPLETS ON SPIDER'S WEB
Autumn is an ideal time to capture these seasonal shots. I frequently walk round my garden in the morning. I noticed this spider's web with its profusion of tiny water droplets. I needed additional extension on the macro to increase the magnification beyond life-size in order to capture a small section.
Mamiya 645, 120mm macro lens plus extension tube, Fuji Velvia

Suggestions

Many photographers assume that colourful or exotic subjects are the only ones worth pursuing. However, I find that the common, everyday subjects are the ones that sell more often than anything else.

Anyone who enjoys nature can easily create a miniature nature reserve on their own back door with a little thought and planning. Neatly kept gardens with weed-free borders and prize-winning flowers are to be avoided if you want to attract insects and other creatures into your garden. A mature garden that has a variety of miniature habitats like a small pond, or an area where nature is left to its own devices, will attract all manner of wildlife.

Stinging nettles, brambles, old decaying logs and the planting of some traditional wild flowers will create an environment to entice all manner of wildlife for you to photograph. Planting flowers and shrubs that are rich in nectar will attract butterflies and provide opportunities for photographing feeding and resting adults. Buddleia, teasels and Michaelmas daisies are all plants that butterflies find tempting.

Many moths visit gardens at night to feed, and seek shelter there during the day. Honeysuckle and tobacco plants emit a strong scent in late evening and will attract Hawk-moths and other night-flying species. Running a small portable light trap, especially during the

summer months, will provide you with many potential subjects for photography. I have recorded around 80 species of moths in my own garden since it was created. The larvae of some of the common species of butterflies and moths can also be found in the garden if their food plants are available.

A small garden pond will attract several of the common dragonflies, which may breed if conditions are suitable. The larvae can be looked for in the spring to be photographed. You can also monitor the pond during the summer months in early morning for emerging adults. Frogs and aquatic insects will also colonize your pond, providing subject material for tank photography in the early spring when there is little else about. Decaying logs with early signs of fungal infection can be brought home and left in the garden to develop. They can be photographed at will. Leaving them in the garden will provide a refuge for beetles, spiders, woodlice and many other insects.

Planting a wide assortment of flowers will give you colour throughout the seasons and a variety of subjects to experiment with. Compiling a photographic account of your garden throughout the seasons can be a worthwhile project. Abstracts, raindrops on flowers, frost on leaves, and water droplets on spiders' webs are only a few suggestions. Frequent observation, experimenting with different subjects and lighting, and forward planning are the key elements to creating good photographs.

Professional tips

○ Experiment on static subjects first at various magnifications and in different lighting conditions and evaluate your results.

○ Leave one corner of the garden to its own devices and plant flowers that encourage insects to visit.

○ If you are planting flowers or shrubs to attract insects, be mindful of where you place them in terms of sunlight and the background.

CLEMATIS 'NELLY MOSER'
Rather than taking a straight record shot here, I wanted to create something soft and moody. I used selective depth of field and photographed through other flowers in the foreground to create a soft blur. I used a tripod for precise framing and locked up the mirror.
Mamiya 645, 120mm macro lens, Fuji Velvia

BLEEDING HEART *DICENTA SPECTABILIS*
I have a few of these plants in different colour forms in my garden. What makes this shot more appealing is the fine rain droplets. I used selective depth of field to keep the background as soft as possible.
Mamiya 645, 120mm macro lens, Fuji Velvia

Photographing aquatic life

Photographing aquatic animals seems less popular than other types of nature photography, possibly because of the advance preparation needed. The photographer also needs to have some elementary knowledge of the subject's habits and behaviour and the conditions necessary to keep them alive during their stay in captivity. However, this should not dissuade you from exploring and photographing the fascinating creatures that exist in our rivers and ponds. This chapter deals with freshwater animals, since they are easier for the beginner to work with and their requirements are less complicated than marine fauna.

Preparation

Standard-sized aquaria are unsuitable for photographing small subjects because of their large size and the thickness of the glass. Having a large depth of water between the lens and subject makes it difficult to focus; the sharpness of the image is also greatly impaired.

My aquatic set-up comprises several tanks, which are of different sizes and made to suit the size of the subjects I want to photograph. Your local DIY store will cut the glass to the appropriate dimensions. I normally use thicker glass on the base and sides, and fine picture or high optical glass on the front. Very small tanks can be made from standard microscope slides, which have a much higher optical quality. The side can be bonded with clear silicone cements. Be careful when using the cement, especially on smaller tanks; you don't want a surplus around the joints that may be become visible in the backgrounds of your shots. I normally use a small piece of tape down each side of the joint and remove it prior to setting; this produces a fine straight edge to the silicone.

Collecting subjects

To familiarize yourself with your set-up and to get used to working with aquatic animals, it is sensible to start with a few common species. These will help you to fine-tune your approach and technique. A small nylon net with a metal frame and not too coarse a bag is ideal for trawling through vegetation and stones near the edges of the bank, where many small creatures, such as small fish, snails, beetles and dragonfly larvae, can

be found. Examine specimens carefully and take only those that are perfect and free from disease or damage; any defect will be obvious, especially when viewed in close-up.

You should take only a few specimens at a time until you gain experience and become more competent at looking after them. It is vital to keep predators segregated from other specimens. Many creatures taken from ponds or slow-moving stretches of streams and rivers will survive for quite a while if they are kept cool and are not over-crowded. Putting a small

SOUTHERN HAWKER LARVA *AESHNA CYANEA*
I wanted to concentrate mainly on the head and thorax and avoid getting highlights in the subject's eyes. I lit this larva with a single overhead flash, to minimize the highlights.
Mamiya 645, 120mm macro lens, flash positioned overhead, Fuji Velvia

aeration pump into a large container at home will keep them more comfortable. Creatures that live in fast-flowing water that is generally well oxygenated are highly sensitive to changes in temperature and oxygen levels. They can quickly die when exposed to different temperature extremes.

Keep a separate container for collecting props in the form of different weeds and stones. You should avoid using stones and other light-coloured props, as these will cause an exposure differential when you are photographing dark-coloured subjects. Look carefully at the type of habitat that your specimens exist in naturally and try to emulate this as much as is practical when you are setting up your tank in the studio environment.

It is a sensible approach to keep a separate container for collecting your props in the form of different weeds and stones. Don't keep them all together as your subjects will become difficult to locate when you get back home and they may also get damaged resting among the stones or weeds.

SMOOTH NEWT
TRITURUS VULGARIS
It is useful to use a separating glass to restrict larger subjects to the front of the tank so they don't mess up your setting.
Mamiya 645, 120mm macro lens, flash positioned overhead, Fuji Velvia

Setting up the tank

The size of your subjects will largely dictate the dimensions of the tank needed to photograph them comfortably without causing them additional stress. Animals behave more naturally in an environment they feel comfortable in. It is better to use a tank that is slightly larger than one that is smaller, for two reasons. First, a large subject in a small tank means that you need to ensure the subject is always resting in the middle of the tank; otherwise, you may see the vertical edges of the back glass. Second, a slightly larger tank will give a little more compositional latitude, which is useful since most subjects often settle towards the edges. Another approach with tank design is to have the back longer. This eliminates the vertical margins of the joints appearing in the background. The front glass should be absolutely clean and free from scratches and imperfections – although most subjects settle a few centimetres beyond the glass, which means the lens will be focused beyond the glass, rendering any slight mark out of focus.

Any props in the form of weeds and stones should be washed carefully before use. It's a good idea to keep all of your stones and weeds in water prior to any photography; this will help to reduce the air bubbles that you normally get when immersing dry stones and cut weeds in water. Stones can be used to anchor weeds. I also often use heavy-gauge lead foil, which I cut into tiny strips and wrap around the end of the plant. Many freshwater subjects are shades of brown and green, which helps them to blend into their surroundings.

Photographing against the same background will produce a series of images that look repetitive unless you disguise it by adding extra interest. Care should be taken to ensure that your set-up is as authentic as possible. For example, do not use rocks for subjects that naturally live among the silt and detritus at the bottom of a river or pond.

When all the props are in place, you need to select a coloured background that reflects the environment. Some photographers use blues, but I tend to favour greens and browns since they reflect the environment that most species inhabit. You can place the background against the outside of the back glass, but this can give rise to reflections. I prefer to place it inside the tank as this eliminates reflections completely. You can use heavy-duty painted card, but I prefer to use glass or

Perspex that I spray the appropriate colour. I use the background as a means to fill the gaps in between props, but I would not use it on its own.

Water and filtration

Water taken from a pond or river is generally not clear enough for photography. Mains water can be used, but it must be boiled and left to stand overnight. Alternatively, rainwater collected in the garden can also be used. Some smaller aquatic organisms are highly sensitive to the chemicals in tap water and will die if they are exposed to them.

The water will also have to be filtered in order to remove any particles and other micro debris; otherwise, when illuminated against a dark background, it will produce a multitude of distracting highlights. This is especially the case when working in close-up, since you are enlarging the subject and any particles in the background. Any obvious bits of debris can be removed by pouring the water through a fine handkerchief, but the finer particles will have to be filtered through a proper filtration unit. Filter paper or cotton wool placed in the bottom of a funnel ought to be adequate for this.

Tank Set-up
This is a typical tank set-up for photographing medium-sized subjects including small newts. Working with small subjects requires the use of smaller tanks.

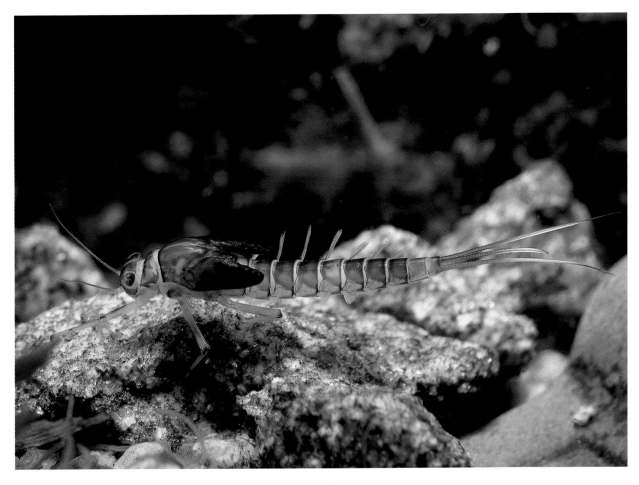

LARGE DARK OLIVE NYMPH

BATIS RHODANI
I used a very small tank made out of microscope glass for this tiny mayfly nymph. The magnification was in excess of twice life-size.

Mamiya 645, 80mm macro lens reversed plus extension tubes, flash, Fuji Velvia

Lighting

When the props are in place, run a test film to establish the correct exposure with different lighting set-ups and magnifications. Note the settings for future reference. Select apertures of around f/11 and f/16 to maximize depth of field. For large subjects, I normally light the tank from the top using a single flash. For most other subjects, I place a flash unit at each side of the tank. I normally use a small anglepoise lamp to illuminate the tank. This makes it easier to focus and to evaluate different lighting positions. The lamp can be left on while shooting as it has no bearing on the exposure.

Reflections on the front glass are less of an issue when working in close-up, but you can remove them if necessary. Get a small black card mask around the same dimensions of your tank with a hole in the centre and secure it over the front of the lens. If you plan on doing a lot of this type of photography, a more secure method is to stick an old filter ring onto the card. This can then be fixed firmly to the lens.

Introducing the subject

Before starting the photography session, it is a good idea to allow the tank to stand overnight. This will help to minimize the tiny air bubbles that appear on the inside of the glass. These can be removed with a small instrument or a small plastic drinks spatula. However, if the water is well aerated the bubbles will often reappear. Check this carefully before you photograph – it's surprising how easily they can be overlooked.

Remember when you focus that you are viewing the subject at the widest lens aperture, not the actual taking aperture. With small tanks, the water can heat up quite quickly, especially with an overhead light positioned close to the surface. The increase in temperature can cause some aquatic creatures to behave abnormally. I use ice cubes in small tanks to help keep the temperature down.

Subjects should be kept in containers at a similar temperature to your tank. Most aquatic creatures can usually tolerate a small gradual increase, but many

PART THREE

Photographing the seasons

- *Spring*
- *Summer*
- *Autumn*
- *Winter*

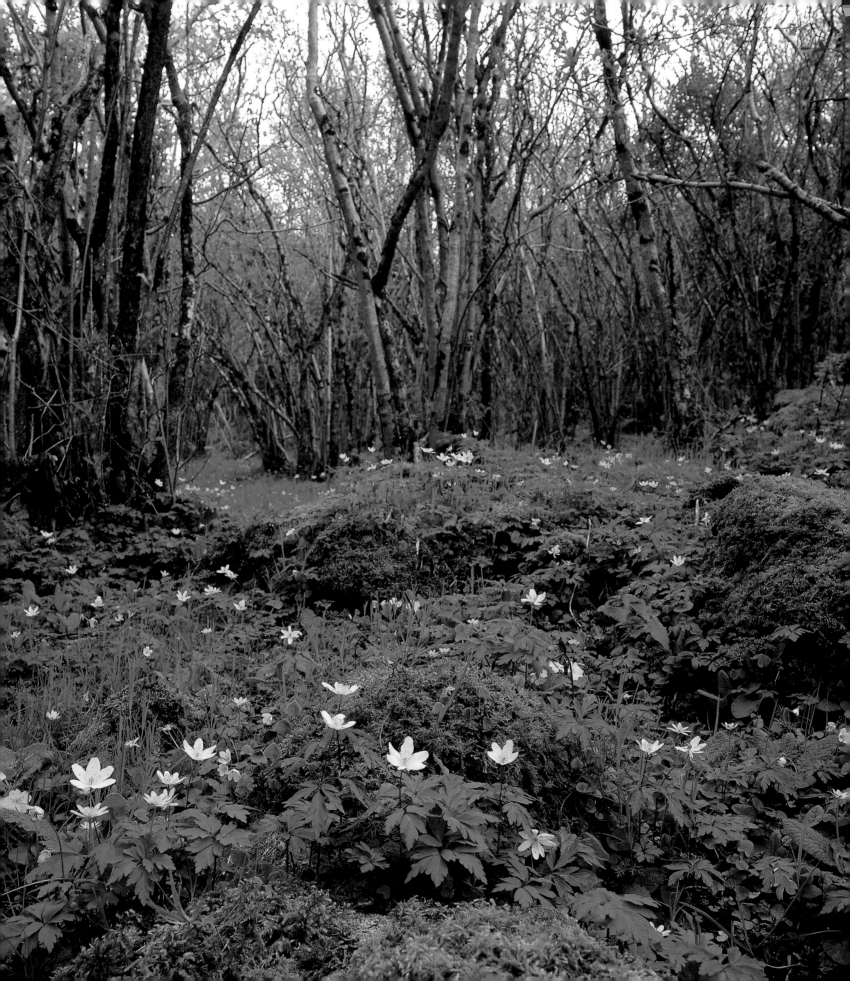

Spring

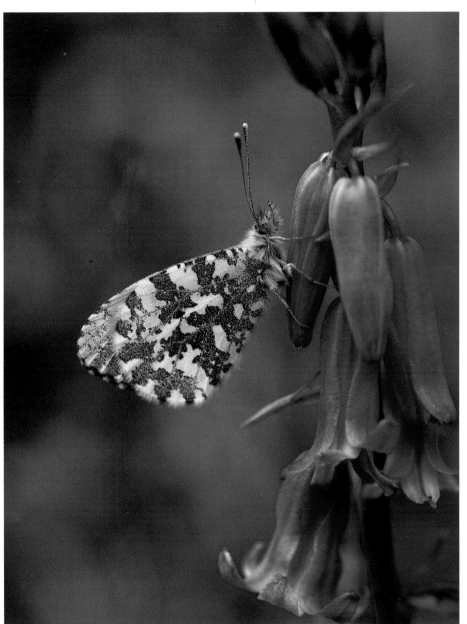

ORANGE-TIP *ANTHOCHARIS CARDAMINES* (MALE)

This distinctive butterfly is a common sight in damp meadows and along woodland fringes in early spring, where it visits a variety of flowers. I had been out very early in the morning when I found this resting male. I used a short telephoto lens with extension tubes and shot through the bluebells in the foreground.

Mamiya 645, 150mm lens plus extension tubes, Fuji Velvia

CROCUS *CROCUS VERNUS*

I wanted to try something different with this plant rather than photographing it in a conventional manner. I looked at several plants and experimented with different positions and aperture settings. I decided to opt for an abstract interpretation and used additional extension to increase my magnification.

Mamiya 645, 120mm macro lens plus extension tube, Fuji Velvia

KENTISH GLORY
ENDROMIS VERSICOLORA
*The larva of this attractive
moth feeds on birch, and the
adults fly in late spring. The
colours and patterns on the
forewings of this female are
beautifully harmonized. I used
a little fill-flash to accentuate
the contrast.*

Mamiya 645, 120mm macro lens,
fill-flash, Fuji Velvia

LESSER CELANDINE *RANUNCULUS FICARIA*
*These flowers are a common sight in many woodland habitats
in early spring. I liked the arrangement of these plants and the
fallen branch, which adds additional interest to the image.*
Mamiya 645, 120mm macro lens, Fuji Velvia

EARLY PURPLE ORCHIDS *ORCHIS MASCULA*
*This is one of the early spring species; it normally appears in
the latter half of April. They are quite variable in colour, with
some pure white forms existing in some of the larger populations.
Each spring, with new-found enthusiasm, I visit this woodland
site near my home to add more images of this pretty orchid to my
already bulging files on this species.*
Mamiya RZ67, 50mm wide-angle lens, Fuji Velvia

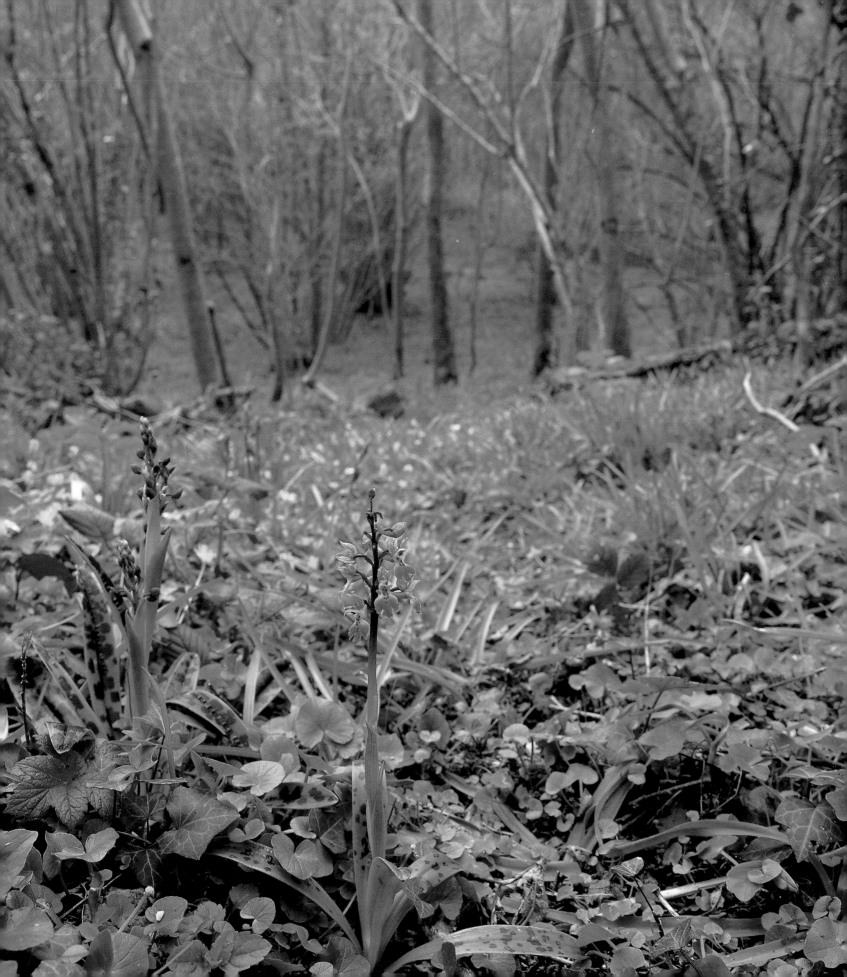

HYBRID LARCH FLOWERS *LARIX SPECIES*

Early spring is still a quiet time for the macro photographer. If larch trees grow in your area, it is worth searching their small, thin branches for these tiny, attractive flowers. The colour of the flowers varies depending on the species.

Mamiya 645, 120mm macro lens plus extension tube, Fuji Velvia

LONGHORN BEETLE *RHAGIUM BIFASCIATUM*

The larva of this attractive beetle lives in the rotten timber of a variety of trees. It is frequently seen on hawthorn flowers in springtime.

Mamiya 645, 120mm macro lens, flash, Fuji Velvia

GREY DRAKE MAYFLY *EPHEMERA DANICA*

Mayflies are a common sight around rivers and lakes during spring and early summer. This species is the largest and is often seen in prolific numbers resting among trees and ground vegetation. The wings are highly reflective and are prone to flash hot spots. I took a few shots with fill-flash, but preferred the natural light versions.

Mamiya 645, 120mm macro lens, fill-flash, Fuji Velvia

DIVING BEETLE DYTISCUS CIRCUMCINTUS (LARVA) WITH PREY

Early spring is an excellent time for photographing aquatic creatures, as many move in from deeper parts of the pond to the shallows. This larva is quite aggressive and can inflict a nasty bite from the formidable clasp-like projections it uses to capture and hold prey. I used a small 20cm (8in) tank with two flash units positioned at each side of the tank.

Mamiya 645, 120mm macro lens, two flash units, Fuji Velvia

COMMON FROG

RANA TEMPORARIA

Frogs leave hibernation in early spring and assemble at breeding sites. I found several individuals resting among the vegetation at the edge of a shallow bog pool. This individual was aware of my presence, hence its posture. I used a short telephoto with extension tubes and worked off a tripod.

Mamiya 645, 150mm lens plus extension tube, Fuji Velvia

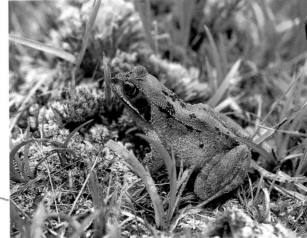

VARIABLE DAMSELFLY COENAGRION PUELLA

Damselflies have many predators, including birds and larger dragonflies. Unsuspecting adults can also fall prey to insectivorous plants such as sundews.

Mamiya 645, 120mm macro lens, fill-flash, Fuji Velvia

BOG ASPHODEL NARTHECIUM OSSIFRAGUM
This small photogenic flower is a common sight in early summer on many bogs, where it can be seen growing in large numbers.
Mamiya 645, 120mm macro lens, Fuji Velvia

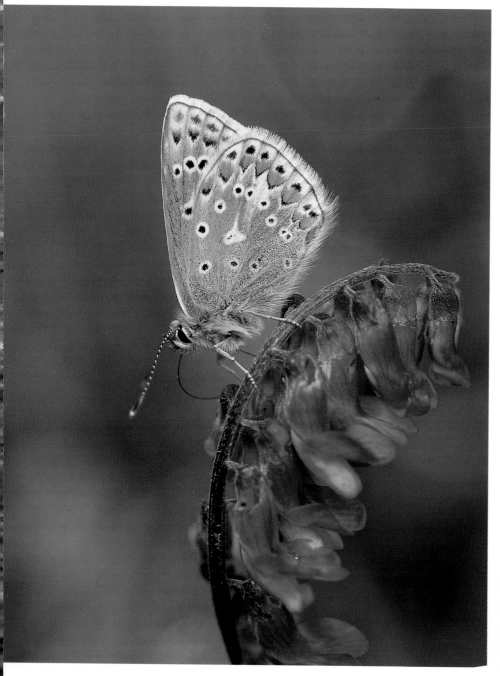

COMMON BLUE POLYOMMATUS ICARUS
This striking butterfly is found in a wide variety of habitats. This male was sucking up moisture from the plant. I shot from a monopod and used selective depth of field to keep the background well diffused.
Mamiya 645, 120mm macro lens, fill-flash, Fuji Velvia

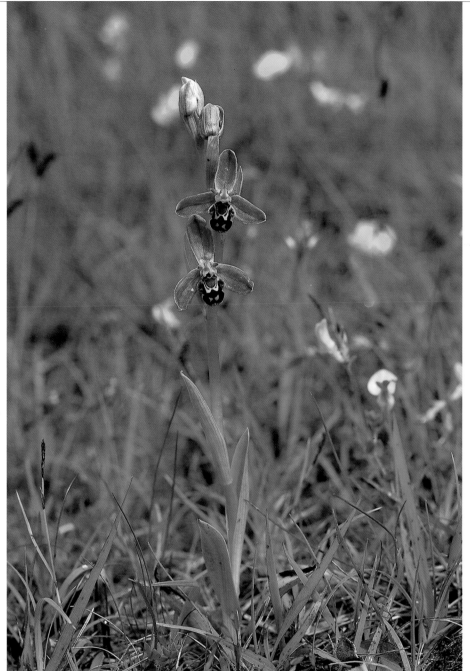

BEE ORCHID OPHRYS APIFERA
This unusual orchid is perhaps one of the best-known and photographed plants. It occurs in a variety of different habitats. There are many species and varieties throughout Europe that share this distinctive flower structure.
Mamiya RZ67, 140mm macro lens, Fuji Velvia

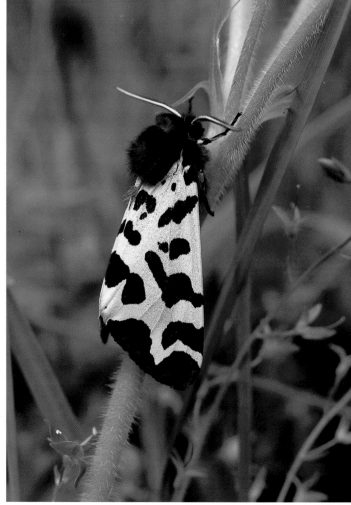

GARDEN TIGER ARCTIA CAJA
This attractive moth has distinctive chocolate-brown blotches on its forewings and beautiful orange-coloured hindwings with blue-black spots that are concealed when at rest.
Mamiya 645, 120mm macro lens, Fuji Provia 100F

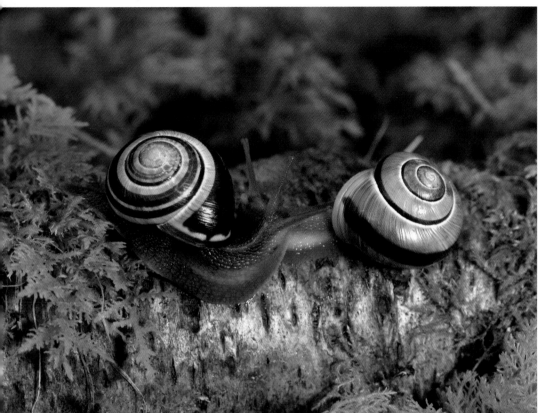

SWALLOWTAIL *PAPILIO MACHAON*
This species is one of the most sought-after and photographed butterflies. It is widespread throughout most of western Europe.
Mamiya 645, 120mm macro lens, Fuji Velvia

COMMON OR GARDEN BANDED SNAILS *CEPAEA NEMORALIS*
Dewy mornings in late spring and early summer are a good time to see and photograph this species. It occurs in a wide variety of habitats from gardens to woodlands, where it is often seen in numbers. Reflection is a major problem with molluscs when using flash. I used a diffuser to help reduce the flash highlights.
Kodak DCS Pro 14/nx, Nikon 200mm macro lens, flash, ISO 160, Raw format converted to Tiff

COMMON BLUE DAMSELFLY *ENALLAGMA CYATHIGERUM*
This is a common and distinctive damselfly found in large numbers on many lakes in early summer. The bright blue males can be seen perched on the bank-side vegetation waiting for passing females. The light was quite overcast so I used fill-flash to add a little contrast to the image. I worked off the monopod with the flash bracket.
Mamiya 645, 120mm macro lens, fill-flash, Fuji Velvia

SCARCE MERVEILLE DU JOUR
MOMA ALPIUM

This species is mainly associated with oak woodland. It is remarkably cryptic when at rest among lichen-covered tree trunks.

Mamiya 645, 120mm macro lens, Fuji Velvia

COMMON HAWKER
AESHNA JUNCEA
Many of the large hawker dragonflies emerge at night. However, some can occasionally be found during the day. I used natural light and positioned the tripod flat on the ground to hold the insect in focus.

Mamiya 645, 120mm macro lens, fill-flash, Fuji Velvia

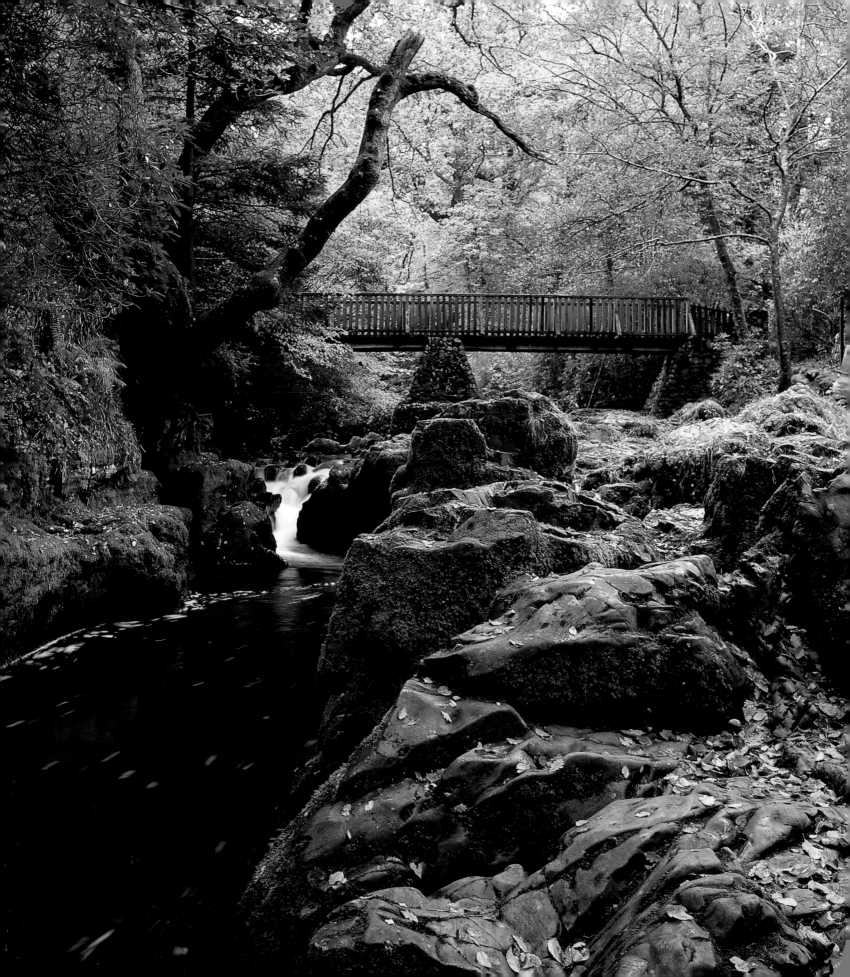

Autumn

SWEET CHESTNUT *CASTANEA SATIVA*
The fruit seeds of this tree are evident in the autumn lying among the leaf litter near the tree. There was still enough leaf cover to force exposure times in excess of 20 seconds at a small aperture.
Mamiya 645, 120mm macro lens, Fuji Velvia

FALLEN BEECH LEAF *FAGUS SYLVATICA*
Streams are often interesting at this time of year. The autumn colours are reflected in the water and leaves become trapped in the quieter parts away from currents. I made several exposures of this single leaf trapped in the small current. I used a polarizer to kill the reflection and flash to darken the bottom of the stream.
Mamiya 645, 120mm macro lens, polarizer, flash, Fuji Velvia

LARCH BOLETE
SUILLUS GREVILLEI

This is a common fungus found mainly in conifer woodland from late summer onwards.

Mamiya 645, 80mm macro lens plus fill-flash, Fuji Velvia

BLUSHING BRACKET
DAEDALEOPSIS CONFRAGOSA
FUNGAL GILLS

The gills on fungi are as remarkable and diverse as the species themselves. There are countless different patterns to experiment with. I homed in on the mosaic of tiny structures of this decaying boletus.

Mamiya 645, 120mm macro lens, Fuji Velvia

AMETHYST DECEIVER
LACCARIA AMETHYSTINA
This is a rather small species
commonly encountered in a wide
variety of habitats throughout
the autumn months.
Mamiya 645, 120mm macro lens,
Fuji Velvia

COCK'S COMB LICHEN
CLADONIA COCCIFERA
This small attractive lichen is
fairly common and widespread
on heathland and other peaty
habitats, especially during the
autumn months. Conditions
were heavily overcast, and
I therefore used fill-flash to
increase the contrast.
Mamiya 645, 120mm macro lens,
fill-flash, Fuji Velvia

BONNET MUSHROOM
MYCENA METATA
The cold dew-covered mornings that are associated with autumn can be a productive time for the macro photographer. I often go out very early in the morning. I found this group of fungi at the edge of woodland; I was attracted to the rain droplets on the surrounding leaves. Exposure times were long. I was also mindful of where I placed the tripod legs, as I did not want to disturb the surrounding leaf litter.

Mamiya 645, 120mm macro lens, Fuji Velvia

FROSTED LEAVES

After an overnight frost, I headed out quite early in the morning before the temperature began to rise too much. I was attracted to the rim of frost around the periphery of these leaves. I used a long lens to reduce the background coverage and underexposed by one stop to keep the background dark and the frost from burning out.

Mamiya 645, 300mm lens plus extension tubes, Fuji Velvia

XANTHORIA CALCICOLA

I was in a small nature reserve in southern France photographing orchids when I was attracted to the brightly coloured lichens growing on these rocks. A tripod and cable release is essential for photographing lichens if you want to retain complete sharpness throughout the subject.

Mamiya 645, 120mm macro lens, Fuji Velvia

FLY AGARIC
AMANITA MUSCARIA
*This colourful fungus is one
of the most familiar and
photographed toadstools. It
is poisonous if consumed,
though not usually fatal. It
is mainly associated with
birch and occasionally conifer
woodlands and can be seen
from mid-summer onwards.*
Mamiya RZ67, 140mm macro
lens, Fuji Velvia

AUTUMN GREEN CARPET *CHLOROCLYSTA MIATA*

As its name suggests, this small geometrid moth is found in mixed woodlands in early autumn.
My initial few shots were taken with fill-flash as a precaution. I also took a few natural-light shots,
as the scales on some species of moth can be highly reflective. I much preferred the natural-light shots.
Mamiya 645, 120mm macro lens, Fuji Velvia

Winter

FROSTED OAK LEAF *QUERCUS PETRAEA*
*Heavy frosts provide great opportunities for photographs that may
appear mundane under normal conditions. I noticed this solitary
leaf frozen on top of a young fir tree. Shots involving frost should
be taken on a tripod if you want to achieve really crisp and
well-defined edges.*

Mamiya 645, 120mm macro lens, Fuji Velvia

FROSTED BEECH FRUIT CAPSULES *FAGUS SYLVATICA*

Walking through open woodland habitats during the winter when the leaves have fallen means you discover a multitude of fallen objects or scattered seedpods from various trees. Each makes for interesting photographs in their own right.

Mamiya 645, 120mm macro lens, Fuji Velvia

FROSTED BRAMBLE LEAVES *RUBUS SPECIES*

Here, I was attracted to the heavily frosted bramble shoot that had forced its way up through the fir tree.

Mamiya 645, 120mm macro lens, Fuji Velvia

FROSTED ANGELICA SEED HEAD *ANGELICA SYLVESTRIS*

A heavy overnight frost saw me rise from my bed at an unrespectable hour and drive to a nature reserve near my home. Everything was frozen hard. I wandered up to a main pool and spotted this isolated seed head. It was sidelit with the early rising sun. I took a spot reading to be sure of the exposure as I did not want to the burn out the highlights.

Mamiya RZ67, 140mm macro lens, Fuji Velvia

STONES FROZEN IN ICE

The beauty of taking close-ups is that you don't have to travel far in search of subjects. After a heavy frost and a long day's shoot in a nature reserve, I came back to my vehicle, put my bag into the boot and sat down for a cup of tea. I then noticed several frozen puddles beside a small stream. On closer inspection, I homed in on the patterns of the frozen stones. I knew from experience that the meter would register them as middle grey. I underexposed by one stop to deepen the black and make the frozen edges stand out.

Mamiya 645, 120mm macro lens, Fuji Velvia

Evernia Prunastri and Hypogymnia Physodes on Fallen Branch

During the autumn winds, many branches fall to the ground, and some impede the flow of water. I was drawn to this branch because of the bright green lichen set among the yellows and browns of the fallen leaves.

Mamiya 645, 120mm macro lens, Fuji Velvia

Frosted Spider's Web

Frosts can reveal a plethora of spider's webs hanging among vegetation. I was out walking the riverbank near my home when I came across the arrangement. The sun was just beginning to appear as I took the first few shots. I wasn't happy with the background, as I felt it was too noticeable. I switched to a longer lens to reduce the angle of view and underexposed by one stop. I was much more satisfied with the outcome.

Mamiya 645, 300mm lens, Fuji Velvia

WINTER MOTH
OPEROPHTERA BRUMATA
While the vast majority of insects die off at the approach of winter, a small number of moths survive throughout the winter months. The most widely known is the winter moth, which can occasionally be seen resting on the trunk or among the small branches of birch.
Mamiya 645, 120mm macro lens, Fuji Velvia

BRANCH RINGS ON LARCH
LARIX DECIDUA
The unusual patterns formed by the growth rings on the old branch stumps of this fallen trunk looked like eyes. I spent almost an hour examining different rings and patterns before I settled on this arrangement.
Mamiya 645, 120mm macro lens, Fuji Velvia

FROSTED BRACKEN LEAVES
I backlit these bracken leaves and added
a very weak fill-flash to highlight
some of the detail.
Mamiya 645, 120mm macro lens, Fuji Velvia

FROSTED RHODODENDRON SHOOT
I was attracted to this young shoot because of
the soft early-morning side lighting from the
sun. I used a small reflector to bounce light back
into the shadow areas to reduce the contrast.
Mamiya 645, 120mm macro lens, Fuji Velvia

Useful contacts

Colorworld Ltd
PO Box 2, Norham Road, North Shields,
Tyne & Wear, NE29 0YQ, UK.
*High-quality E6 processing, digital printing and scanning.
FlashTrax portable storage devices.*

Fixation Ltd
Suite 508, 71 Bondway, London, SW8 1SQ, UK.
*Nikon and Canon official professional service centre;
also Kodak digital repair centre.*

Mamiya UK
JP Distribution, Hempstalls Lane, Newcastle Under
Lyme, Staffordshire, ST5 0SW, UK.
*Agents for Mamiya, Lastolite, Billingham, Peli cases, Gepe,
Sekonic and Schneider.*

Manfrotto
Via Sasso Rosso 19, PO Box 216, 1-36061 Bassano
de Grappa VL, Italy.

SmartDisk UK
38 Invincible Road, Farnborough, Hampshire,
GU14 7QU, UK.

Unilock Tripods
Unit 10, Firbank Court, Firbank Way, Leighton
Buzzard, Bedfordshire, LU7 4YJ, UK.

Useful website addresses

Equipment:
Fixation Ltd – www.fixationuk.com
FlashTrax – www.smartdisk.com
Fuji – www.fujifilm.com
Gitzo – Tripods www.gitzo.com
Hasselblad UK – www.hasselblad.co.uk
JP Distribution – www.johnsons-photopia.co.uk
Kirk Enterprises – www.kirkphoto.com
Kodak – www.kodak.com
Mamiya – www.mamiya.co.uk
Manfrotto – www.manfrotto.com
Nikon – www.nikon.co.uk

Digital camera reviews:
www.dpreview.com
*This is a great site for equipment reviews,
information and forums on various camera brands.*

Nature photographers online magazine:
www.naturephotographers.net
*This is an excellent site for information and articles
relating to photographic techniques, forums and
readers' galleries.*

Dragonflies of Ireland:
www.habitas.org.uk/dragonflyireland

Butterflies and Moths of Northern Ireland:
www.habitas.org.uk/moths

UK Moths:
www.ukmoths.force9.q.uk

British Mycological Society:
www.britmycolsoc.org.uk

**Atropos (Journal on Butterflies, Moths and
Dragonflies):**
www.atroposuk.co.uk

Natural History Photographic Agency:
www.nhpa.co.uk

Suggested reading

Books:
Angel, H. *Nature Photography: Its Art and Techniques*
Fountain Press, 1980

Braasch, G. *Photographing Patterns In Nature*
Amphoto, 1999

Dalton, S. *Caught in Motion*
Weidenfeld & Nicolson Ltd, 1982

Harcourt Davis, P. *The Complete Guide to Close-up
and Macro Photography*
David & Charles, 1998

Martin, G. *Macrophotography: Learning from a Master*
Harry N. Abrams, INC, 2003

McCarthy, G. *Photographing Fungi In The Field*
Guild of Master Craftsman Publications Ltd, 2001

Nichols, C. *Photographing Plants and Gardens*
David & Charles, 1994

Rouse, A. *Digital Masterclass*
Photographers' Institute Press, 2004

Shaw, J. *The Nature Photographers' Complete Guide
to Professional Field Techniques*
Amphoto, 1984

Shaw, J. *Close-ups in Nature*
Amphoto, 1987

Shaw, J. *John Shaw's Nature Photography Field Guide*
Amphoto, 2000

Thompson, R. *Close-up on Insects, a Photographer's
Guide*
Guild of Master Craftsman Publications Ltd, 2002

Field guides:
Bon, M, *The Mushrooms and Toadstools of Britain and
North-western Europe*
Hodder & Stoughton, 1987

Chinery, M. *Field Guide to Insects of Britain and Western
Europe*
Collins, 1986

d' Aguilar, J., Dommanget, J. L. and Préchac, R. *Field
Guide To the Dragonflies of Britain, Europe and North
Africa*
Collins, 1986

Dobson, S. *Lichens: An Illustrated Guide*
Richmond Publishing Co. Ltd, 2000

Fritter, R., Manuel, R. *Field Guide to Freshwater Life*
Collins, 1986

Nelson, B., Thompson, R. *The Natural History of
Ireland's Dragonflies*
Magni Publication, Ulster Museum, 2004

Press, B., Gibbons, B. *Photographic Guide to Wild
Flowers of Britain and Europe*
New Holland, 1993

Tolman, T. *Field Guide to Butterflies of Britain and
Europe*
Collins, 1997

Index Page numbers in *italics* refer to illustrations